Merry Christmas
= 2011"

Love,
Dad

HOCKEY'S ORIGINAL 6

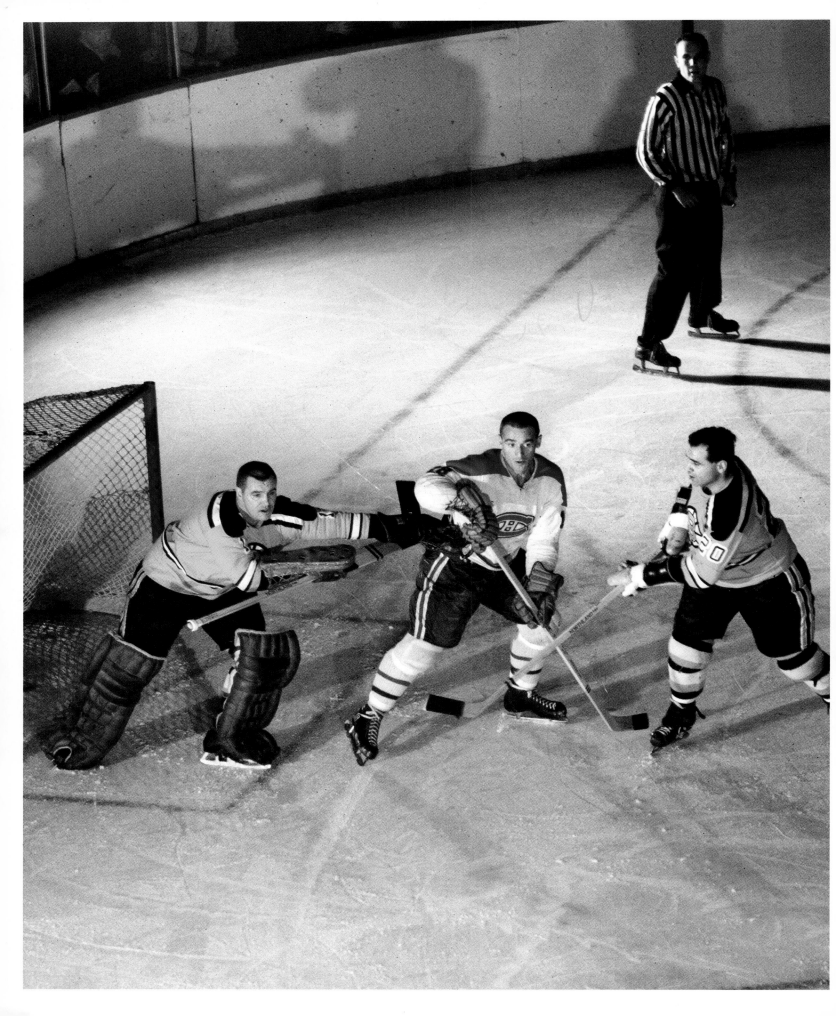

FOREWORD BY **JEAN BÉLIVEAU**

HOCKEY'S

GREAT PLAYERS OF THE GOLDEN ERA

ORIGINAL 6

PHOTOS BY **HAROLD BARKLEY** | TEXT BY **MIKE LEONETTI**

GREYSTONE BOOKS

D&M PUBLISHERS INC.

Vancouver/Toronto/Berkeley

frontispiece: Marcel Bonin (#18), here battling
Boston goalie Don Head and defenseman Leo
Boivin, won four Stanley Cups during the 1950s:
one with Detroit and three with the Canadiens. He
recorded 272 points in 454 career regular season
games and had 25 points in 50 playoff games.

This book is dedicated to the memory of HAROLD BARKLEY (1920–2003),
hockey's greatest photographer

A very special thank you to the family of Harold Barkley: his wife, Rosalind;
daughter, Sharon; and sons, Robert and Doug. The Barkley family was very
cooperative in reviewing text and in providing photographs as needed. The author
and publisher are both very grateful to the entire Barkley family. The author wishes
to thank his wife, Maria, and son, David, for their support and understanding.
The author would like to thank the following people at Greystone Books for
their efforts in putting this book together: Michelle Benjamin, Rob Sanders,
Derek Fairbridge, Lucy Kenward, Peter Cocking, and Carra Simpson.

Photos copyright © 2011 by Harold Barkley Archives
Text copyright © 2011 by Michael Leonetti
Foreword copyright © 2011 by Jean Béliveau

11 12 13 14 15 5 4 3 2 1

Greystone Books
An imprint of D&M Publishers Inc.
2323 Quebec Street, Suite 201
Vancouver BC Canada V5T 4S7
www.greystonebooks.com

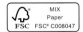

Cataloguing data available from
Library and Archives Canada
ISBN 978-1-55365-563-3 (cloth)
ISBN 978-1-55365-966-2 (ebook)

Editing by Derek Fairbridge
Jacket and interior design by Peter Cocking
Jacket photographs by Harold Barkley
Printed and bound in China by
C&C Offset Printing Co., Ltd.
Text printed on acid-free paper
Distributed in the U.S. by Publishers Group West

We gratefully acknowledge the financial support of
the Canada Council for the Arts, the British Columbia
Arts Council, the Province of British Columbia through
the Book Publishing Tax Credit, and the Government
of Canada through the Canada Book Fund for our
publishing activities.

CONTENTS

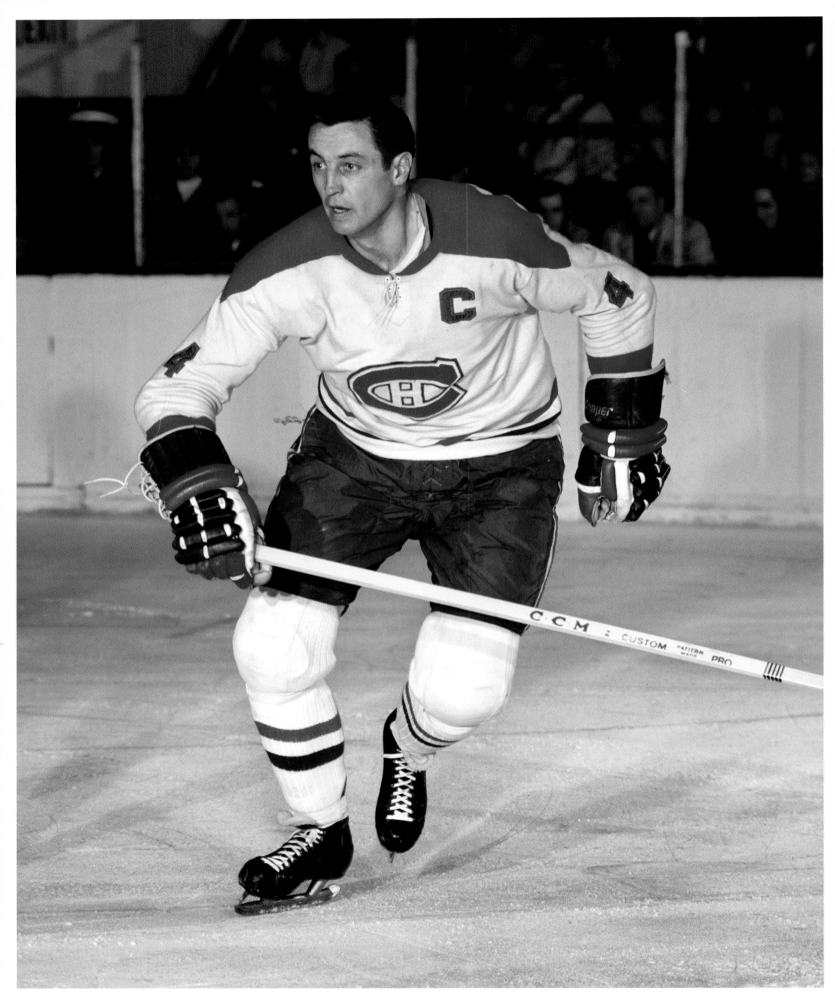

FOREWORD
by JEAN BÉLIVEAU

I'VE ALWAYS FELT fortunate to have played hockey when I did. My National Hockey League career, which ran from 1950–71, coincided with the second half of the league's "Original Six" era, the period from 1942–67 in which there were only six teams. It was an honor to be one of just 120 players playing NHL hockey. And it was an honor to be a member of the Montreal Canadiens, a team that won five straight Stanley Cups (1956–60)—a record that may stand forever.

As with every young Quebecer, it was my childhood dream to wear the Canadiens jersey. As true then as it is now, young fans around the world wanted to wear the jersey of their hometown team or their favorite hockey hero. It was a dream shared by the players. In my day, money came second; we didn't worry too much about our contracts, though maybe we should have. What mattered to us at that time was the opportunity to wear the uniform and become part of our beloved teams. That was such a great joy for me, and for all of us who took to the ice in the Original Six era. It's been sixty years since I first pulled on the *bleu-blanc-rouge*, a jersey I was privileged to wear through my entire career.

With only six franchises, the tone of the competition was different. Rivalries were more intense than they are today. We played each team fourteen times in a season (seven games at home and seven away), which really allowed the intensity of the

match-ups to develop. It also meant we could learn how each team and individual athletes played, and we could adjust our game accordingly. Montreal had a particularly strong rivalry with the Toronto Maple Leafs, which continues to this day. Along with those contests, I also always enjoyed match-ups against Detroit. The Canadiens and the Red Wings were both strong offensive teams, so fans at those games got to watch great back-and-forth action. I especially liked to face the Alex Delvecchio and Norm Ullman lines, and I also enjoyed playing at the old Detroit Olympia. That rink had the best ice. Unfortunately, like many of the old arenas, the building no longer exists.

But, really, I loved playing against all five teams. Stan Mikita, Bobby Hull, and the rest of the Chicago Black Hawks were formidable opponents. Toronto, with Tim Horton in its line-up, was a fast, close-checking team. We always knew that we were in for a tough game with Boston—with Leo Boivin, Johnny Bucyk, and a few others on the ice. And in New York, we watched for Andy Bathgate and his superb scoring touch.

As a Montreal Canadien, I played with some of the best players of the era. The great Maurice "Rocket" Richard, of course: he and I formed an impressive power-play line with Bert Olmstead or Dickie Moore, and with Doug Harvey and Bernie "Boom-Boom" Geoffrion on the point. One day, Coach Toe Blake told me that he was going to put me on a line with the youngsters—Dick Duff, Yvan Cournoyer, Gilles Tremblay, and Bobby Rousseau, and I didn't mind at all. I advised them to not change their style of play because they were playing with me. "Play your game," I told them. I've always known that the only way to win is to play as a group, to be a team, and to help each other.

As a centerman, I was always aware of the importance of strong defensive players, and I had the opportunity to play with and against some outstanding blueliners. In 1953 I played with Émile "Butch" Bouchard, the Canadiens' captain when I joined

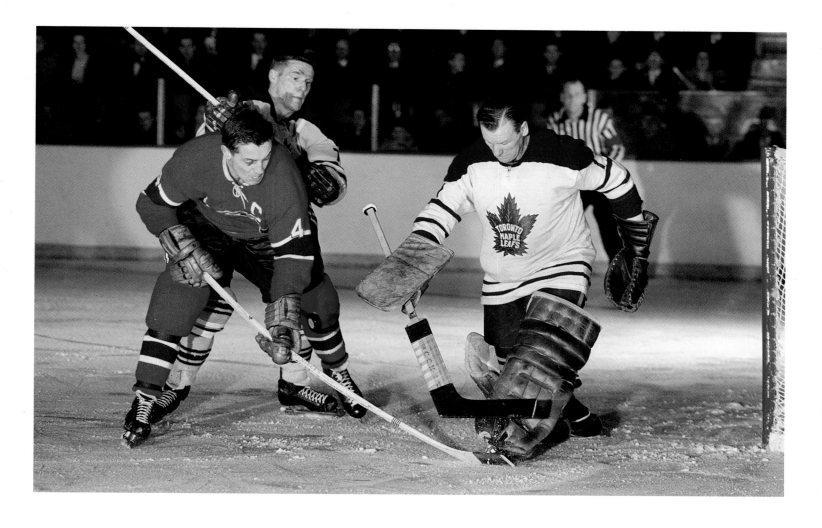

the team. He was a big, strong defenseman—tenacious but never vicious, and always ready to step in. Doug Harvey and Bobby Orr (whose amazing rookie season occurred in the final year before the NHL expanded beyond the Original Six) were great defensemen: the best ever, as far as I'm concerned. And let's not forget the final line of defense. The key to winning is a strong goalie who can keep you in the game and save you when you need it. Jacques Plante won many games for the Canadiens, as other goaltending greats from his era did for their teams: Terry Sawchuk for Detroit and Johnny Bower in Toronto. Great players manned all of the positions.

Hockey in the golden era of the fifties and early sixties was different from today's fast-paced game. Although we had many fast skaters then too, overall the game seems to have sped up. Yet I have a feeling that the most talented players of my era

could have adjusted their game and become valuable competitors in today's NHL. I certainly would have enjoyed playing alongside some of the fast and skilled players currently on the ice.

And what about the tough guys? Has the game changed when it comes to fighting and body-checking? It's difficult to say, of course. Personally, my approach was always to play according to the rules—I was a skilled skater and shooter, not a fighter. But we had some tough players in the league in my day as well. My teammate "Rocket" Richard was involved in some spectacular fights, especially against Detroit's tough guy Ted Lindsay. But Montreal was a small-statured squad for many years and General Manager Frank Selke thought we were being manhandled by some of the bigger teams, so in the early sixties he made some trades for larger

players. In 1963, we acquired John Ferguson and Ted Harris, two big and tough players, and were able to play a more physical game; in fact, they helped us recapture the Cup in 1965 and 1966. The whole team contributed to those wins, but the presence of some larger, more physical players definitely helped our game.

Perhaps the biggest change that NHL hockey has undergone since the Golden Era is how the game is covered. From newspaper to radio, from television to the Internet—the evolution has been stunning. Just as today, however, the sports media then was essential to the development of hockey. Newspaper writers and broadcasters—the great Foster Hewitt, René Lecavalier, and Danny Gallivan to name a few—reported on each team's progress and allowed fans to follow the action in a game. But as the saying goes, a picture is worth a thousand words, and so the work of the photographers was invaluable to hockey fans who would check the daily papers and weekend magazines for images of their favorite players, especially before everyone could watch the games on their high-definition TVs, computers, or even smartphones.

The Original Six period was a golden era for photography. An outstanding example was the work of Harold Barkley, the gentleman photographer who did so much to change the way the game was photographed. Barkley, with his technical innovations and instinct for capturing the on-ice action, was responsible for bringing the game and players into the homes of fans across the country.

Hockey provided a great life for me, and I'm grateful to have played during the NHL's Golden Era. I'm also grateful to photographers like Barkley since, because of their work, I can look back at these outstanding images and vividly remember my days on the ice: the intense competition and wonderful camaraderie, and our shared passion for the great game of hockey.

JEAN BÉLIVEAU, 2011

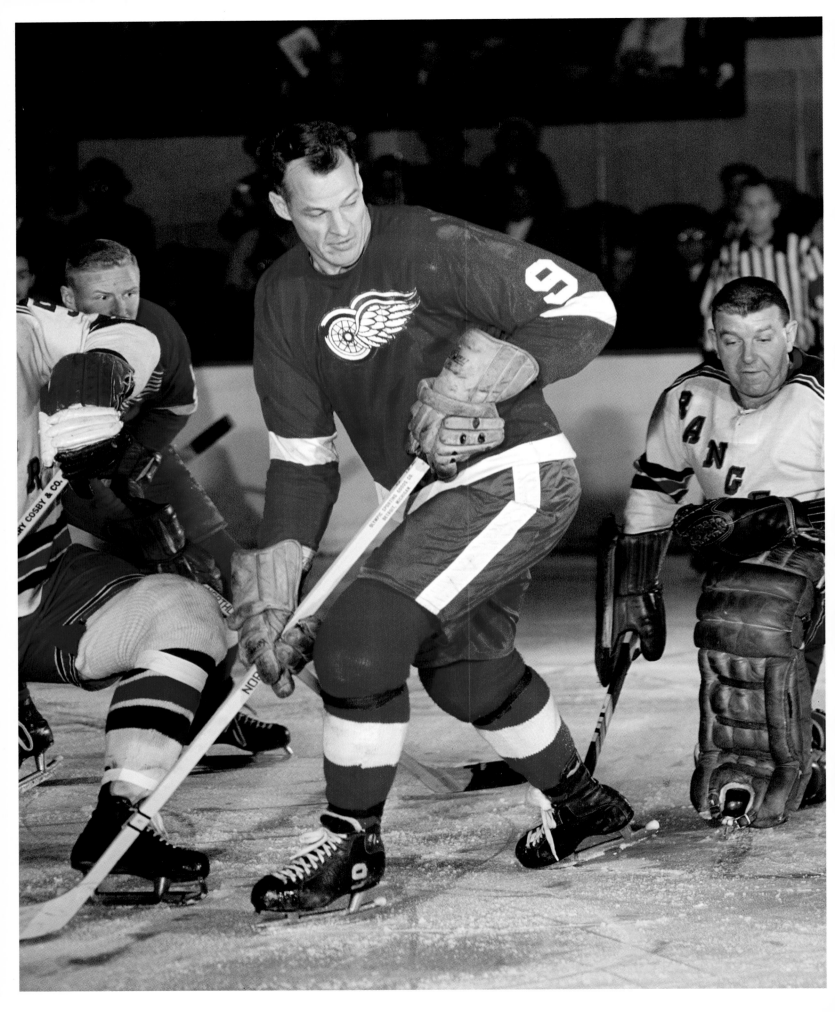

HOCKEY'S GOLDEN ERA
A TIME FOR LEGENDS

WHENEVER THE WORD "golden" is used to describe a time period, people are invariably led to imagine a special, exceptional age. This is certainly the case with the Golden Era of the National Hockey League, a period covering the seasons between 1942 and 1967 in which six teams battled for on-ice supremacy. This "golden" time period ironically began with a failure: the franchise last known as the Brooklyn (New York) Americans folded after the 1941–42 season. The departure of the Americans left six NHL teams in operation—the Boston Bruins, Chicago Black Hawks, Detroit Red Wings, Montreal Canadiens, New York Rangers, and Toronto Maple Leafs. And although World War II was still going on in Europe, the slimmed-down league was about to embark on a period of great stability and excellence that has not been seen before or since. There was no expansion during this time and franchises did not leave one city for another, so great players were able to play for many years and set new standards of achievement. Young players were always welcome and given a chance to play—provided they were good enough.

Describing an era as "golden" can also suggest simpler times, an uncomplicated, purer age. And certainly, one of the most striking aspects of the NHL's Golden Era was its simplicity. With just six franchises, only 120 players made up the entire league. Practically all of these players were born or developed in Canada, and fans

facing: The New York Rangers finally made it back to the playoffs when they finished fourth in 1966–67, after struggling to return for several seasons. Players like defenseman Arnie Brown (#4) and goaltender Eddie Giacomin (#1) helped lead the team back to respectability.

could literally name everyone on each team (try doing that now with over 700 players and thirty teams!). It was a simple game with no helmets, much smaller equipment—especially on the goalies—and hockey sticks with straight blades so players could take a great backhand shot. And, in a situation that is hard to imagine now, there was no advertising along the boards. At the time, fans could not get very close to the players (newspapers, radio, and eventually television offered basic coverage) but they could buy a pack of hockey cards for five or ten cents or send away labels in return for five- by seven-inch black-and-white "Bee Hive" photos of the players. Hockey magazines did not start up until the fifties, though the *Hockey News* began as an in-house N H L-approved publication in 1947, making the information it provided about the hockey stars rather sanitized. However, there was no great sense that the public wanted to know everything. Unlike today when the Internet reigns supreme and nothing is sacred, players' private lives were respected.

If fans were somewhat in the dark about the off-ice exploits of their heroes, they were absolutely thrilled with the feats they performed on the ice. As the Golden Era was a time when many hockey players were looking for jobs and N H L positions were limited with only a six-team circuit, competition for work at the highest level was fierce. Players who had had a bad season or even a few bad games in a row might feel threatened by a coach or general manager all too willing to remind them that their positions were easily replaceable. At the time, the athletes feared management and few dared to challenge the upper echelons of the league's administration. In 1957, the N H L players tried to unionize—with great trepidation—but were not able to start their association until the league doubled in size ten years later. There was never any talk of lockouts or strikes, and hockey fans never even heard the term "free agent."

The popularity of the league grew as postwar prosperity boomed. Most N H L arenas were generally filled to capacity as the fifties turned into the sixties, even in Boston where the struggling Bruins could still draw a large crowd. Also during this

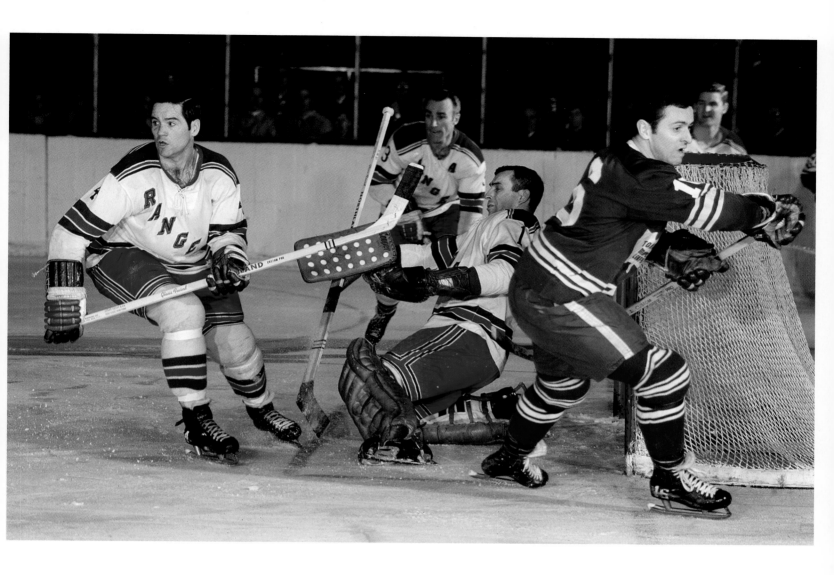

period the advent of television helped launch the popularity of the game beyond the six cities in which the games were played. In 1952, the Canadian Broadcasting Corporation (CBC) started devoting national airtime every Saturday night during the hockey season to show games from Toronto and Montreal. (In the U.S., CBS began televising hockey games in 1957.) Gathering around the TV to watch *Hockey Night in Canada* became a family ritual right across the country. As mid-week games did not start until the sixties and were not always a given, the weekend broadcast was a program no hockey fan would miss. Many epic contests played right before their eyes, and youngsters watching in their pajamas begged mom and dad to let them stay up

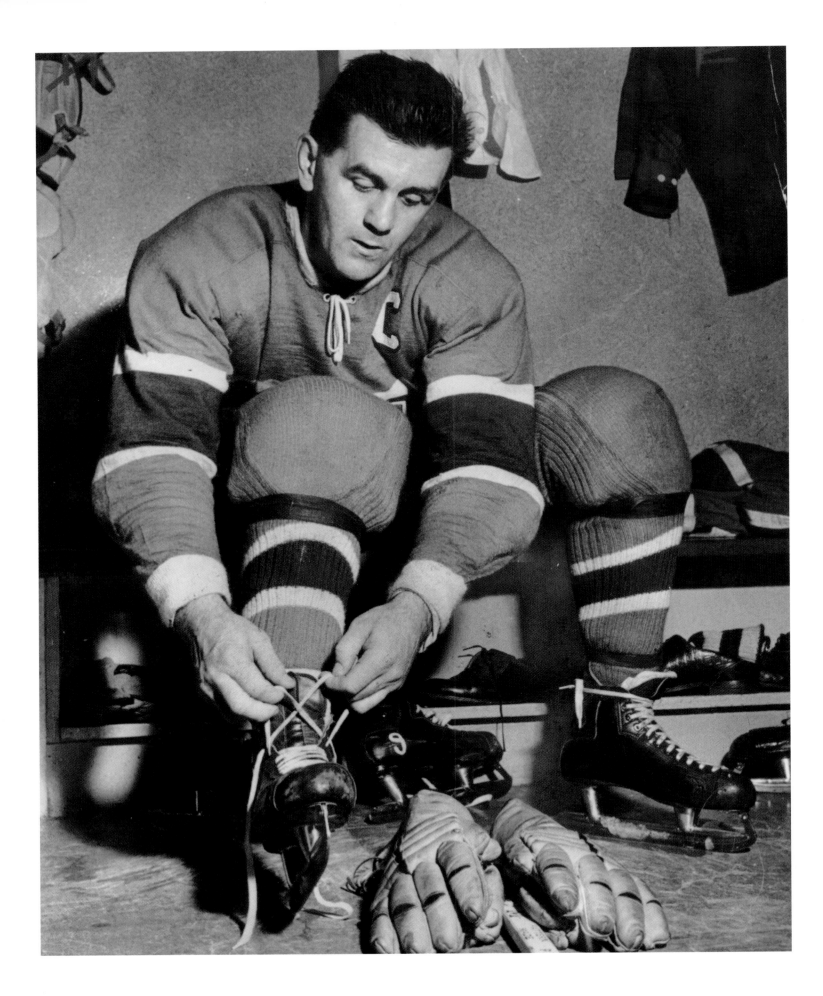

facing: Maurice "Rocket" Richard likely would have won the Art Ross Trophy had he not been suspended for the last three games of the 1954–55 regular season and the playoffs. Richard had 74 points in 67 games but teammate Bernie Geoffrion passed him to finish with 75 points.

a little longer to watch the stars of the NHL strut their stuff. Bobby Hull, Chicago's legendary and flamboyant goal scorer once said, "Everything stops when *Hockey Night in Canada* comes on." Now that fans can watch all the games on cable, satellite, or Internet TV, however, this weekly ritual has lost much of its special aura of ceremony.

Team dynasties flourished during the Golden Era. During that period, teams could stay together without worrying about a salary cap (few contracts exceed a yearly sum of twenty thousand dollars), and trades were made based on player performance rather than on team budgets. Between 1943 and 1967, the Stanley Cup was won by one of three teams—Montreal won 10; Toronto, 9; and Detroit, 5—except for one win by the Black Hawks in 1961. Some fans may like the variety offered by today's game, where the Cup changes hands every year, but this modern version will likely never produce a great dynasty like the Montreal Canadiens, whose attacking "firewagon" hockey (end-to-end rushes, exciting scoring chances, and wide-open play) won five straight championships between 1956 and 1960. Many long-time observers believe the Habs of the fifties are still the greatest team in hockey history. Certainly there were dynasty teams in the seventies (Montreal) and eighties (Islanders and Oilers) but many of those teams were augmented by trades along the way, which was not as often the case in the Golden Era when players were cultivated by one franchise and stayed with that team, often until retirement.

The rosters of these great dynasty teams were, of course, filled with great players. That generation of hockey stars set the gold standard for NHL records, with each future player chasing the milestones set by his childhood hero; for example, Wayne Gretzky following Gordie Howe. In 1957, the explosive and exciting Maurice "Rocket" Richard of the Canadiens became the first to score 500 career goals. A kind of folk hero in Quebec, Richard was also a respected and feared opponent in all the NHL cities. In 1960–61, another Canadien, Bernie "Boom Boom" Geoffrion,

11

and Toronto's Frank Mahovlich (known simply as the "Big M") tried to challenge the fifty-goal barrier but could not exceed the magic mark (though Geoffrion at least tied the record first set by the Rocket in 1944–45). In that era, no player reached the 100-point mark and a twenty-goal season was considered to be a very good, if not excellent, year.

Among goaltenders, Richard's teammate Jacques Plante, the quirky but inventive netminder, was a standard bearer, becoming in 1959 the first goalie to wear a face mask on a regular basis. Meanwhile, rival goaltender Glenn Hall played a remarkable 502 consecutive games for the Black Hawks (a streak that ended in 1962) without ever wearing a mask.

Later, Gordie Howe, the big kid from Saskatchewan, plowed his way through all defenders and eventually shattered Richard's career mark for goals scored when he netted his 545th (in 1963), all of them in a Detroit uniform. A year later, stoic teammate Terry Sawchuk recorded his ninety-fifth shutout as a Red Wing and tallied 103 over his entire career to establish a mark that would last almost forty years. Hull, the burly left winger of the Black Hawks, became the first player to score more than fifty goals in one season (in 1965–66). Hull's nearly 120-mile-per-hour shot and blond good looks made him the darling of the NHL and he was more than willing to be the people's star. In 1965, Jean Béliveau, the classy captain of the Canadiens, became the first-ever recipient of the Conn Smythe Trophy as most valuable player in the Stanley Cup playoffs, and in 1967 the smooth-skating and industrious Dave Keon became the first (and still only) Maple Leaf to win that coveted trophy. In the same year, Stan Mikita of Chicago, a slick playmaker with a deadly shot, became the first player to win three major trophies in one year.

Reviewing the list of great accomplishments by players of the Original Six era, it doesn't take long to realize that the Maple Leafs, Canadiens, Red Wings, and Black Hawks dominated the list of best—or perhaps, most-famous—stars. But there were

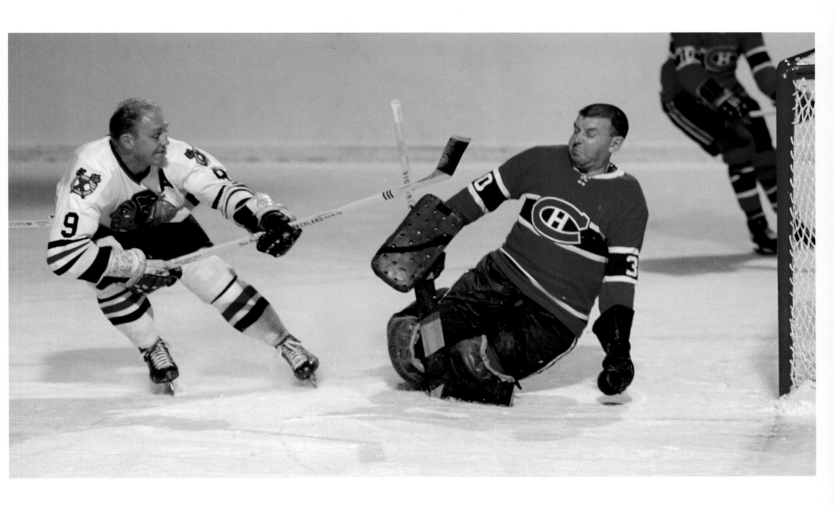

good players in Boston and New York as well. High-scoring winger Johnny Bucyk, hard-hitting Leo Boivin, and iron-man goaltender Eddie Johnston (who played in all seventy games for Boston in 1963–64) were Bruin stalwarts whereas top scorers like Rod Gilbert and Jean Ratelle were youngsters who led the Rangers back to respectability along with goalie Eddie Giacomin, a netminder plucked out of the minor leagues. The end of the Golden Era saw the great Bobby Orr (a rookie in 1966–67) change not only the fortunes of the Boston Bruins but the very nature of how the game was played.

The stars of the era also set the standard for gritty, physical hockey. Players had to be tough in those days. And while they respected each other more on the ice (no hitting from behind or direct blows to the head), it was also a time filled with bench-clearing brawls. Fighting was very much a part of the game, and on occasion sticks

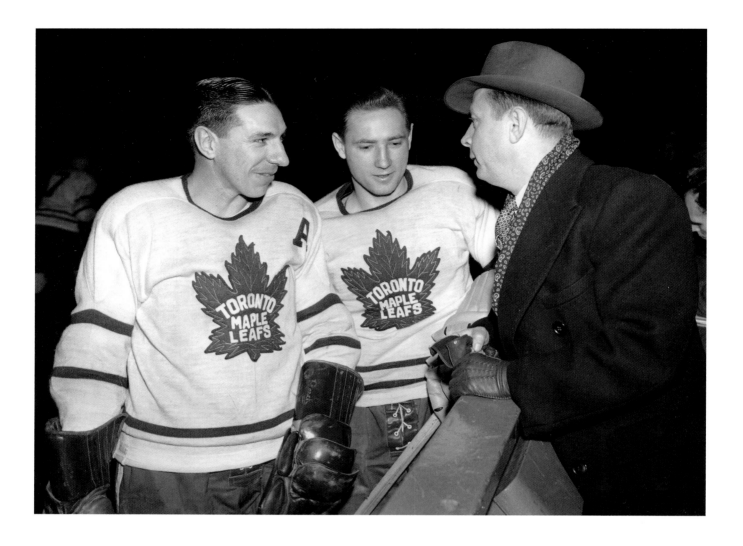

were swung haphazardly. Every team had tough guys and they could be pretty scary characters. Montreal winger John Ferguson always had a scowl on his face and Reggie Fleming of the Black Hawks would never hesitate to stir the pot. Toronto's Eddie Shack was big and fearless and he gave the Maple Leafs some much-needed color and character. No one wanted to go into a corner with Boston's Ted Green, and New York's Vic Hadfield was a big, rangy winger who liked to throw his weight around.

The most celebrated physical battle of the era featured Detroit's Gordie Howe rearranging the nose of Lou Fontinato, who fancied himself as the league's toughest player when he was with the Rangers. A 1959 fight between the two changed all that, and Howe was crowned the unofficial heavyweight champ. Even he did not want to

tangle with Orland Kurtenbach, a centerman who began his NHL career in 1960 and who could inflict real damage in a fight. Perhaps the toughest of all was Toronto defenseman Tim Horton whose famous bear hug was known to squeeze the breath out of his opponents. Fans loved the rivalries between the teams, and unlike today's enforcers, the tough guys of the Golden Era were also expected to play hockey.

Many of the players mentioned are members of the Hockey Hall of Fame and they were heroes to many youngsters who followed their superlative careers, especially as television rose to prominence. Being able to see players on TV gave kids the chance to put a face to a name, emulate a style of play, and even learn a way to tape a hockey stick. With more meaning than ever before, kids playing hockey on the streets, in school yards, or on frozen rivers and ponds could call out the name of their favorite player before starting an epic battle of their own.

Nowadays, hockey fans who were around for any part of the Golden Era long for the time when all games were pure tests of skill, toughness, and team play. It was these players and their Original Six teams who developed the game of hockey to the point where the league was stable and profitable (if only for the owners). They provided the league with the opportunity for expansion in North America, including to other Canadian cities like Vancouver, Calgary, Edmonton, and Ottawa (as well as Winnipeg and Quebec City for awhile) and to other American cities, even in the south, where the appreciation of hockey, a traditionally "northern" game, varies greatly. It also helped spread the game to other parts of the world such as Europe and the vast country that used to be known as the Soviet Union.

The Golden Era officially ended on the night of May 2, 1967, the day that also marked the last time the Maple Leafs and Canadiens played for the Stanley Cup. Toronto captain George Armstrong put a shot into an empty Montreal net to seal the Leafs a 3–1 win and the fourth Stanley Cup of the decade (and the last in team history to date). The following season ushered in six new teams with funny names

(Penguins and Seals, for example) and strangely colored uniforms (purple and gold for the Los Angeles Kings), and the total number of players in the league doubled. The NHL has kept expanding (while diluting the talent pool) and now comprises thirty teams. The halcyon days of the league's Original Six era have become the stuff of legend.

Thankfully, the *Toronto Star* newspaper had a hockey legend of its own in photographer Harold Barkley (more about him in the pages ahead). His color action photography, taken during the Golden Era, was a very important part of the *Star Weekly*, which was available every Saturday as a supplement to not only the *Star* but to other newspapers across Canada. Full-page reproductions of his excellent photos became collector's items even at the time and kids often posted his images on their bedroom walls as a reminder of their special hockey heroes.

Let's go back to a time when the world was a little less complicated, and sports fans—and arguably society in general—focused less on the banalities of celebrity trivia and more on skill and substance. It was an era when legendary players filled every roster and made any NHL game truly memorable. These larger-than-life heroes played gallantly for the simple love of the game. Many worked every summer to boost their meager incomes and they did not complain about learning skills other than hockey because they thought that once their careers came to an end they would get a regular job (like their fathers). It was this attitude that reminded hockey fans that the players, despite their special talent, were just like them. However, make no mistake: it was their exceptional skills and abilities that made hockey in the Original Six period a dazzling game to watch and follow. Enjoy this look back at the Golden Era, through the magic lens of Harold Barkley.

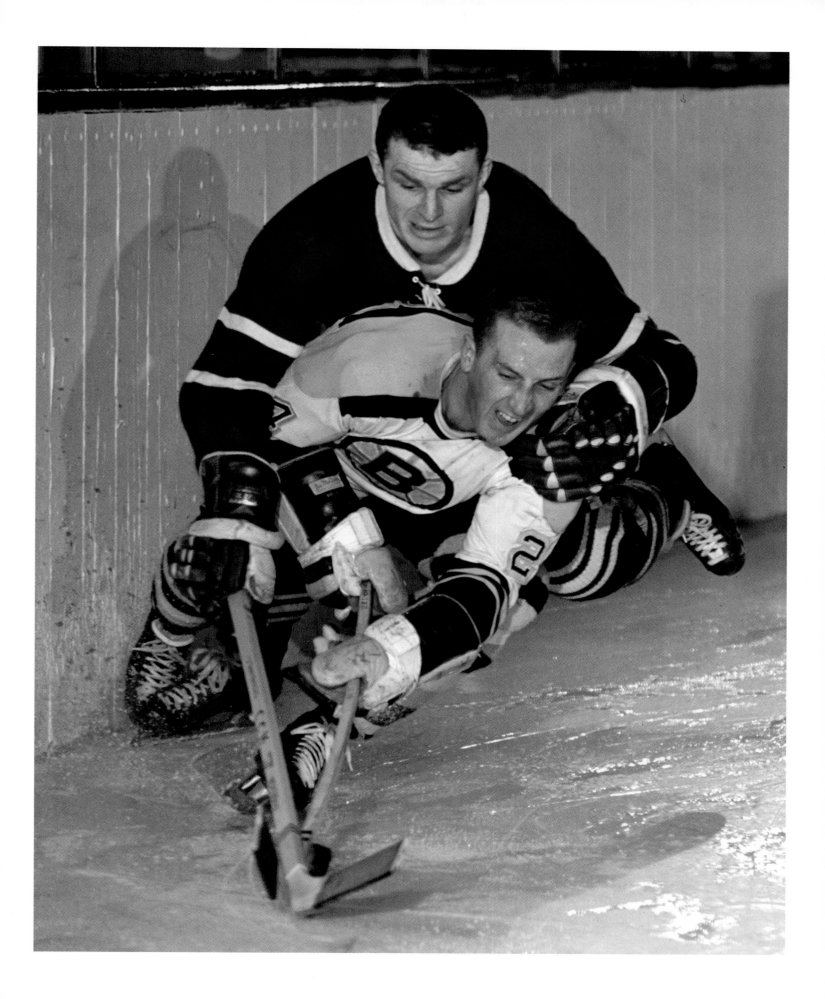

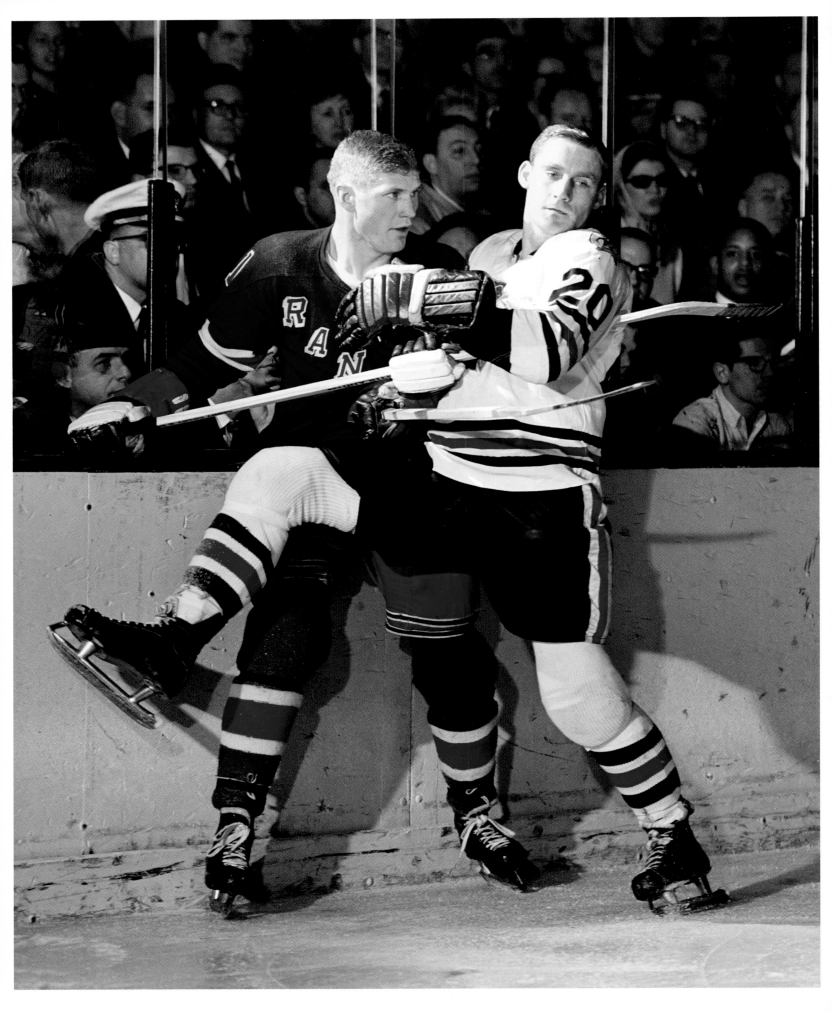

HAROLD BARKLEY

PORTRAIT OF THE ARTIST

HAROLD BARKLEY WAS one of the greatest and most innovative hockey photographers, and his work captures the spirit of the golden era of the game. Some of the most important images in hockey history might never have been captured if Barkley had pursued his original career plan, which was to follow in his father's footsteps and become a commercial artist. But when he was eighteen years old, his hands got caught in a rock-crushing apparatus at a Quebec mine and five of his fingers were damaged—doctors told him he would never use them again. However, a determined Barkley built model trains to remind himself that he could accomplish detailed tasks even with his mangled hands, and a camera given to him by an uncle gave him a new focus on life.

Harold Barkley (Hal to his friends and family) was born in Victoria, British Columbia, on October 24, 1920. His family moved to Toronto in 1925 after his father passed away, and Barkley was preparing to attend the Ontario College of Art when he suffered his mining accident. In the winter of 1942 (just as the National Hockey League was becoming a six-team circuit), he turned his attention to photography and snapped his first black-and-white hockey photographs. He worked at the Miller Photo Agency and then as a freelance photographer for a number of magazines (including those dedicated to sports) and also for the *Toronto Star* newspaper. In 1958 Barkley became a full-time member of the *Star* staff, working as

much as seven days a week, starting his job at eleven a.m. and not leaving until late at night when everything was done.

Sports photographers were gaining in prominence and when the iconic *Sports Illustrated* magazine made its debut in 1954, the demand for action color photography continued to grow. In the hope of boosting circulation, the *Star* began printing color hockey photos in its *Star Weekly* supplement. Barkley saw a future market but he had to figure out how to capture the action. During a trip to Detroit, Barkley noticed that a photographer working for the *Detroit Free Press* was using a strobe light instead of the usual flashbulbs to take his shots. The results were impressive, even with black-and-white film. Barkley then learned of a new strobe lighting system that had been developed in Sweden and he met with a Swedish engineer who helped design a system to capture on-ice hockey action in color. In the era before television crews arrived with their bright lights, poor lighting inside hockey arenas made color action photography virtually impossible. Barkley's new strobe system largely solved that problem and set in motion a technological revolution in hockey photography.

Soon afterward, Barkley set up his strobes along the glass at the ends of the ice, attached to two cameras that are often clearly visible in the photos and were only allowed at that one spot in the arena. The strobes were wired and synchronized to the camera shutter so that when he clicked, the flashes highlighted one area of the ice for that split second and in effect "stopped" the action, capturing an image with incredible sharpness, detail, and light. Using Kodak film, Barkley took many of his shots as large-format transparencies (roughly four inches by five inches), which made them easier to reproduce. Using a large-format camera allowed Barkley to shoot a bigger negative of better quality, and with the strobes in place he could capture the action at 1/1200th of a second.

Barkley's entire system used an estimated 350 pounds of equipment that was stored in specially designed cases and that he transported with him to games in

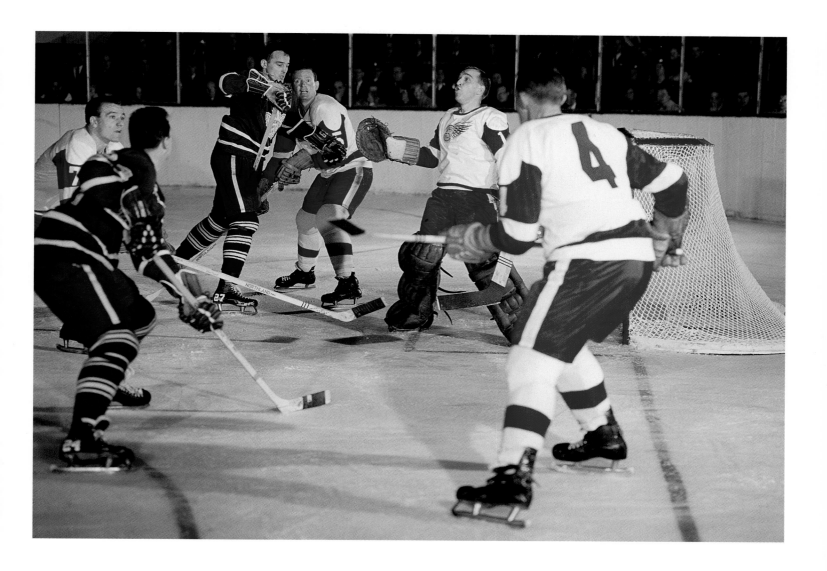

each of the Original Six cities. Since he worked for a Toronto newspaper and lived in Oakville, Ontario, most of Barkley's shots come from Maple Leaf Gardens. But he also traveled to Boston, Chicago, Detroit, Montreal, and New York to take photographs in those cities' arenas. It was a lot of effort but the results Barkley produced were spectacular and captured some of the best players and plays of that era.

Barkley encountered some difficulties in doing his job. One night the ever-finicky Jacques Plante became agitated. The Canadiens goaltending legend skated over to where Barkley had his strobes set up and knocked on the glass. He told the photographer in no uncertain terms that the flash was bothering him. Referee Frank Udvari

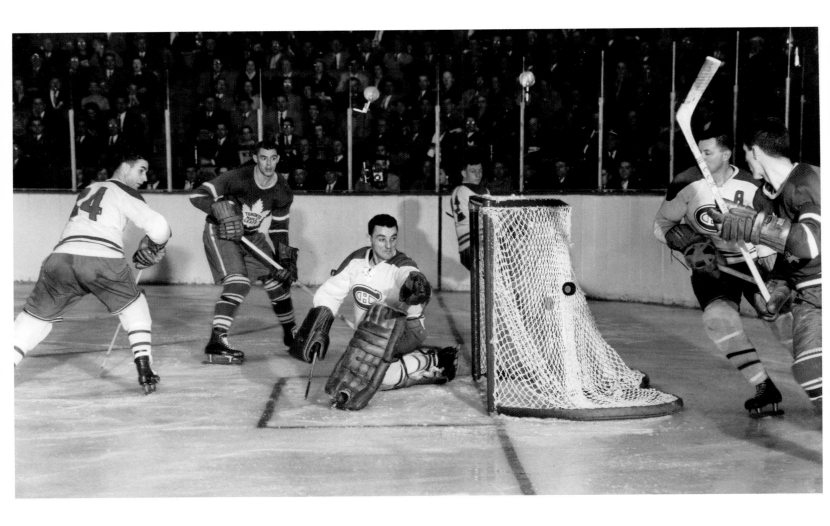

ordered Barkley to stop shooting. This incident forced the photographer to work out the kinks with his system in the pregame warm-up to ensure there were no further complaints from goalies. At another game in New York, a woman grabbed one of Barkley's lights and hid it under her seat, claiming it was distracting the players. At the Chicago Stadium one night, a fan poured a bottle of soda pop over Barkley's equipment and the sparks that resulted gave the fans an extra light show.

As Barkley was the inventor of color hockey-action photography, his collection was one of the only places to find high-quality work in this field from the late fifties through the late sixties. Much of his best material appeared in the Star Weekly across Canada under the headline "Stars of the World's Fastest Game." Each weekend during the hockey season, fans collected the large photos and pasted them

into scrapbooks. Youngsters would pin up images of their favorite players in their bedrooms. Barkley's best shots adorned the cover of *Hockey Illustrated*, a popular magazine in the sixties, and his work also appeared in *Sports Illustrated*, *The Sporting News*, *Sport*, and *Time*. Hockey books (biographies of Bobby Hull, Red Kelly, and Stan Mikita, for instance) usually had a Barkley photo on the cover. The *Star* also published two collections of Barkley's photos in the mid-sixties (one with four- by six-inch photographs and the other with four- by four-inch shots, on high-quality paper with captions, a total of ninety action shots altogether). A mint-condition set of each is worth at least three hundred dollars today. How I wish I had kept mine! In 1969 a British publisher put together a colorful, large-sized book featuring much of Barkley's best work, with text by Trent Frayne, one of Canada's foremost sportswriters. Simply titled *Hockey*, it marked the first time a book was made up solely of hockey photos and is still one of the most popular items at collector shows.

Much of Barkley's success is due to his keen sense of timing—he knew when to click the shutter. The late Jim Hunt, a sportswriter who often worked with Barkley, said his colleague studied the players he was photographing to know their tendencies. Bobby Hull, a Barkley favorite, was a good example and is the subject of one of Barkley's best shots. The blond Chicago Black Hawk star was the most entertaining player of the era and the purest goal scorer for more than a decade. Barkley captured the "Golden Jet" at his best as he tried to beat Johnny Bower of the Toronto Maple Leafs during a game at the Gardens. The photo shows the puck in mid-air, already past a sprawled Leafs netminder and about to go just wide of the left goalpost. It won a national newspaper award and came about because Barkley understood his subject so well. He knew Hull would veer left before letting go of his howitzer shot. Similarly, he knew that Gordie Howe would snap a quick wrist shot as soon as he got close to the opposing goal, and Maurice "Rocket" Richard could let a drive go at any point after he crossed the blue line. Preparation gave Barkley terrific action shots

of hockey's great legends like Johnny Bucyk, Rod Gilbert, Glenn Hall, Gordie Howe, Dave Keon, Ted Lindsay, Frank Mahovlich, and a youthful Bobby Orr, to name just a few Hall of Fame players he saw through his lens.

Being able to pick the exact moment to click the shutter was important for Barkley since he did not take too many shots—perhaps as few as fifteen or twenty in a game. In contrast, today's digital technology allows photographers to take hundreds of shots per game. Barkley also had a knack for capturing the puck in his photographs, and where the black disk goes there is sure to be action.

Another distinctive feature of Barkley's work is the look of intensity on the players' faces. In an era without helmets and masks, Barkley captured some of the best faces of the era—hard-nosed players like Bill Gadsby, Ted Green, Harry Howell, Tim Horton, Jacques Laperrière, Pierre Pilote, and Allan Stanley. Of course, none provided better grimaces for Barkley's cameras than netminders like Johnny Bower, Gump Worsley, Eddie Giacomin, Jacques Plante, and Terry Sawchuk (the latter two were also captured wearing their primitive face masks). Stitches, scars, missing teeth, and crew cuts defined the times, and all of these feature up close in Barkley's best efforts. The photos reveal the faces of focused athletes who did not take the privilege of playing in the NHL lightly.

The uniforms of the Golden Era were especially interesting for their use of primary colors and uncomplicated logos, and it was easy to recognize each of the six clubs when the players were on the ice. It was Barkley who realized that he got a better-quality photograph when one team wore a dark uniform and the other wore a lighter color (often both teams wore dark sweaters when games were not being photographed, broadcast, or recorded), and he suggested this permanent change that was adopted by the NHL just as hockey was becoming a televised sport.

If fans appreciated Barkley's great work, so did the coaches and players. Toronto coach Punch Imlach liked Barkley's photographs so much he had prints made for

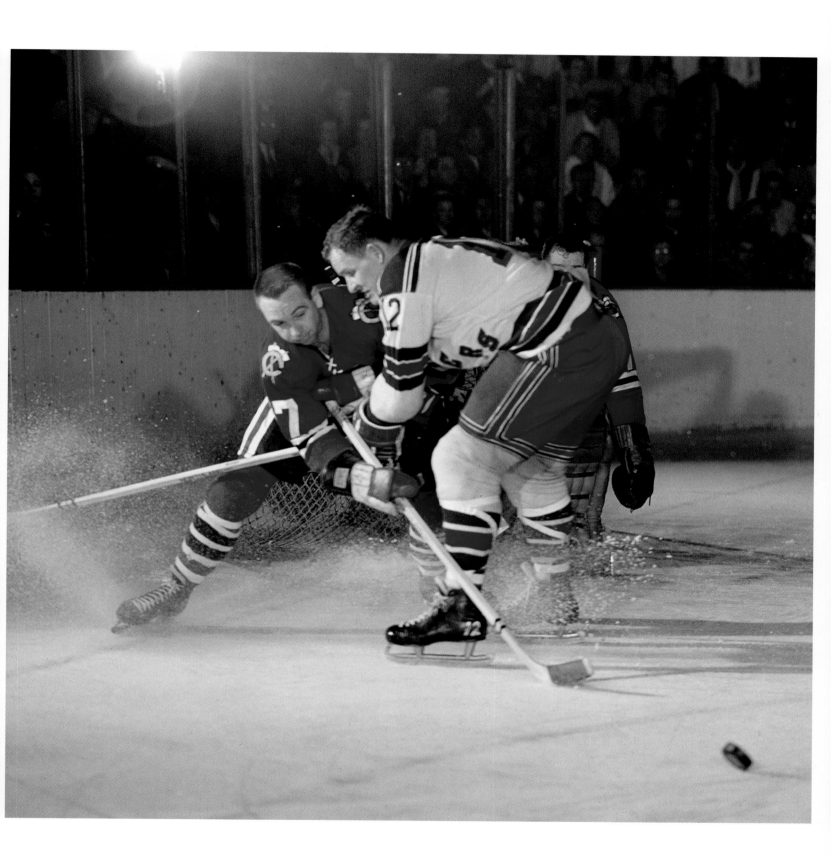

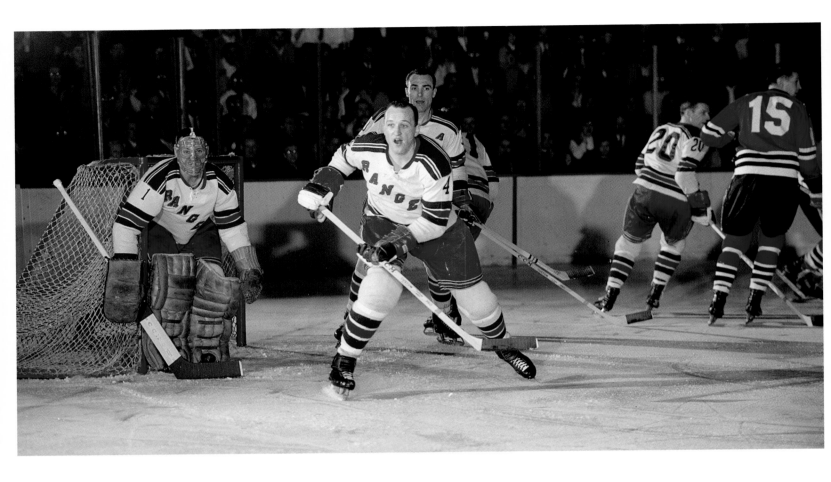

the rec room in his home. One of those photos caught the eye of Dave Keon, and the Leafs Hall of Fame legend asked Barkley for a photo of himself and Bobby Orr. New York Rangers rugged winger (and fifty-goal scorer) Vic Hadfield wanted a copy of a photo of himself and Johnny Bower, one of the best action shots ever taken by Barkley. And Montreal Canadiens legend and long-time captain Jean Béliveau recalled working with Barkley on posed shots and says he cannot count the number of times he has signed the Barkley photo of him fighting off Tim Horton while trying to score on Bower at the Montreal Forum. Bower himself said that he signs more photos taken by Barkley than by any other photographer. When he published his biography a few years ago, it was only right that a Barkley shot adorn the cover.

Hockey fans in the Original Six era loved the great rivalry among the teams and players. But if you look closely at Barkley's photos, the fans often look like they have been painted into the shot. Maple Leafs' owner Conn Smythe admonished season

ticket holders at the Gardens if they were not properly attired. Jackets, ties, and fedoras ruled the day and even when a goal was scored, fans clapped and cheered with more reserve than today (the exception might be when the Stanley Cup was won).

An era ended once the 1967–68 season began and the league doubled in size. Barkley continued working in the early years of expansion but many photographers were now in competition with him. Arena lighting became more powerful due to the demands of television, and in the 1970s, the spot lighting that Barkley had made such great use of was no longer allowed. As a result, hockey photography was not as sharp in the seventies and eighties, but as lighting and photographic technology improved into the 1990s so did the quality of photos. Some might even rival the work of Barkley.

Since Barkley was always associated with hockey, many people do not know that he had a varied career in photography. He chronicled many other sports, including football, baseball, golf, and auto racing and photographed royalty (Queen Elizabeth was a favorite subject), celebrities, prime ministers, governors-general (he followed Canadian Governor-General Roland Michener to India in 1967), and even presidents (Barkley once spent a week with U.S. President Harry Truman). His photos appeared in TV *Guide* and *National Geographic*, and his assignments took him to such places as Jamaica, Korea, and Vietnam.

Behind the lens, he had a way of cajoling his subjects into taking "just one more pose" (Barkley was something of a perfectionist) and if he had to undertake some risk to get a good shot, he did not hesitate to put himself in a tough spot, such as hanging from an airplane or strapping himself to the front of a speedboat. "He was absolutely fearless," Robert Barkley says of his talented dad. He did all of this in a gentlemanly way and he always loved to tell a good story about his experiences. He retired officially in the eighties but he stopped doing the work for which he is best known, taking hockey photos, sometime in the seventies.

Away from work, he lived with his wife Rosalind and their three children (Sharon, Robert, and Doug) on a huge lot in Oakville. Though he had plenty to do around the property, he always had time to be a father: "Above everything else he was a great dad," his daughter, Sharon, says. "By example, he showed us children that we could do anything we put our mind to." Although he had had polio when he was five years old, he had recovered fully except that he'd retained a somewhat gravelly voice. However, in 2003, Harold Barkley passed away on March 22 from complications associated with post-polio syndrome. He was eighty-two.

IN THE LATE EIGHTIES, I started working with Molstar Communications and *Hockey Night in Canada* to produce the Hockey Year calendars. I knew of Harold Barkley not only from his work in the *Star Weekly* but I remembered his work for the covers of *Hockey Illustrated* magazine and in its four-page color photo insert each month. My mother had given me my first issue of *Hockey Illustrated* in December 1963—it featured a glorious shot of my Maple Leafs hero Dave Keon shooting against Detroit's Terry Sawchuk. I was a big fan of Mr. Barkley's work and was determined that any calendar I was associated with would feature his shots. Frank Selke Jr. was able to contact him and cleared the way for me to visit him at his home. Mr. Barkley was hesitant to share his collection but Selke's introduction opened the door, and over time we developed a respectful and positive relationship. His great photographs were part of some outstanding calendars, starting with the 1989–90 season, and fans loved these shots so much that many tore out the classic photos and framed them for their home or office.

After I had visited Mr. Barkley over a few years, he surprised me one day with an announcement. "Mike," he said, "I'm thinking about selling my collection of hockey photos. Are you interested?" I certainly was, but I had no idea how I would meet his asking price, or how I was going to compete with the Hockey Hall of Fame and the

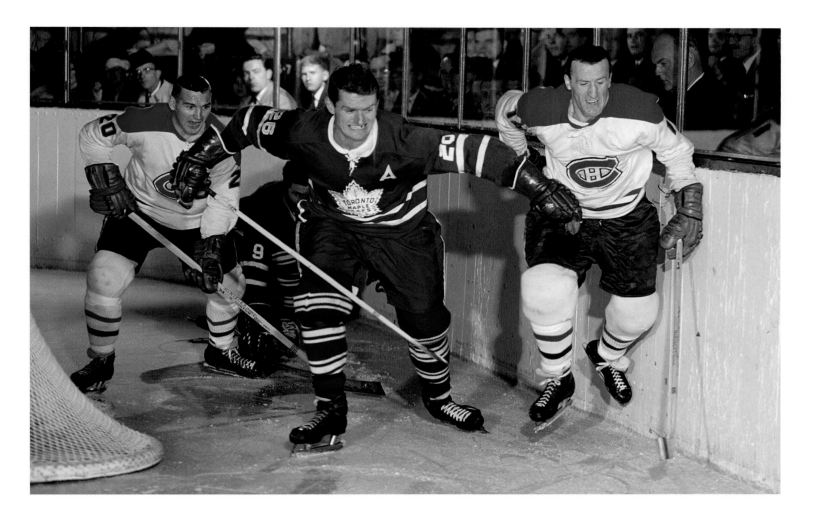

Upper Deck Company who also had their eyes on the collection. Eventually, with the help of a couple of partners and a sincere promise to get the photographs into as many books as possible, my offer edged out the competition. Sharon Barkley helped to negotiate the sale, and the entire Barkley family trusted that I would create a solid collection of books using the photographs. I am proud to say that I have lived up to my commitment.

The archive has been used for many purposes: books by other authors, issues of new old-timer cards, and reproductions of the original photographs. But my proudest moment as manager of the archive happened in 1993 when the Maple Leafs asked for photographs for the lobby of Maple Leaf Gardens, where Barkley did his greatest work. I encouraged my favorite team to give players they were honoring a Barkley

photograph as a memento of their number being raised to the rafters. Johnny Bower, George Armstrong, and Tim Horton (posthumously) all received the gift of a beautifully framed Barkley photo of themselves in a Leafs uniform. The Horton family gave theirs to the Tim Hortons coffee outlet on the ground floor of the Air Canada Centre. I see it hanging there as I exit after each Leafs home game I attend.

Trent Frayne once compared Barkley to legendary radio broadcaster Foster Hewitt in that hockey fans knew his work but would probably not recognize him on the street. Today, while there are some very skilled sports photographers in the game, hockey photography is often as much about the camera and technology as it is about the person taking the shot. Digital cameras with automatic focus make it easy to delete errors, take a large number of shots in any single NHL contest, and capture better images in poor light, though strobes are now placed at numerous locations around the rink to give better overall lighting to the entire photo. Even so, the images are often less sharp and dynamic, in part because the action must compete with colorful uniforms adorned with complicated images, and ice surfaces and boards cluttered with corporate advertisements.

The word "photography" means, literally, writing with light. If that is the case, we can say that Barkley wrote poetry. Perhaps the best line about Harold Barkley's work was written by Frank Selke Jr. who worked at the Montreal Forum in the sixties and recalled the photographer by saying, "On many occasions I arranged for Hal Barkley to set up his cameras in the Forum. I remember Hal as quiet and almost shy— his pictures did his talking. They spoke then and now with great eloquence." Even though he is gone and the arenas he worked in are no longer NHL venues, Barkley's award-winning work survives to remind us of how great it was to be a fan during the golden age of the sport. It has been my great honor to work with the Harold Barkley Archive for nearly twenty years now and I am very pleased to be a part of another book that celebrates Barkley's stellar contribution to the great game of hockey.

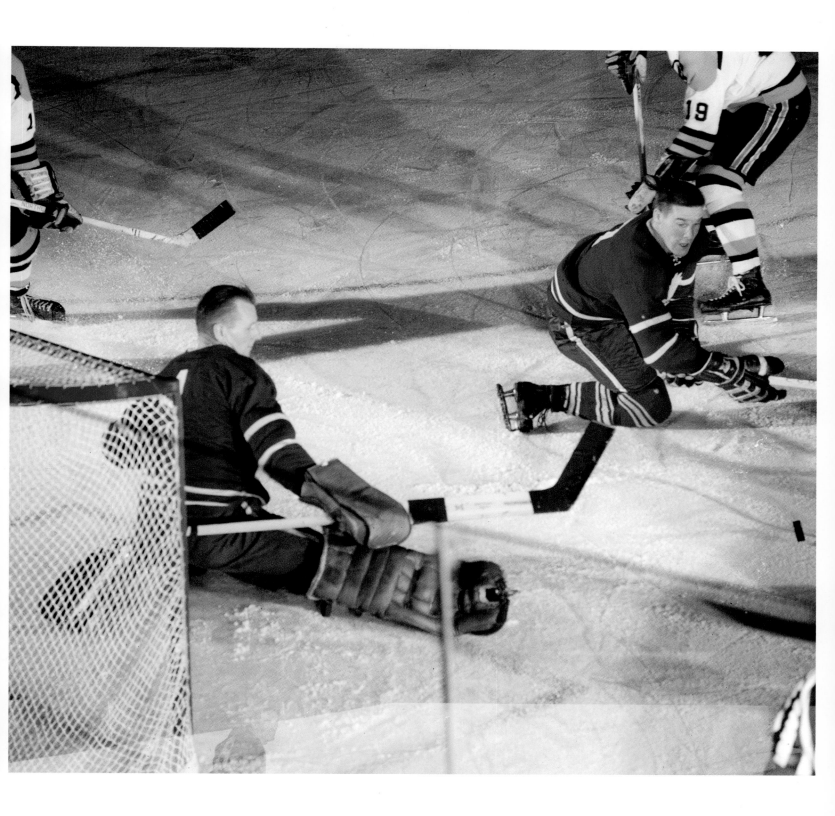

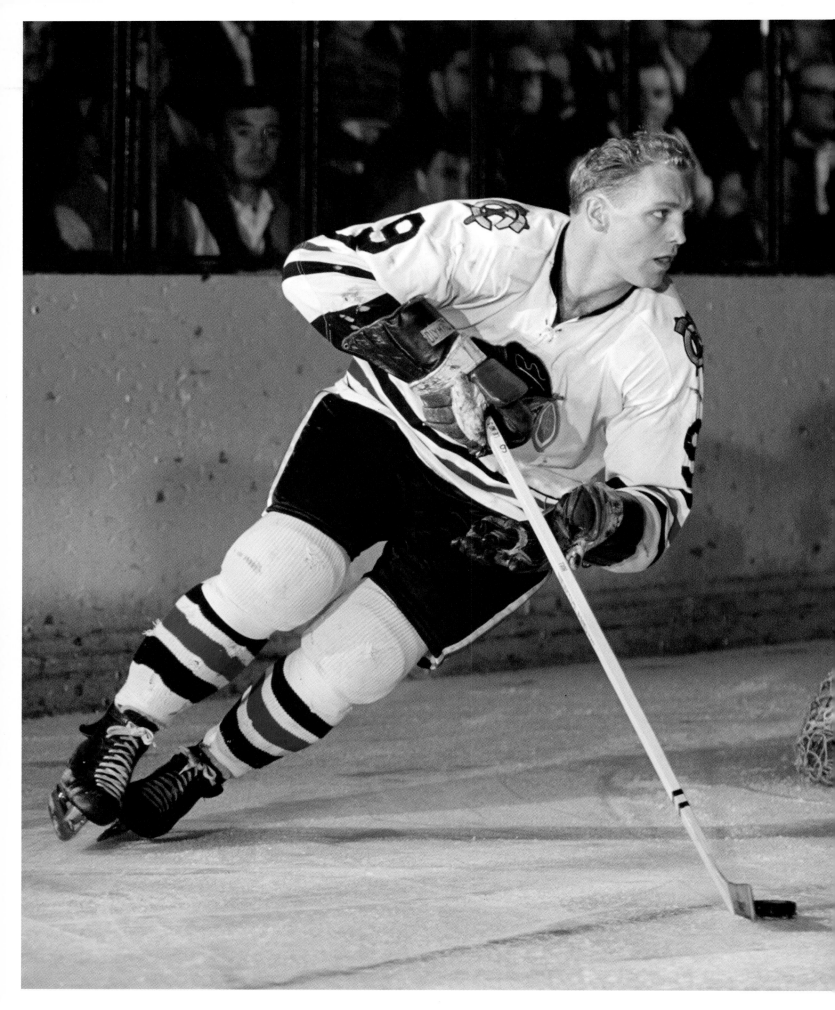

facing: In 1965–66, Chicago's Bobby Hull finally broke the 50-goal barrier (the first player to do so) when he finished the year with 54. Hull scored his 51st of the year on March 12, 1966, when the Black Hawks beat New York 4–2 on home ice.

THE
ORIGINAL 6

below: Toronto forward Harry Watson was a big, bruising winger who could score goals. He was part of four Stanley Cup victories and had 20 or more goals four times while with the Leafs. Goalie Al Rollins won a Cup with Toronto in 1951 and was a Hart Trophy winner with Chicago in 1954.

facing: Montreal goaltender Gerry McNeil shows a battered face after a game against Toronto at Maple Leaf Gardens. McNeil was in net for the Canadiens the night Leafs defenseman Bill Barilko scored a Stanley Cup–winning goal in 1951.

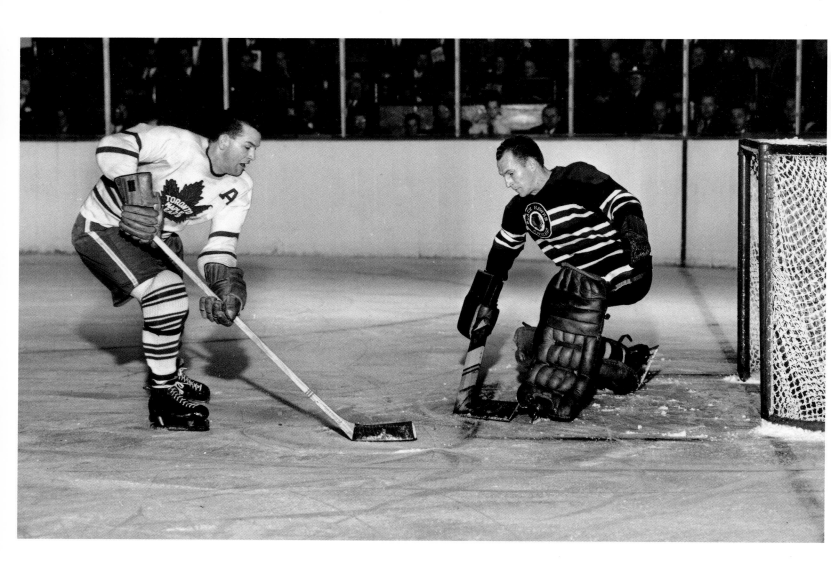

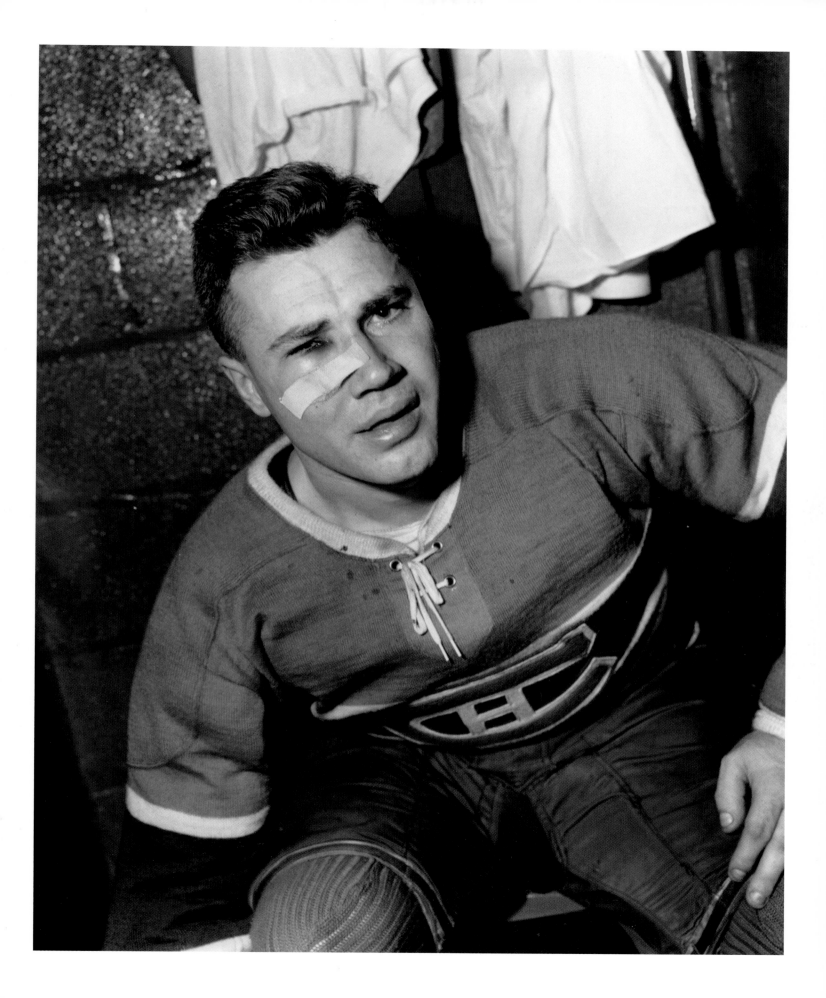

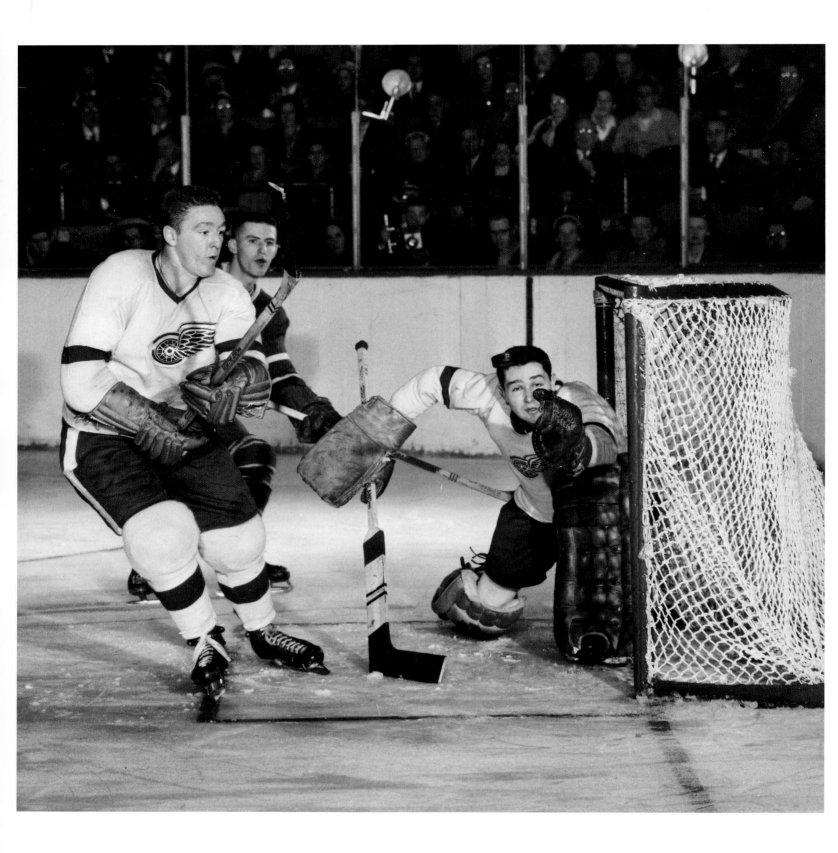

facing: Detroit won the Stanley Cup in 1955 with Terry Sawchuk as their goalie but started the next season with Glenn Hall in net. Sawchuk was traded to Boston, and Hall was named the NHL's best rookie. Here, he is helped by defenseman Marcel Pronovost against Toronto's Billy Harris.

below: Montreal right winger Bernie Geoffrion tries to score on Toronto's Harry Lumley. From the minute he entered the NHL with the Habs in 1950–51, the hard-shooting Geoffrion could score goals. He scored 30 in just his second full season and then led the league with 38 tallies in 1954–55.

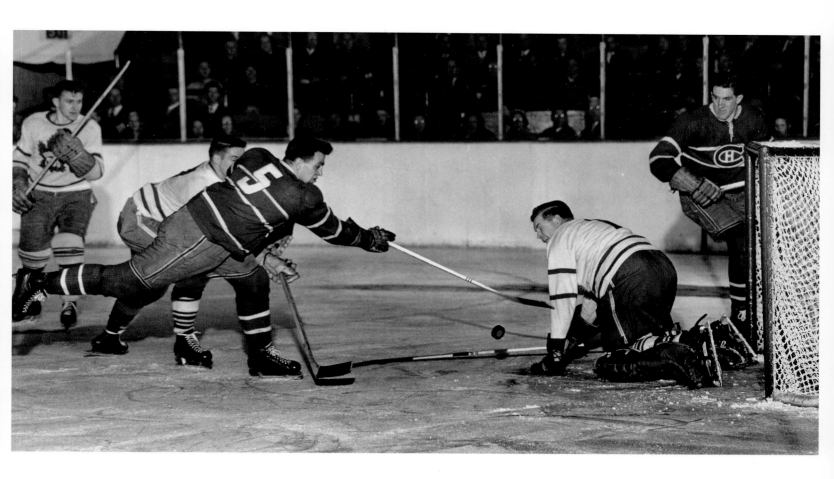

Detroit's Red Kelly (left) and Ted Lindsay (right) attack the Toronto net occupied by goalie Harry Lumley. The Red Wings won the Stanley Cup in 1950, 1952, 1954, and 1955, becoming the first dynasty of the fifties. Kelly and Lindsay were prominent players on all four of those championship teams.

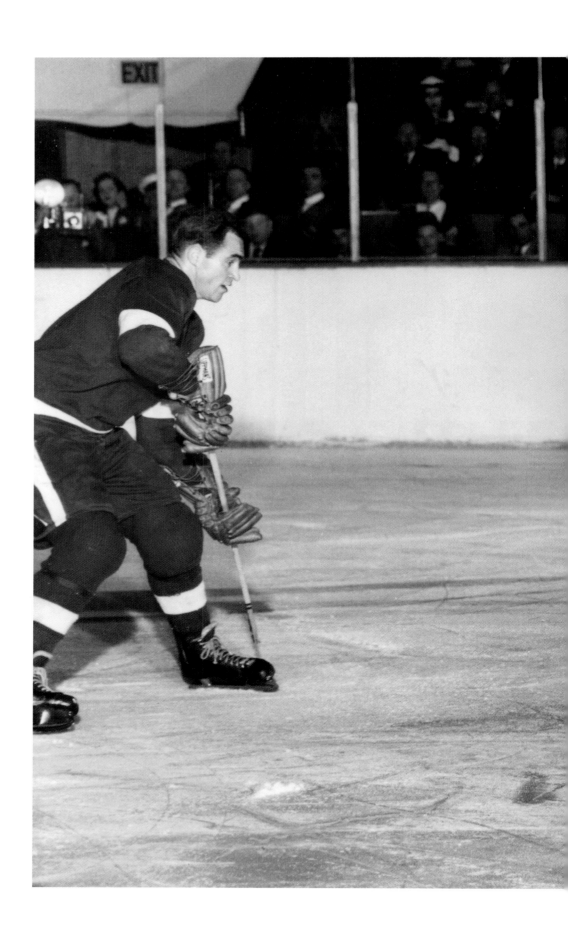

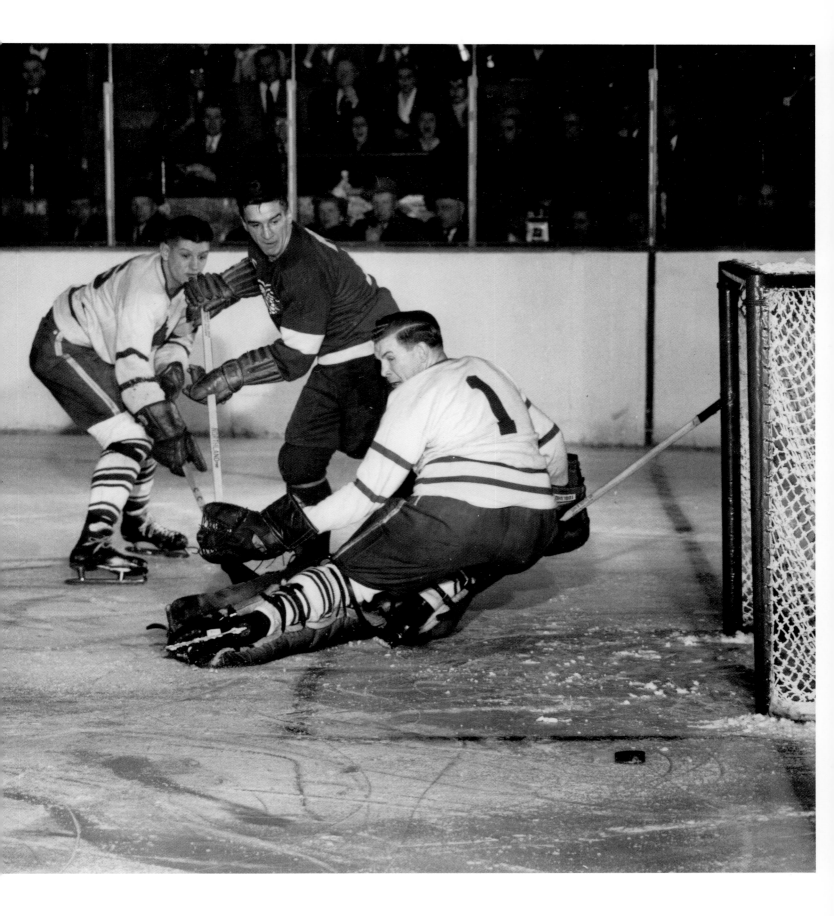

below: Detroit goaltender Terry Sawchuk was named the rookie of the year in three different professional leagues: the USHL, the AHL, and the NHL. Sawchuk's first full NHL season was in 1950–51 when he won 44 games and recorded a league-best 11 shutouts.

facing: Goaltender Don Simmons broke into the NHL with Boston in 1956–57. He took his team all the way to the Stanley Cup finals that year before losing to Montreal. Simmons was with the Maple Leafs in 1962 when they won the Cup with him in net in the last game of the finals.

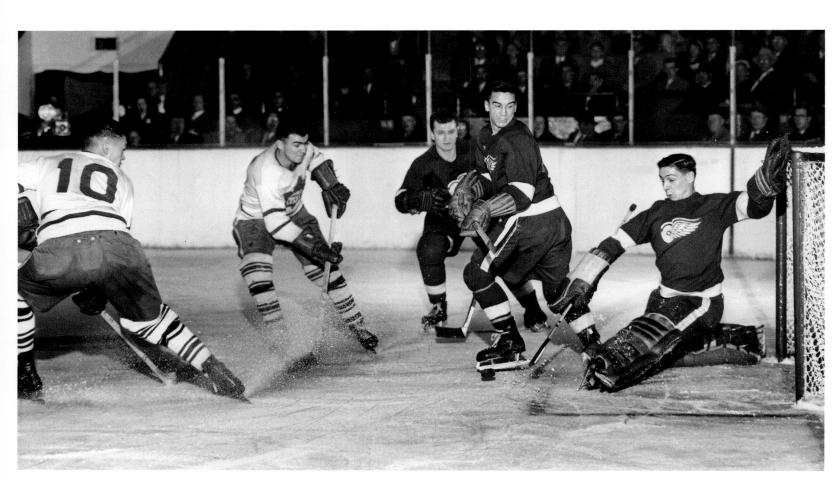

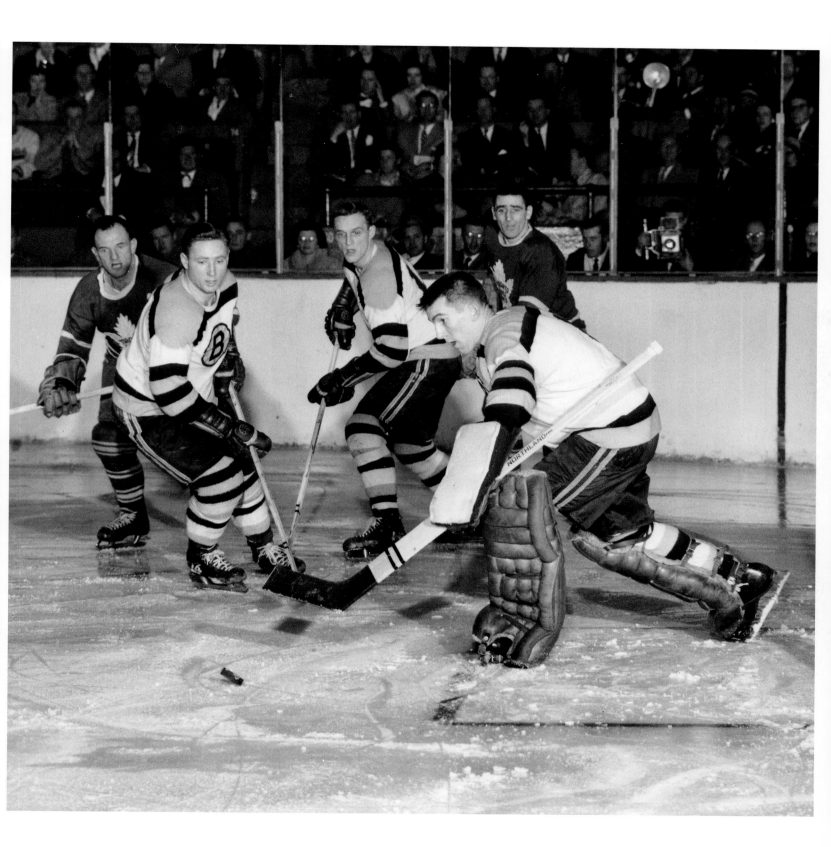

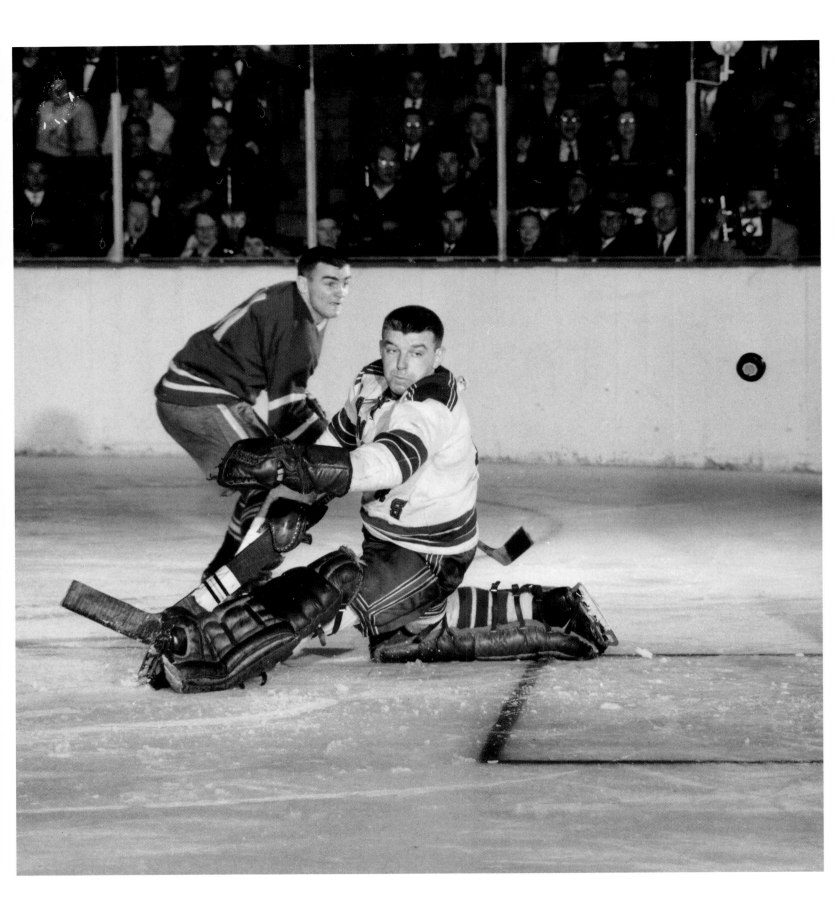

facing: New York goalie "Gump" Worsley was in net for the whole game the night the Maple Leafs beat the Rangers 14–1 on March 16, 1957. Tod Sloan of the Leafs (shown here) scored twice during that contest.

below: Toronto defenseman Jim Thomson (#2) has Montreal's Jean Béliveau all wrapped up. Thomson was a low-scoring but very valuable blueliner who helped the Leafs to four Stanley Cups. Leafs netminder Ed Chadwick (#1) also keeps his eye on the Montreal star.

overleaf: When Eric Nesterenko (#16) was a junior for the Toronto Marlboros in 1951–52 he scored 53 goals and totaled 95 points in 52 games; the Maple Leafs thought he would be their next great star. After four years, the rather unproductive right winger was dealt to Chicago where he had a long career with the Black Hawks.

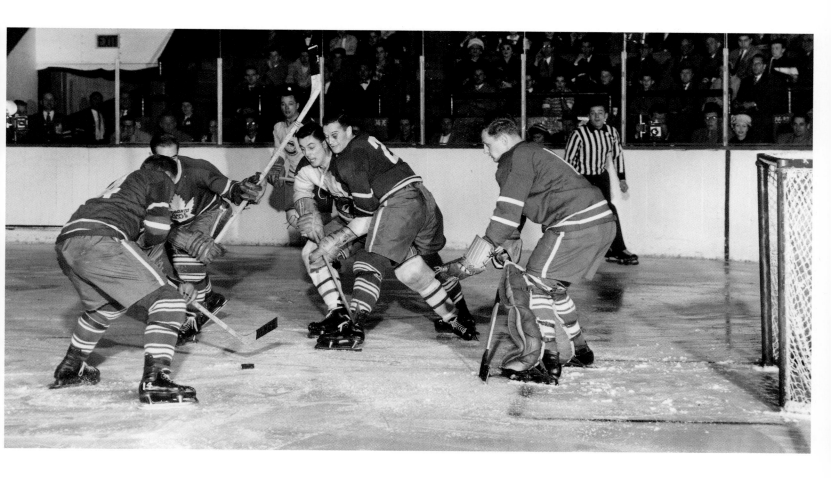

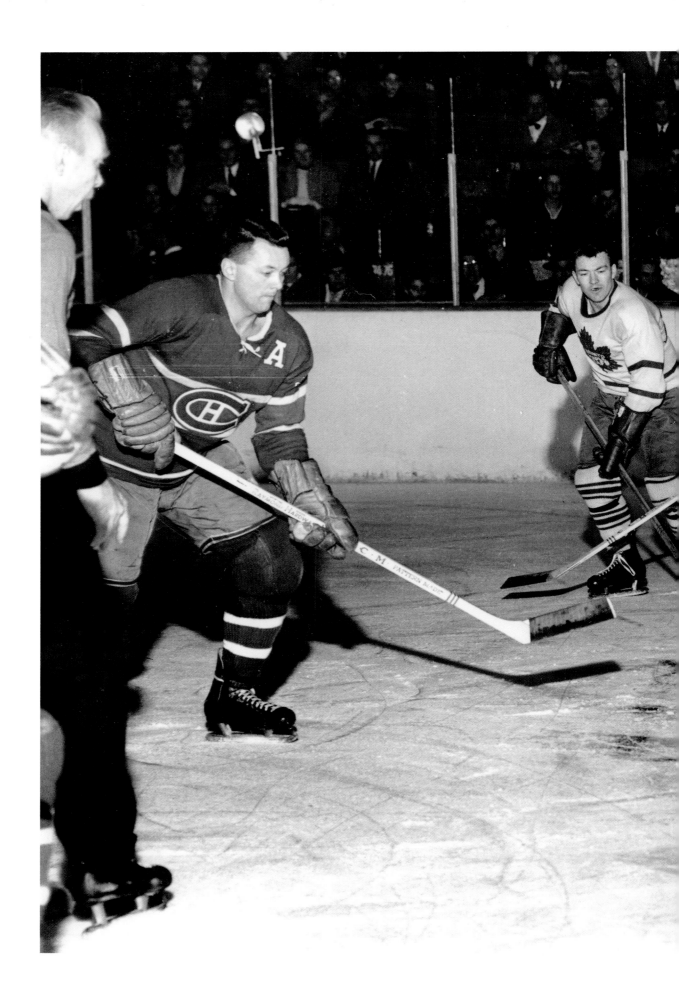

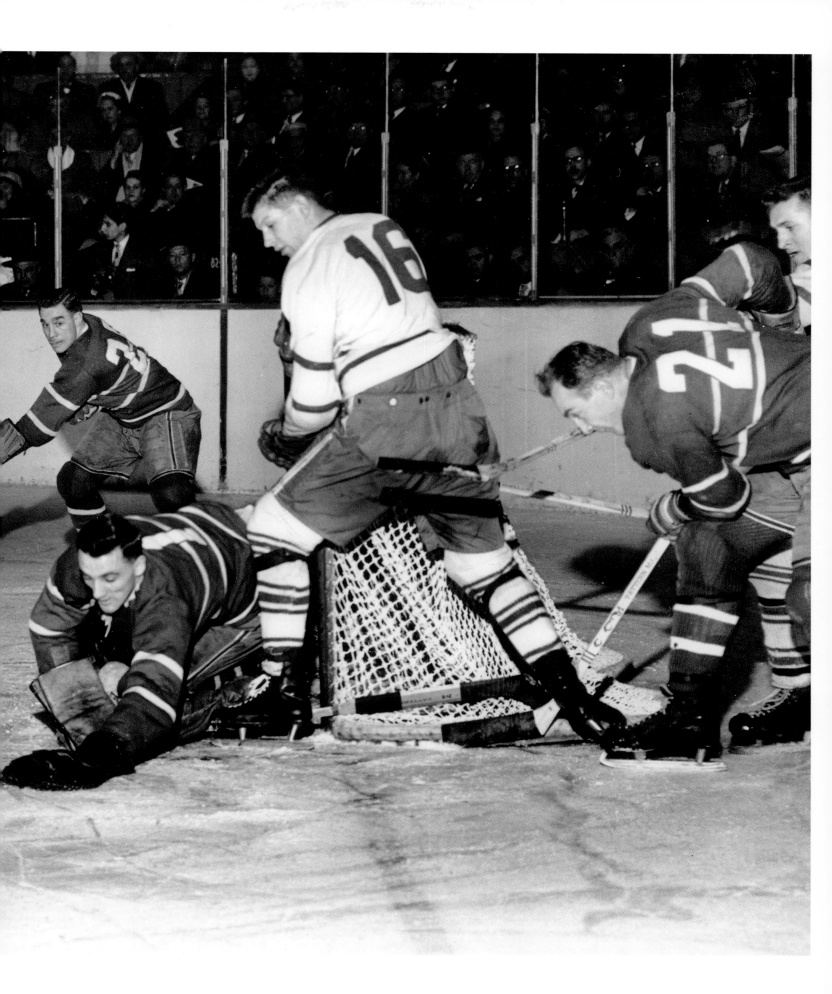

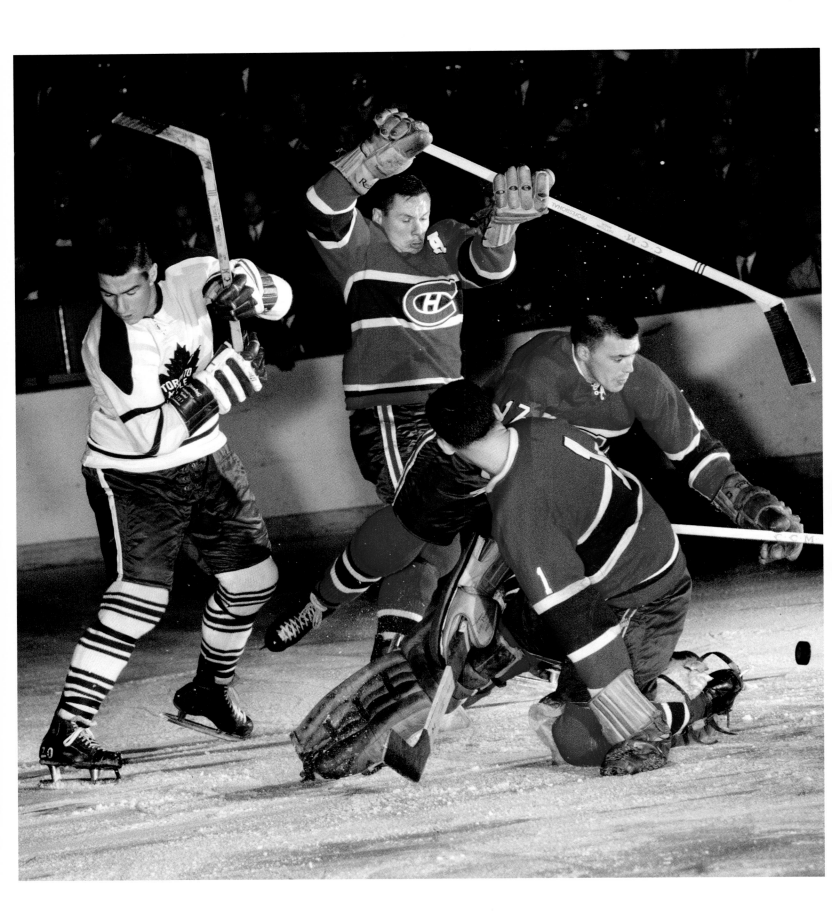

facing: Bob Pulford joined the Maple Leafs for the 1956–57 season and scored 11 goals in his rookie year. He scored over 20 goals four times and won four Cups during his career. Pulford scores here while being checked by Tom Johnson and Jean-Guy Talbot in front of goalie Jacques Plante.

below: Chicago's Jack Evans battles Detroit's Red Kelly for position. Evans began his career with the New York Rangers in 1948 but was picked up by the Black Hawks in 1958. In 1954, Kelly became the first-ever recipient of the Norris Trophy as the NHL's best defenseman.

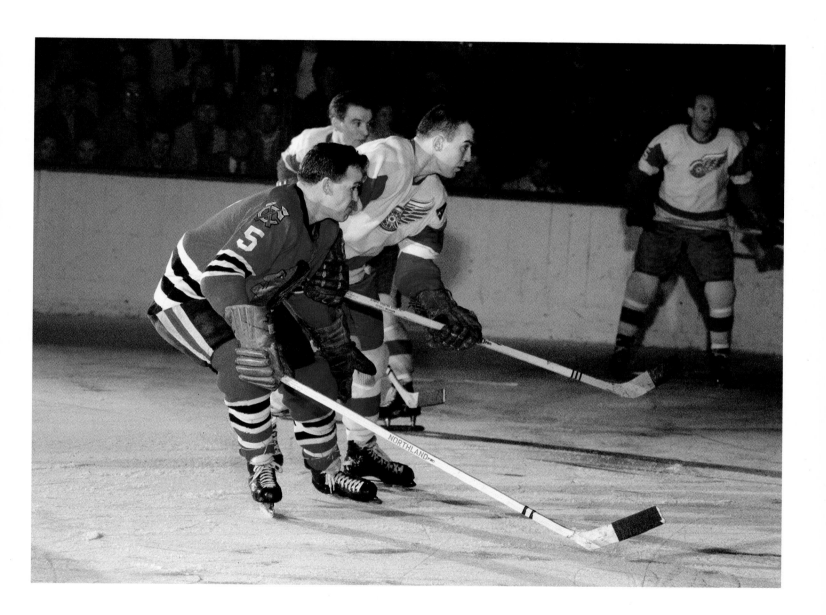

below: Jacques Plante led the NHL in goaltender wins a total of five times while he was with the Canadiens. He won 40 or more games on three occasions and was a first-team All-Star three times as well. Here, Plante watches Chicago's Eric Nesterenko with help from Doug Harvey.

facing: Toronto's Dick Duff gets checked by Detroit defenseman Jim Morrison as Leaf George Armstrong looks for a rebound. On the last night of the 1958–59 season, Duff scored the winning goal for a Maple Leaf victory over the Red Wings to get Toronto the final playoff spot that season.

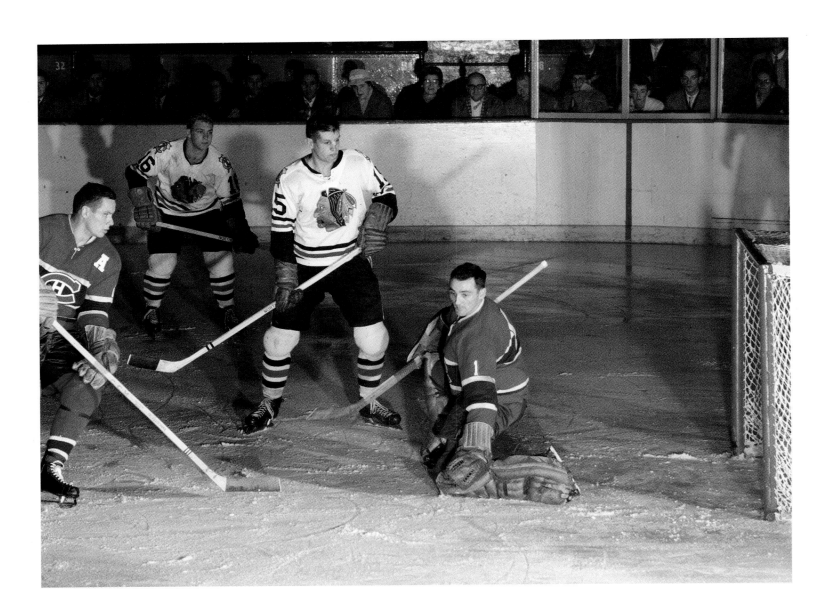

48

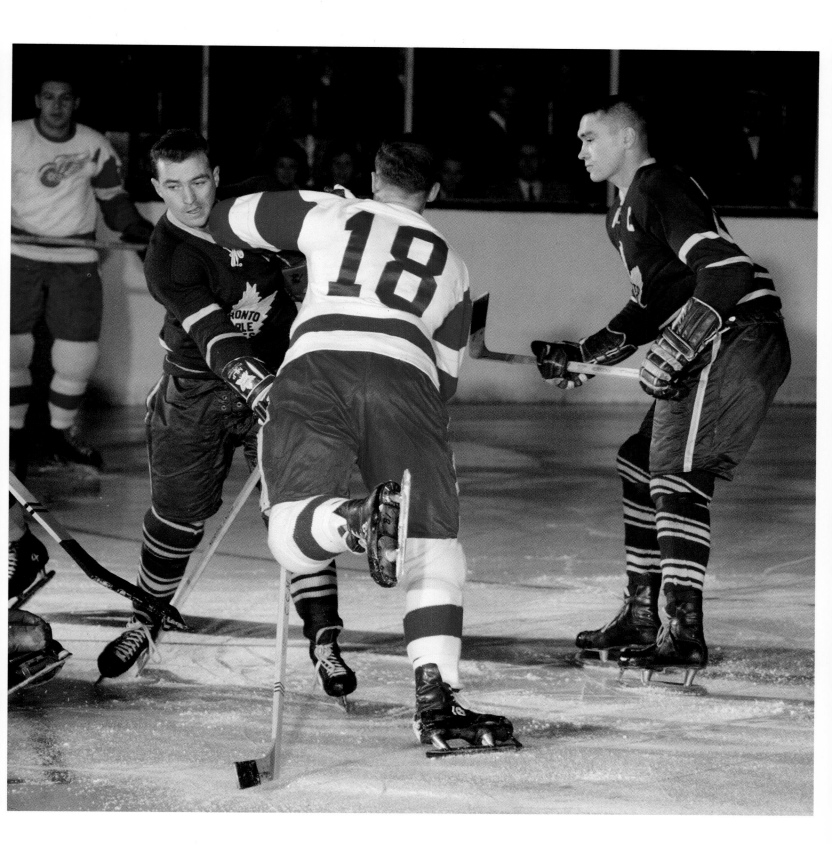

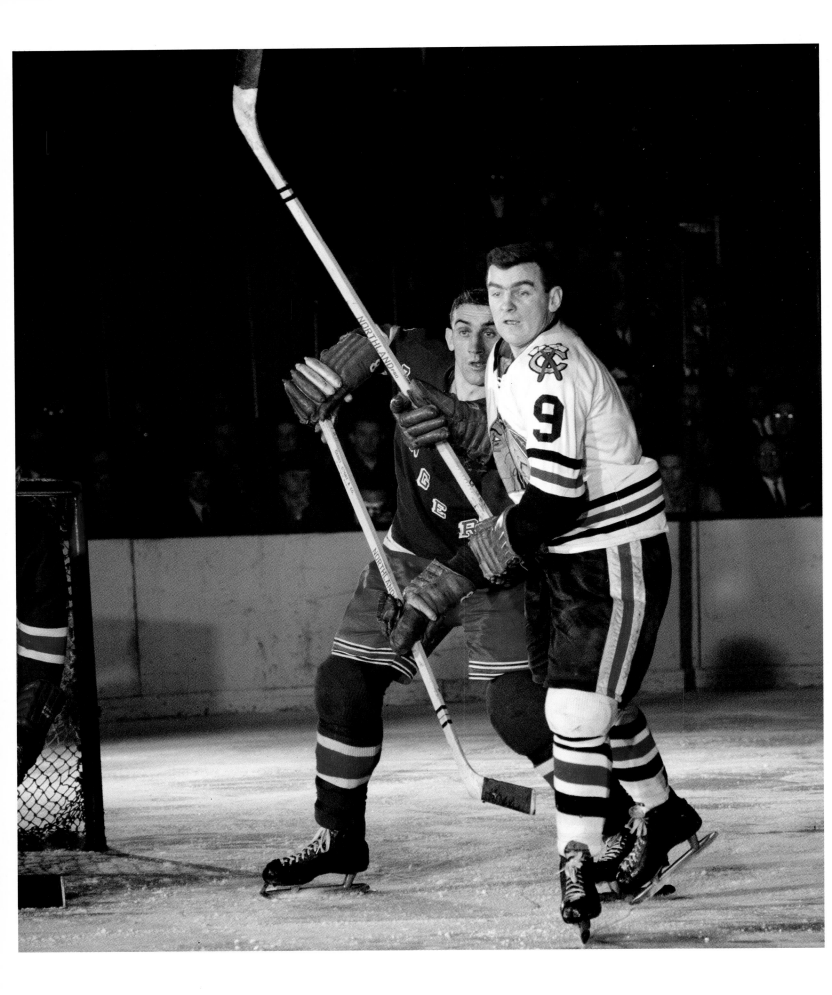

facing: Players' association activist Tod Sloan (#9) was sent to the Black Hawks as a form of punishment imposed by the league owners. Sloan would play three years with Chicago where he won a Stanley Cup in 1961. Sloan is checked here by New York defenseman Lou Fontinato.

below: Winger Ron Stewart joined the Maple Leafs starting with the 1952–53 season but had his best goal-scoring year in 1958–59 when he notched 21 for Toronto. He won three Stanley Cups as a Leaf and played in 1,353 games, scoring 276 goals and totaling 529 points.

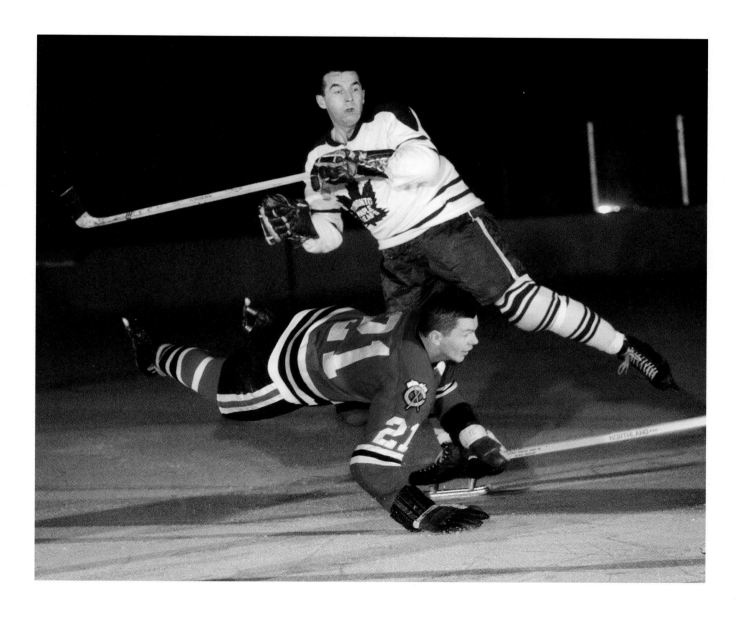

below: When left winger Bobby Hull joined the Black Hawks for the 1957–58 season he wore number 16. He also wore number 7 before finally settling on 9—the number he made famous for the rest of his career.

facing: Born in Czechoslovakia in 1940, Stan Mikita overcame great hardships in his homeland to come to Canada in 1948 for a better life. He first joined Chicago in 1958–59 and stayed with the Hawks until the end of 1979–80 season. Here, Mikita is chasing down Detroit defenseman Marcel Pronovost.

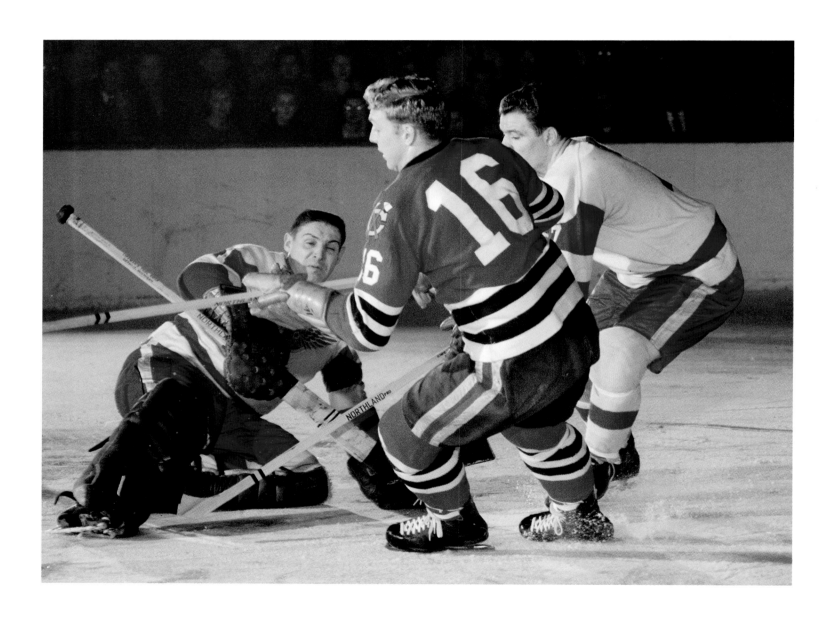

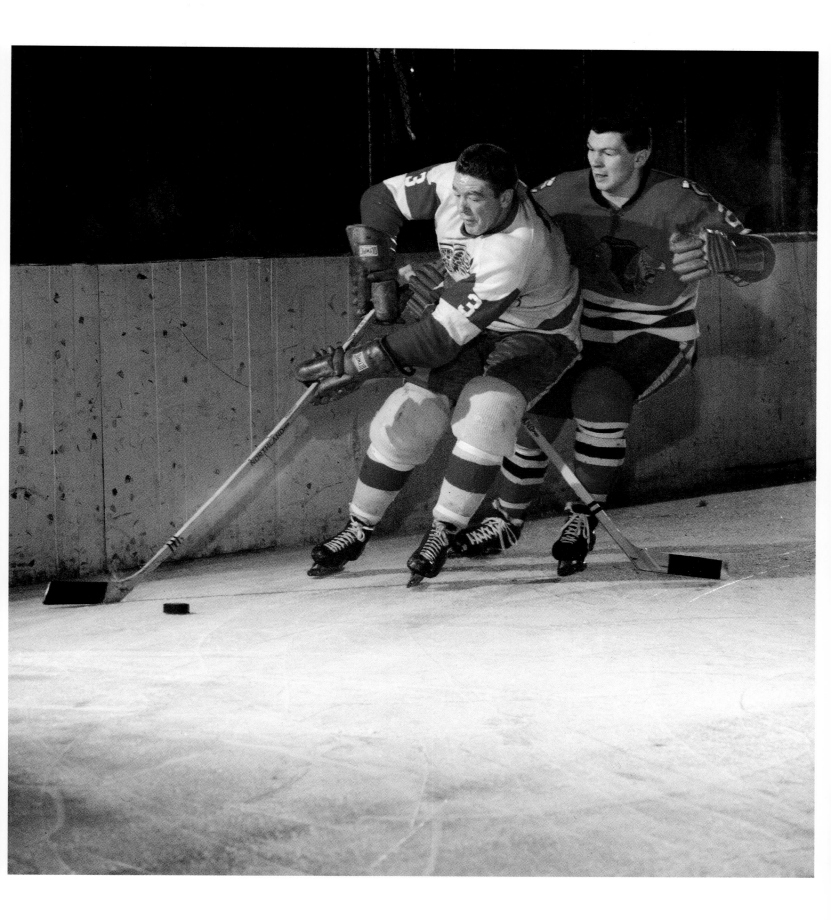

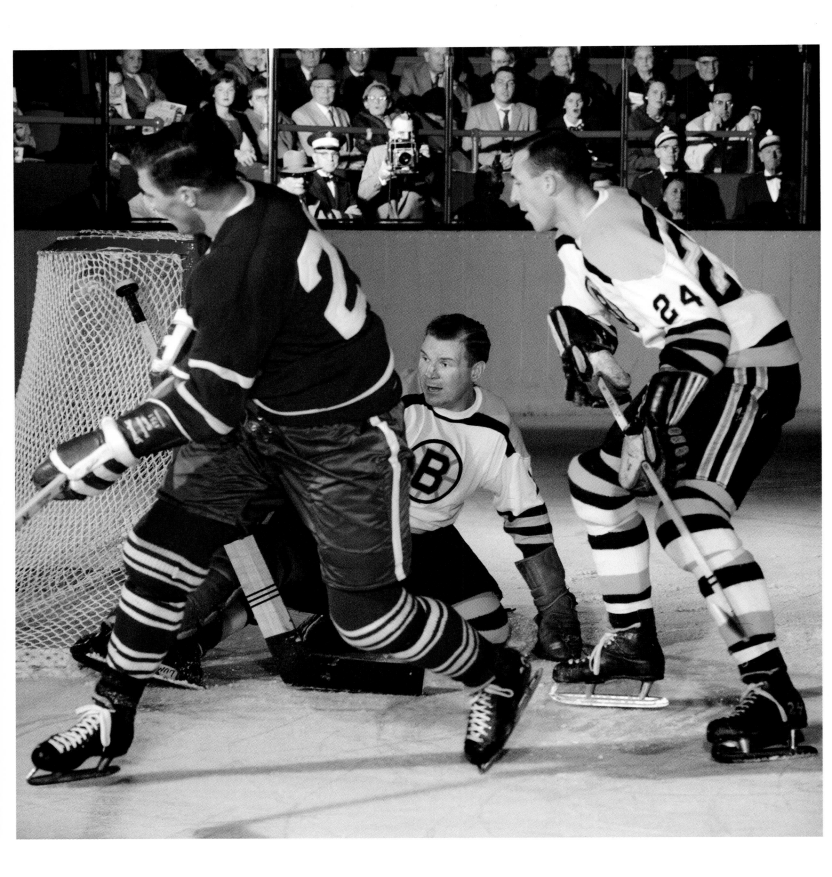

facing: Boston netminder Harry Lumley gets help from teammate Réal Chevrefils against Bob Pulford of Toronto. Lumley began his NHL career when he was just 16 years old with the Detroit Red Wings. He also played for Toronto and Chicago.

below: Johnny Bucyk was as surprised as anyone when he heard on the radio during the summer of 1957 that he had been traded from Detroit to Boston for Terry Sawchuk. He stayed in Boston until the end of his career, scoring 545 of his 556 career goals as a Bruin.

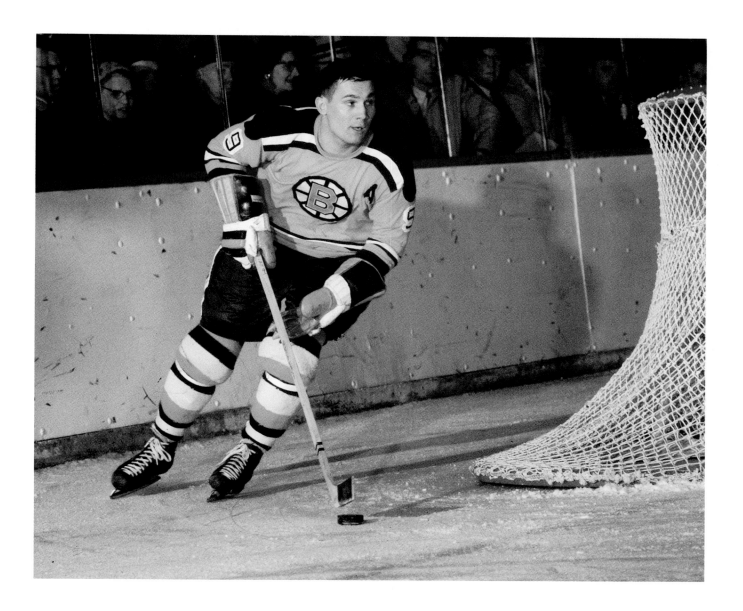

below: The face of hockey changed on the night on November 1, 1959, when Canadiens goalie Jacques Plante refused to re-enter a game against the Rangers after he had been badly cut by the puck, unless he was allowed to wear a protective mask.

facing: New York's Larry Popein looks for the puck against Toronto's George Armstrong. Popein played in 449 career NHL games and recorded 221 points. He also played four games for the Oakland Seals in 1967–68 and would go on to coach the Rangers during the 1973–74 season.

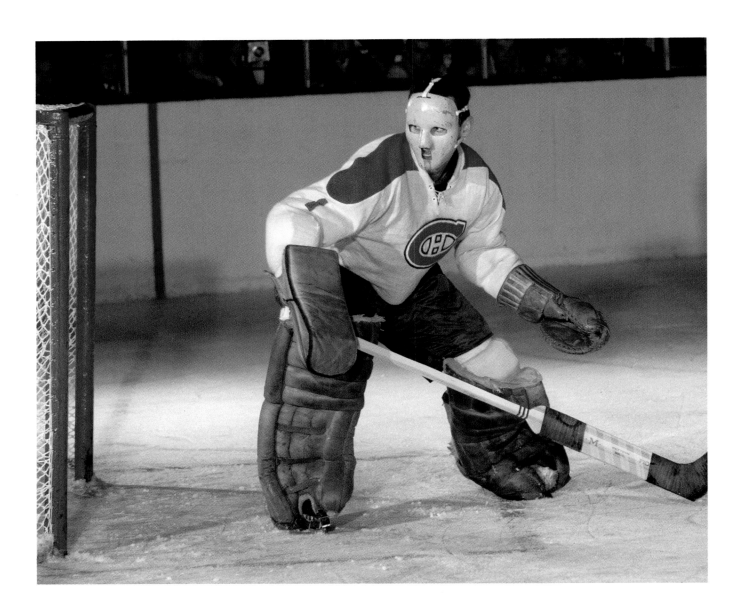

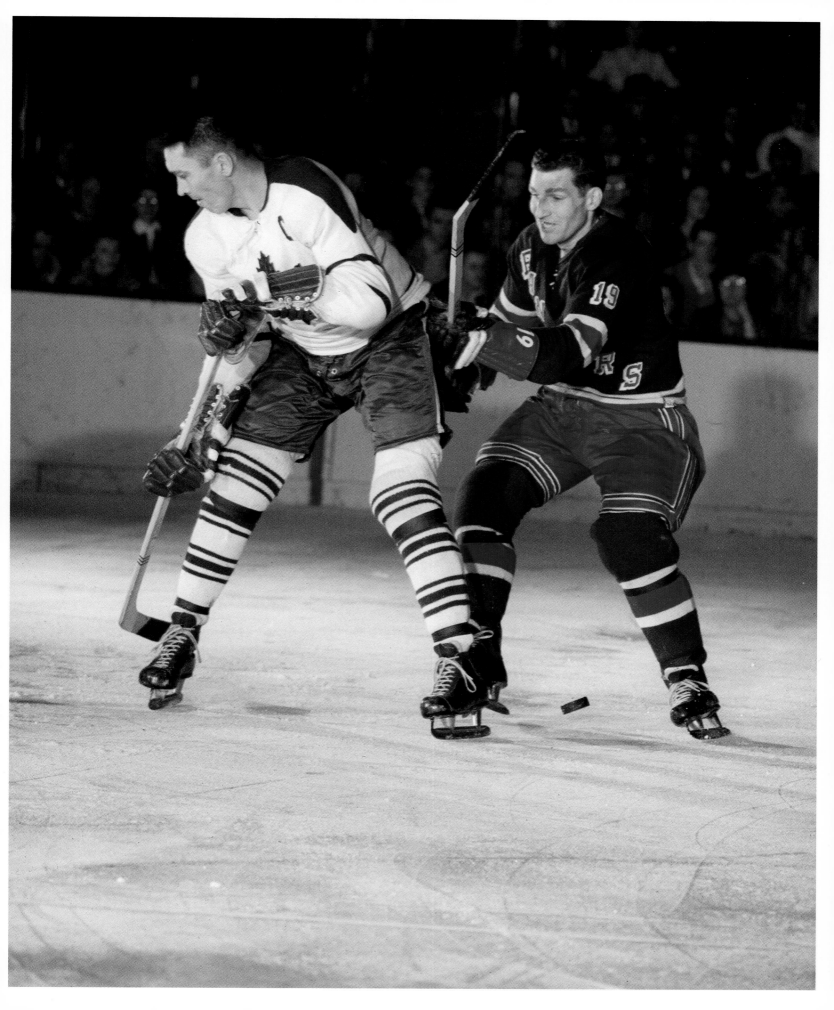

Frank Mahovlich of Toronto has just beaten
goalie Glenn Hall of Chicago. Known as the
"Big M," Mahovlich scored 48 goals for the Maple
Leafs in 1960–61 and beat Hall four times on
December 11, 1960, at the Chicago Stadium
during a 6–1 Toronto victory.

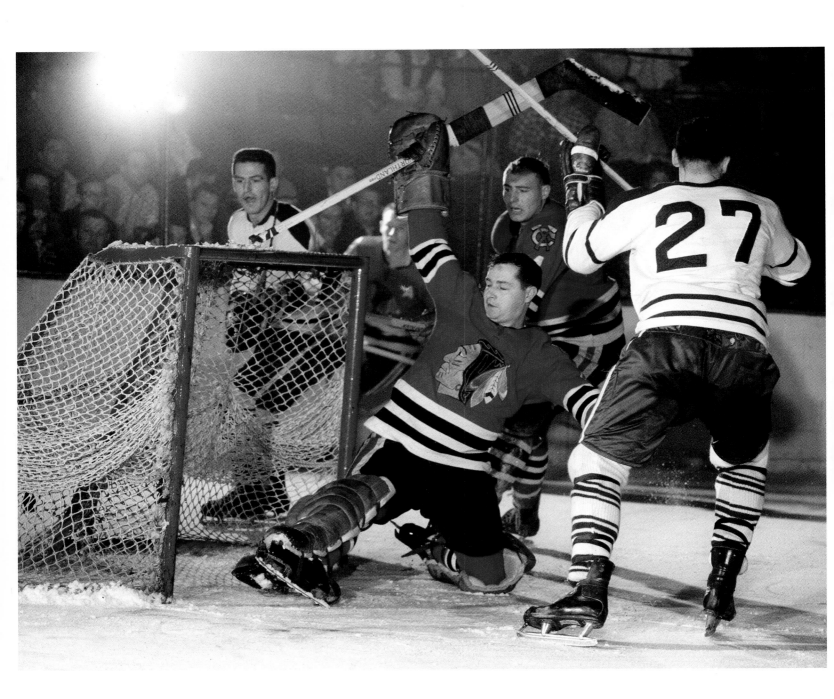

The Canadiens and the Maple Leafs met for the Stanley Cup in 1959 and 1960. Shown here are five Hall of Fame players: Red Kelly (#4) and goalie Johnny Bower of Toronto as well as Maurice (#9) and Henri Richard (#16) and Dickie Moore (#12) of the Canadiens.

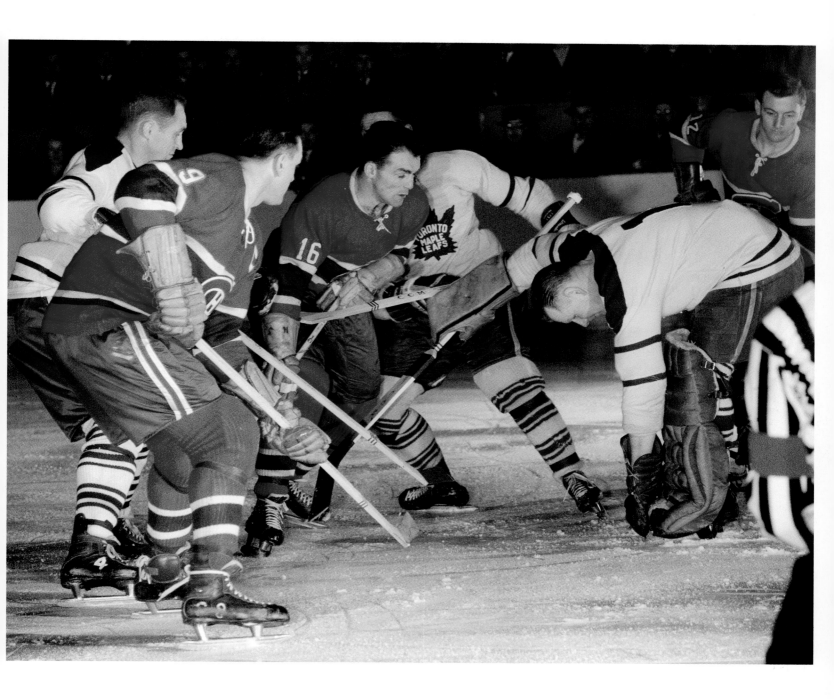

below: Boston forward Charlie Burns was one of the first NHL players to wear a helmet. New York defenseman Harry Howell played most of his Hall of Fame career (1,411 games) with the Rangers but also played for the California Seals and Los Angeles Kings after 1967.

facing: Earl Ingarfield (#10) had many good years with the New York Rangers. He scored a career-best 26 goals in 1961–62 and had a 20-goal season in 1964–65. Here, Ingarfield has scored despite the efforts of Doug Mohns (#19) and goalie Eddie Johnston of Boston.

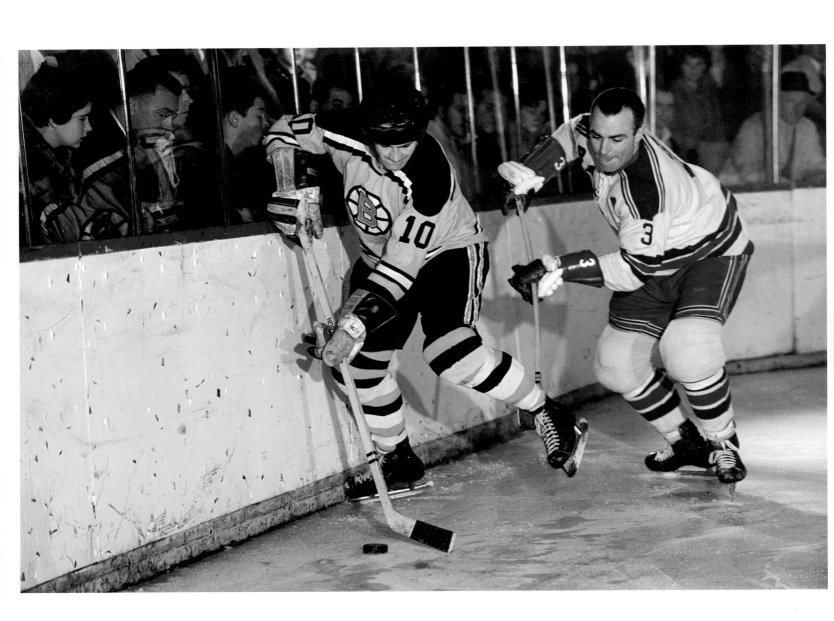

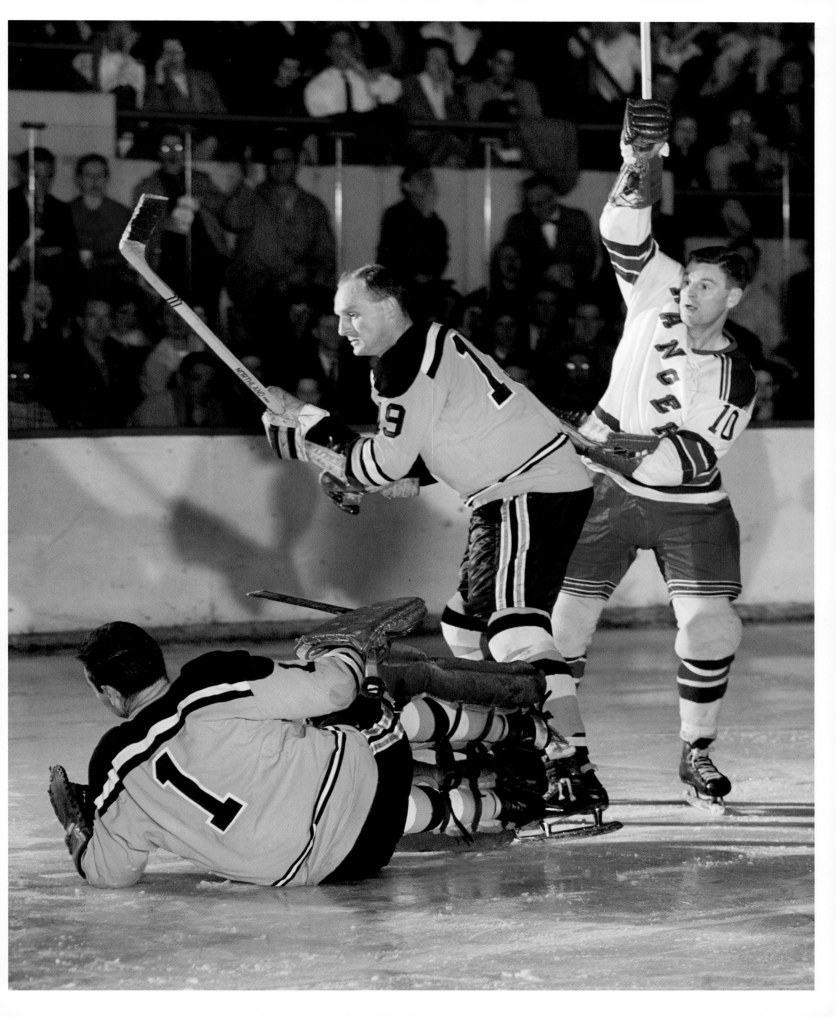

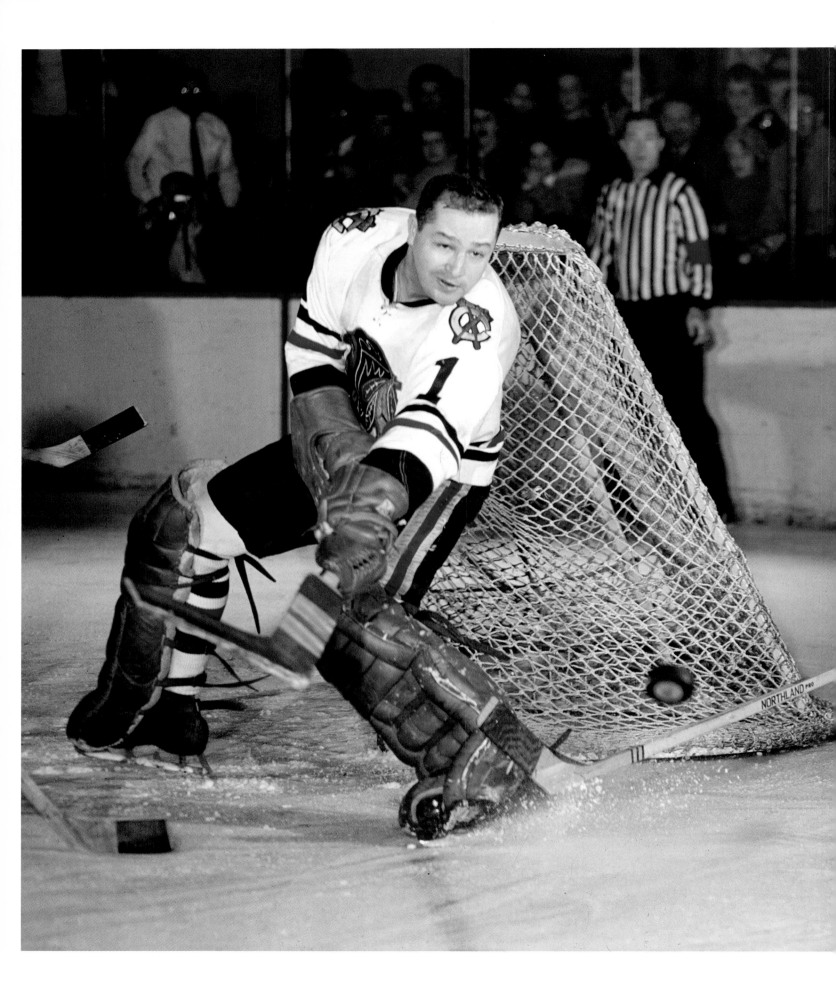

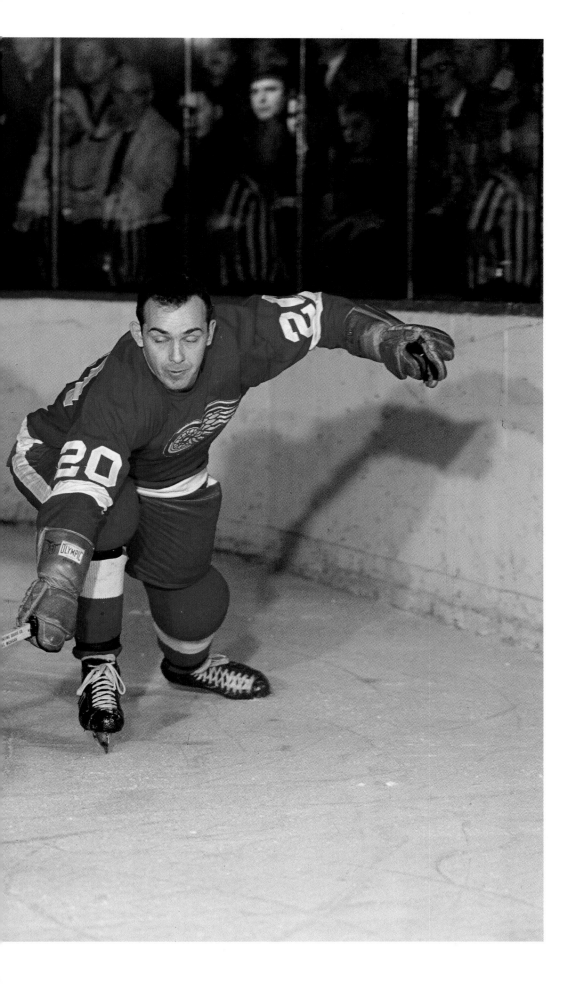

Chicago netminder Glenn Hall fires the puck away from Detroit winger Parker MacDonald (#20). MacDonald began his career with the Maple Leafs before being sent to the New York Rangers. He also played for New York, Boston, and Minnesota before his 676-game career ended. MacDonald recorded 323 career points.

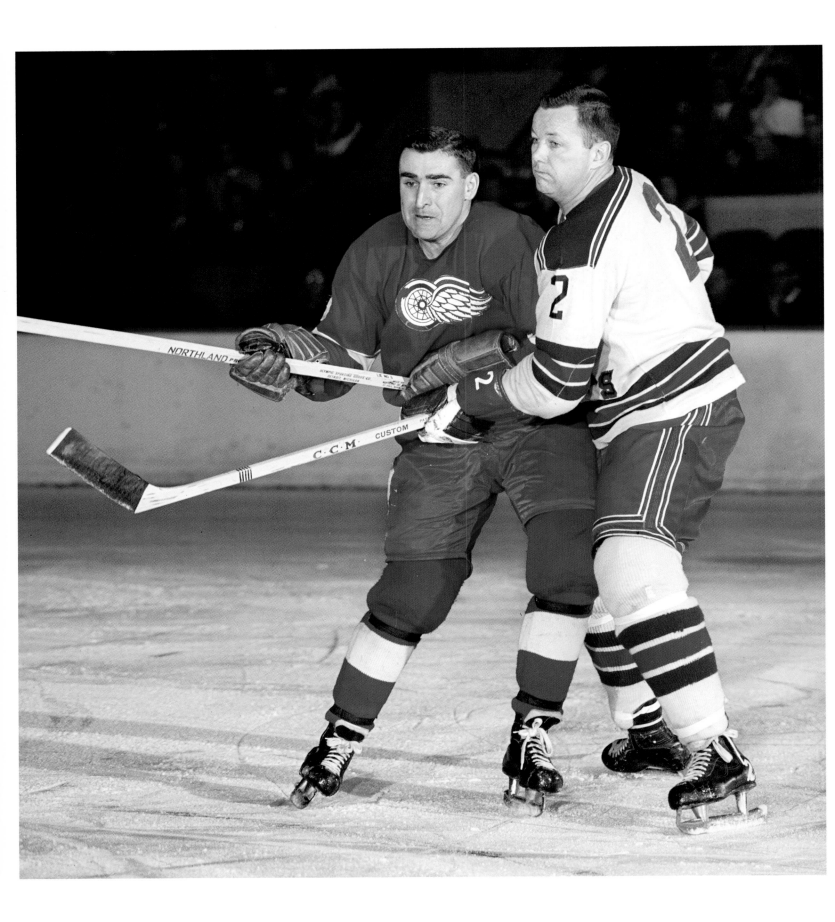

facing: Floyd Smith of Detroit is closely watched by New York defenseman Doug Harvey. Smith began his NHL career with Boston then played with New York, Detroit, Toronto, and Buffalo, where he was first team captain of the 1970 expansion Sabres.

below: Defenseman Pat Stapleton (#4) began his NHL career with Boston during the 1961–62 season, scoring two goals and adding five assists. He played one more year in Boston before going to Chicago where he enjoyed his best NHL seasons. Here, Stapleton is chased by Dave Keon of Toronto.

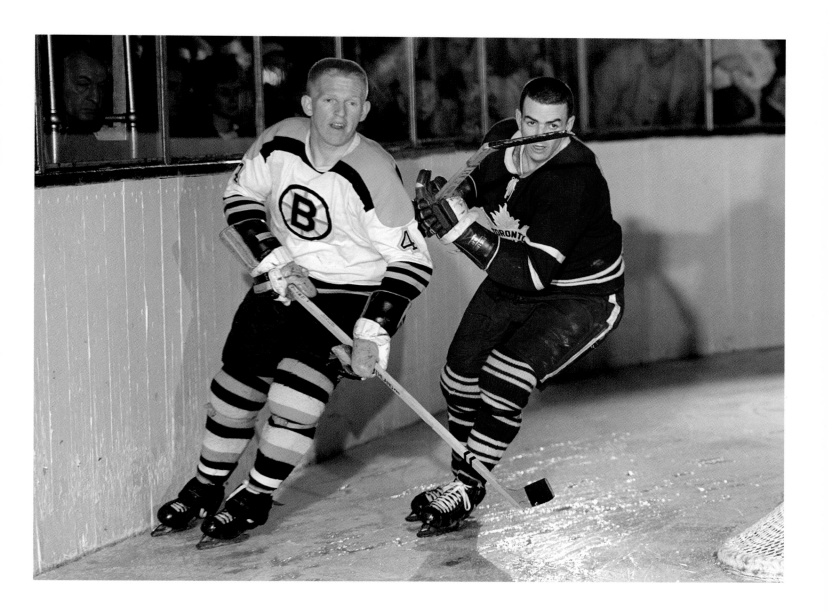

below: Eddie Litzenberger joined the Leafs in December of 1961—just in time to be in on three straight Stanley Cups. He had a two-goal game against Terry Sawchuk and the Red Wings during the 1963 finals. Litzenberger captained the Black Hawks to the Cup in 1961, his first of four consecutive NHL titles.

facing: The Red Wings traded Red Kelly (#4) to New York in 1960 but Kelly refused to report to the Rangers, and Toronto swooped in and picked him up to play center for them. He helped the Leafs win four Cups. Here, Kelly starts a rush up the ice with Dave Keon (#14).

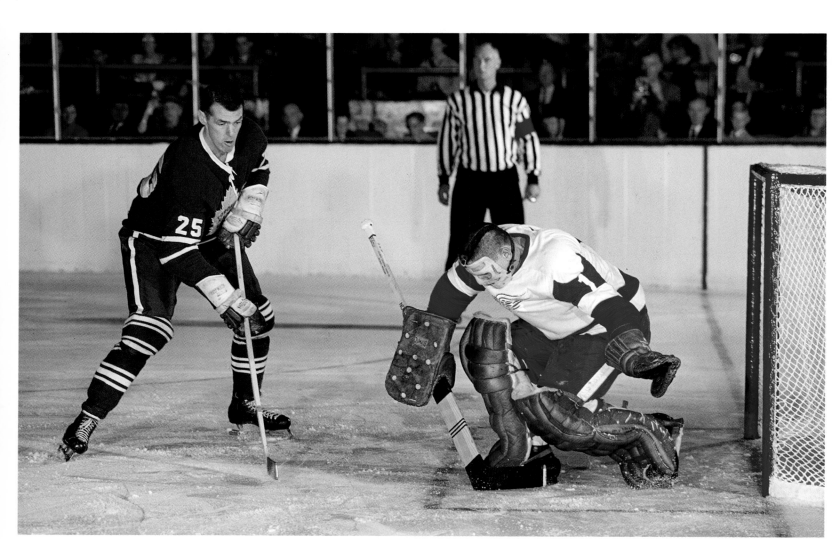

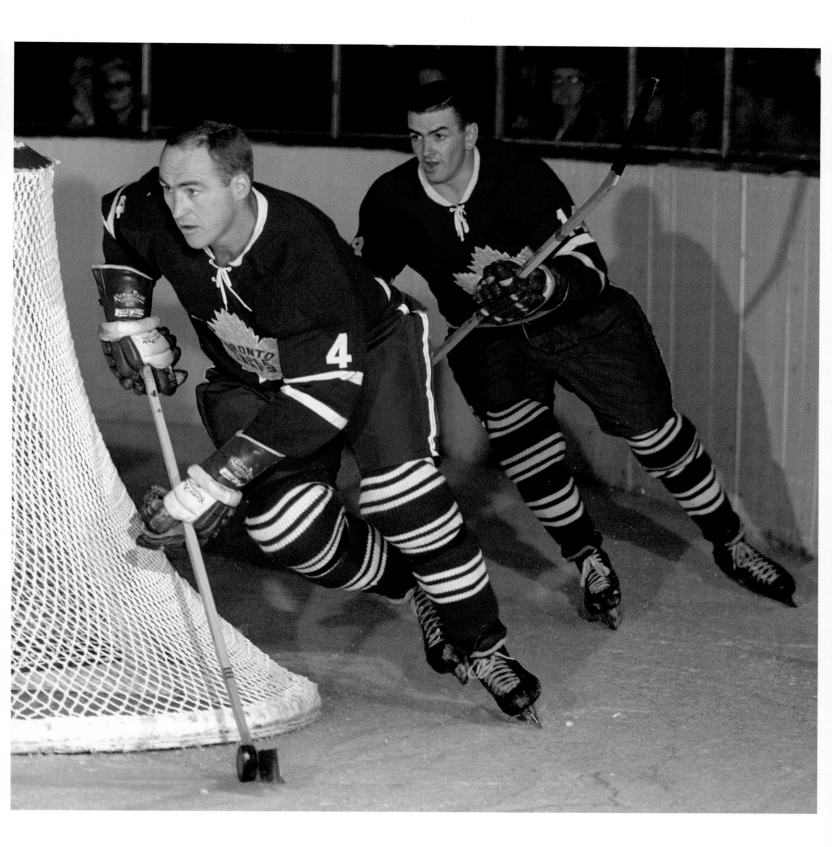

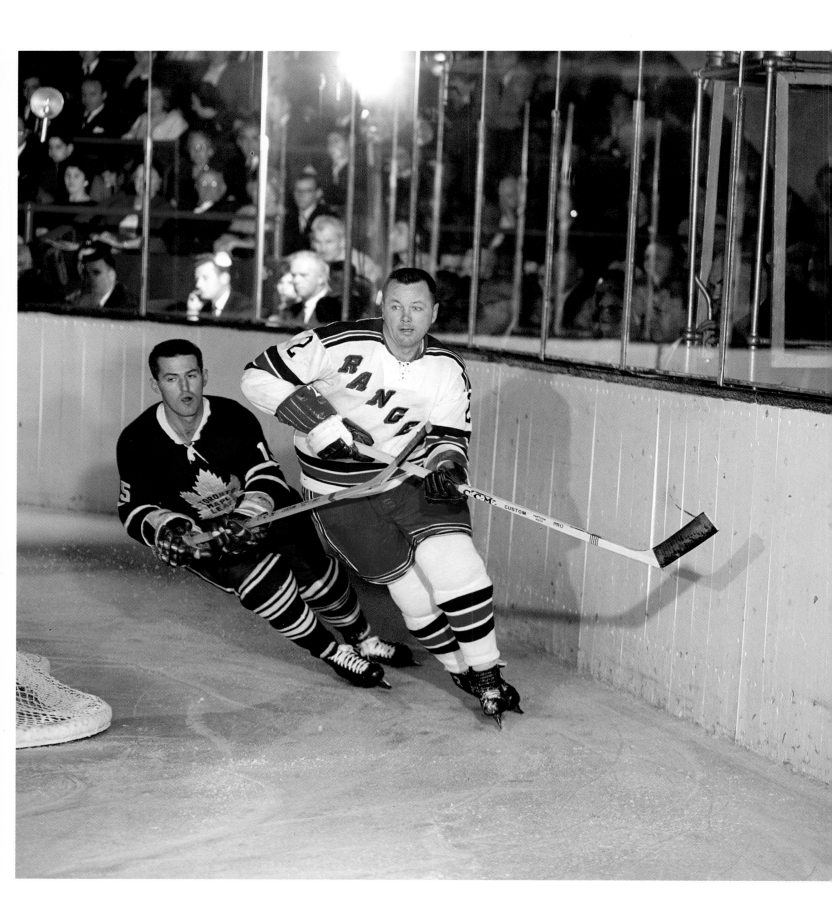

After a great career with the Canadiens, defenseman Doug Harvey (#2) was traded to New York in 1961. He was named as playing coach of the Rangers for the 1961–62 season and promptly won his seventh Norris Trophy as top defenseman. Toronto's Billy Harris (#15) is in hot pursuit. Harris had 287 points in 610 games as a Maple Leaf.

below: Wayne Connelly played four years with Boston (scoring 25 times in total) before going to the expansion Minnesota North Stars for the 1967–68 campaign. He finished his career with 307 points in 543 career games. Here he takes a shot on Toronto's Johnny Bower.

facing: During the 70 games of the 1961–62 season, Chicago left winger Bobby Hull scored 50 goals. Hull also led the league in points that year with 84, giving him his second Art Ross Trophy. Toronto netminder Johnny Bower won 31 games in 1961–62 and another six in the playoffs.

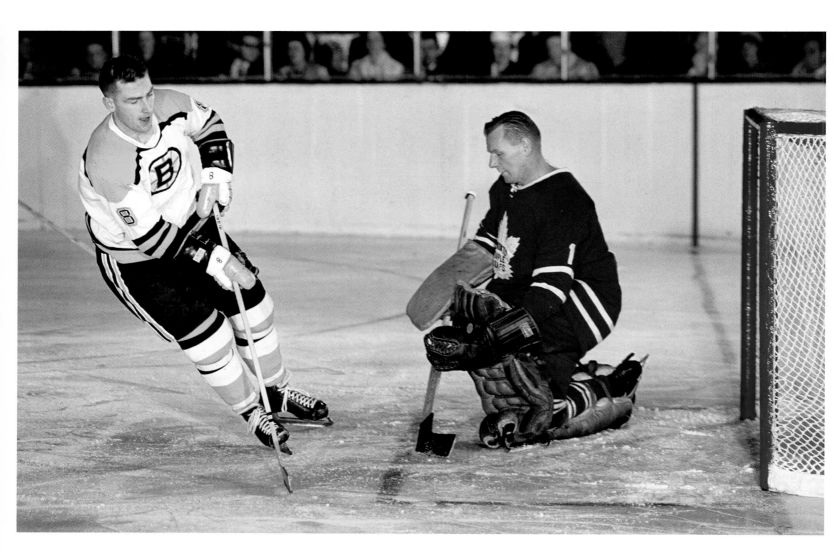

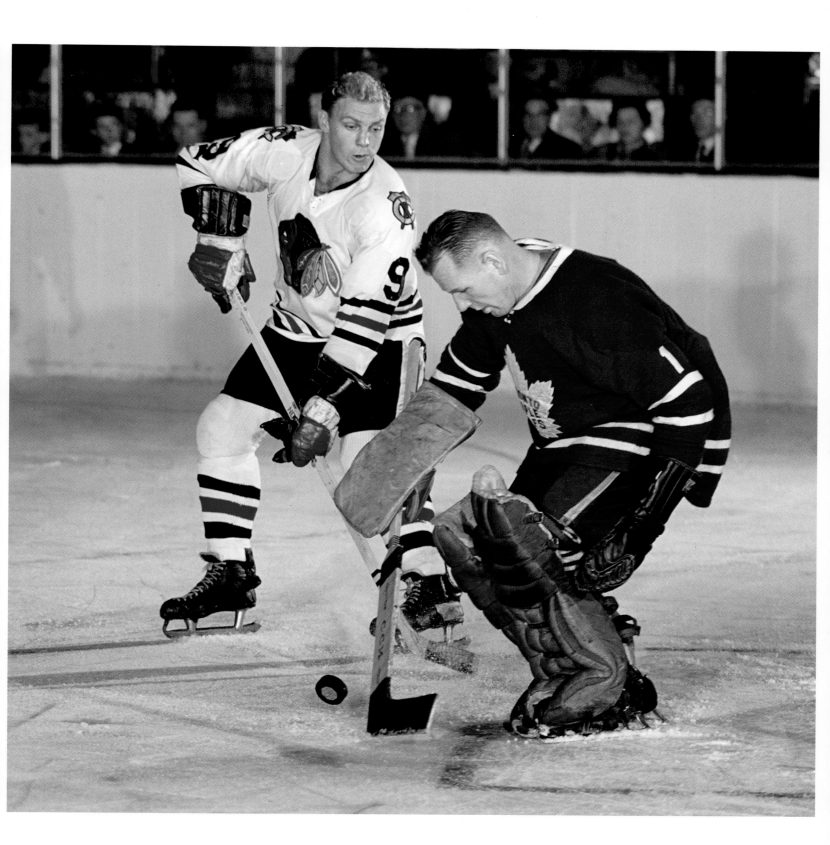

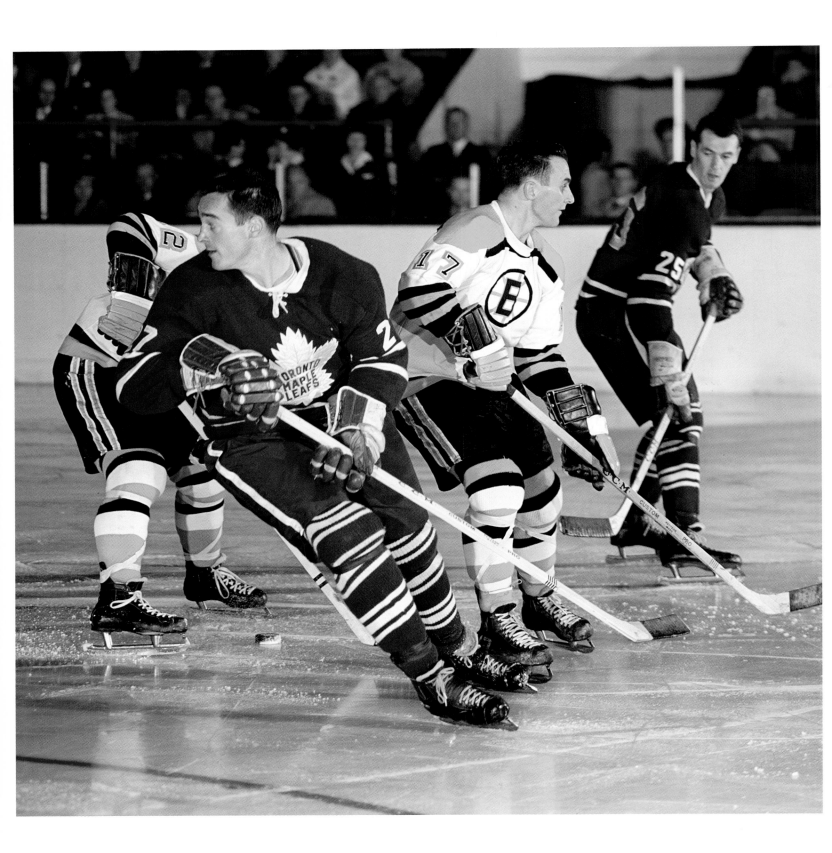

facing: Boston's Dean Prentice, shown here against Frank Mahovlich (#27) and Eddie Litzenberger (#25), had a memorable game against the Maple Leafs on January 18, 1964: Prentice scored three goals and added three assists for a six-point night at Maple Leaf Gardens.

below: The Maple Leafs defeated the Red Wings in five games during the 1963 Stanley Cup finals. Leafs netminder Johnny Bower played all five contests. Detroit defenseman Marcel Pronovost (#3) was the second leading scorer for the Red Wings with four points— all of them assists.

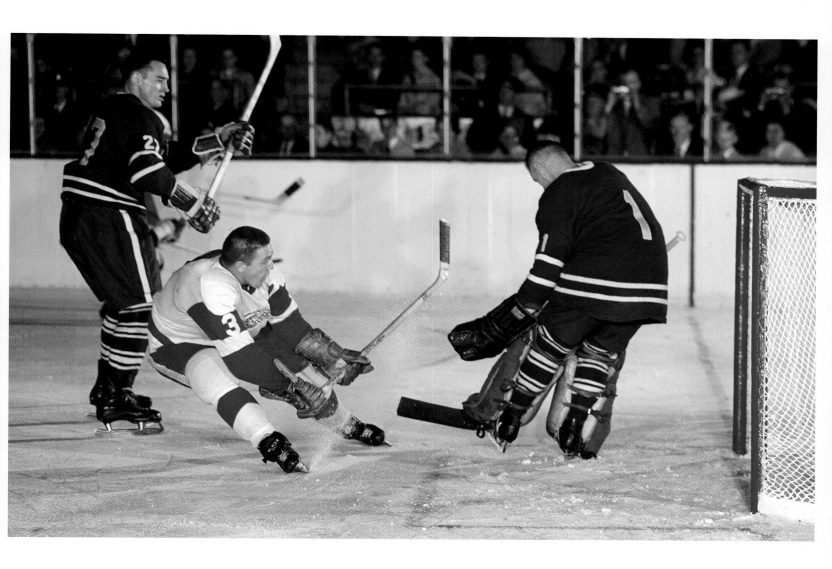

below: Detroit's defenseman Doug Barkley (#5) takes out New York forward Dean Prentice (#17) along the boards. Barkley scored 11 goals for the Red Wings in 1963–64. Prentice had a 32-goal season for the Rangers in 1959–60.

facing: Toronto defenseman Bob Baun crunches Montreal centre Jean Béliveau into the boards. Between 1959 and 1967 the Maple Leafs and Canadiens staged hockey's greatest rivalry during the regular season and the playoffs. The Leafs beat the Canadiens in the semi-finals in 1963 and 1964.

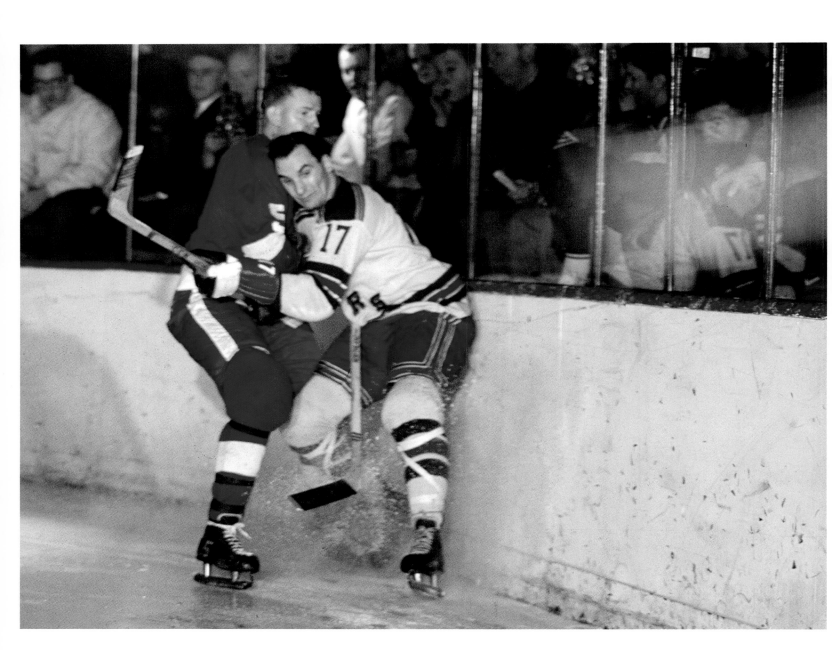

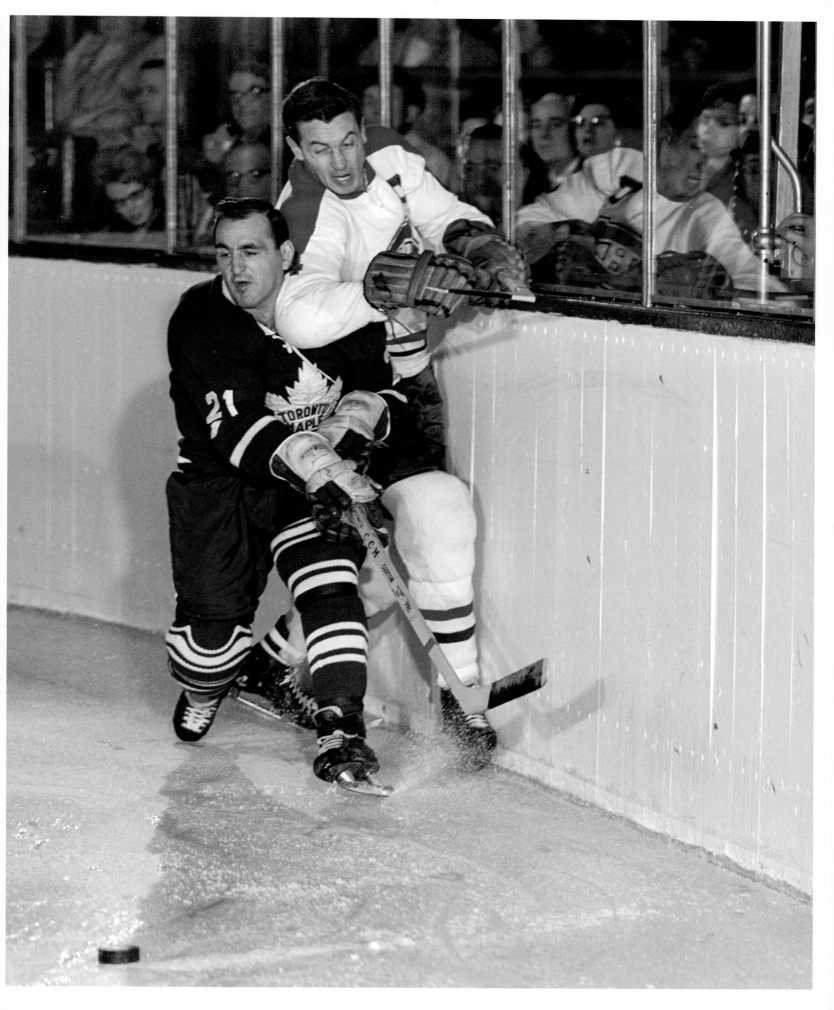

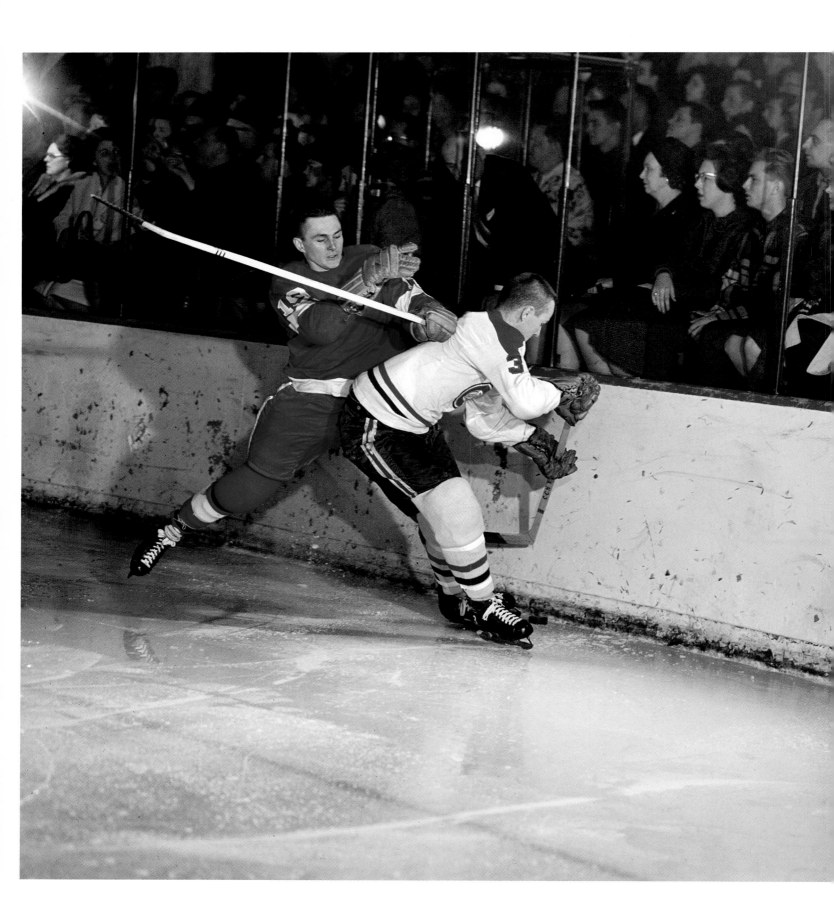

Paul Henderson of Detroit tries to check Montreal defenseman J.C. Tremblay. Henderson's first full year in the NHL was in 1964–65. Tremblay played his entire NHL career (1959 to 1972) with Montreal and he won a total of five Stanley Cups.

overleaf: Vic Stasiuk of the Red Wings blocks out Black Hawks winger Eric Nesterenko behind the Detroit net. Stasiuk was one of the biggest left wingers during his time in the NHL (1949–63), recording 437 points in 745 games. Here, Red Wing goalie Terry Sawchuk (#1) and defenseman Marcel Pronovost (#3) watch the action.

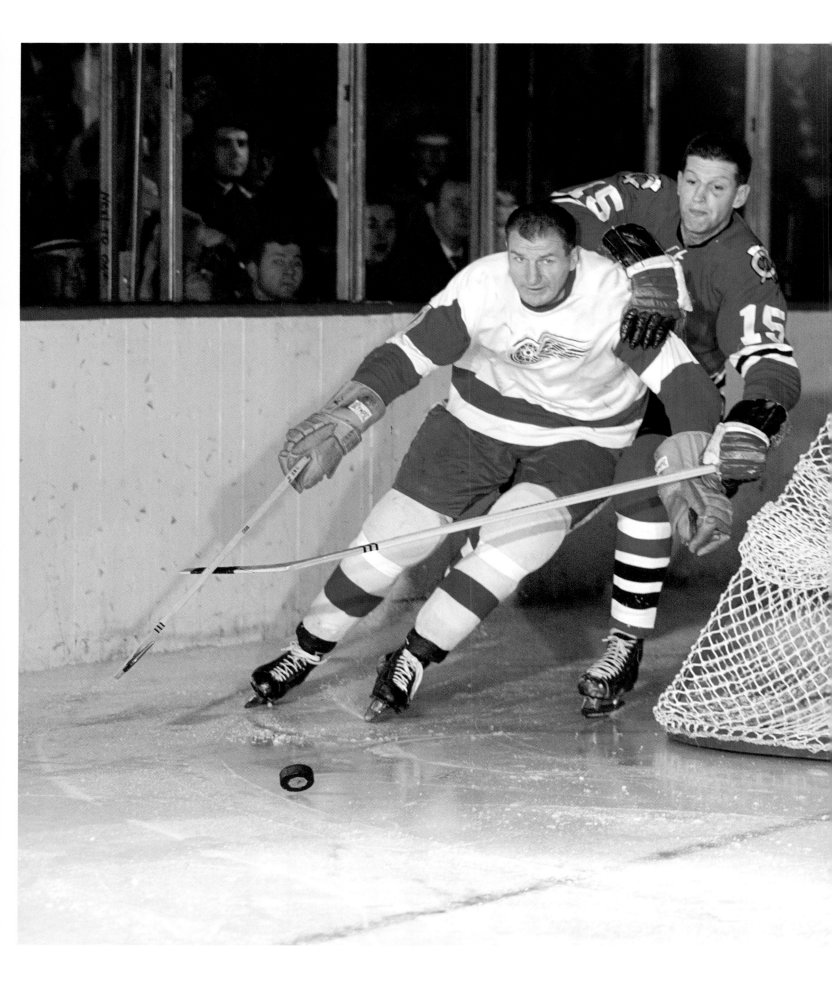

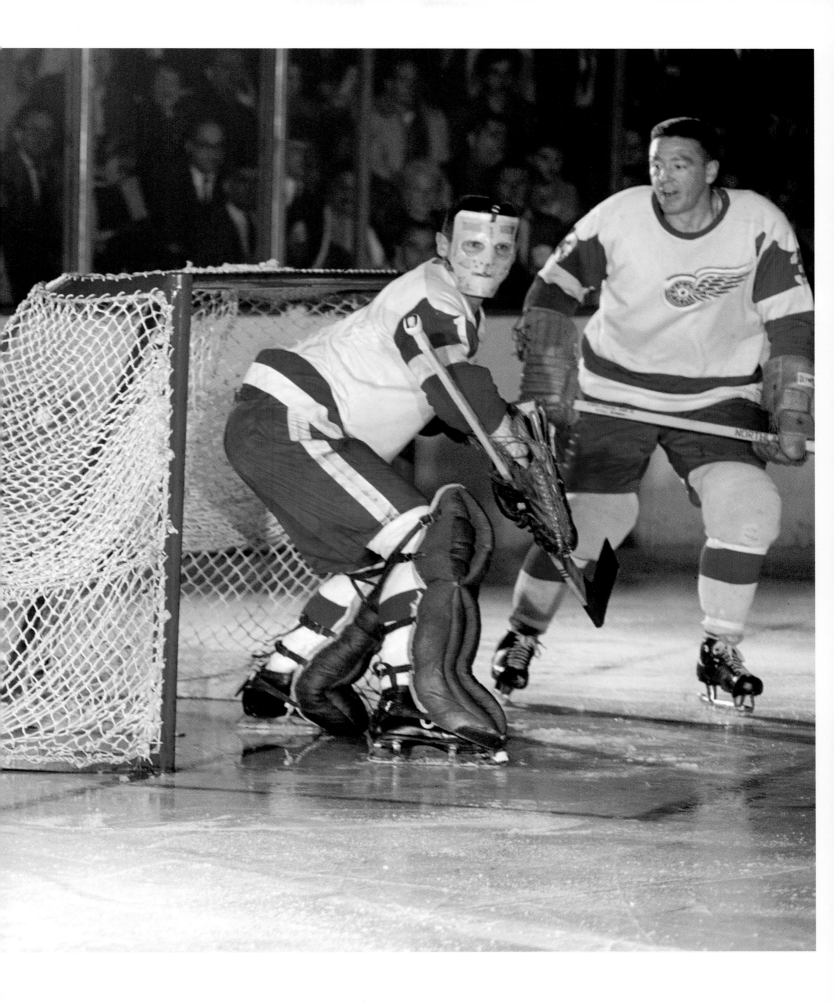

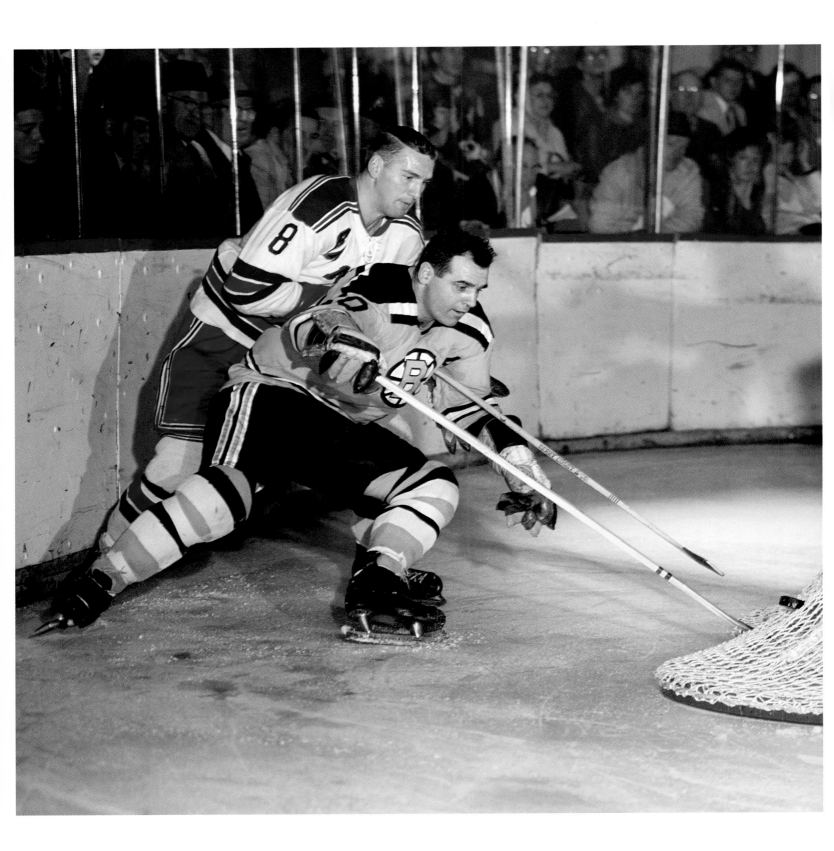

facing: Boston defenseman Leo Boivin has good position on Dave Balon of the Rangers. The hard-hitting blueliner was named captain of the Bruins in 1963 and was elected to the Hall of Fame in 1986 after 1,150 NHL games and 322 points.

below: Both Gordie Howe (from Floral) and Johnny Bower (from Prince Albert) were natives of Saskatchewan. In the summers they would fish together but were fierce rivals during the NHL season.

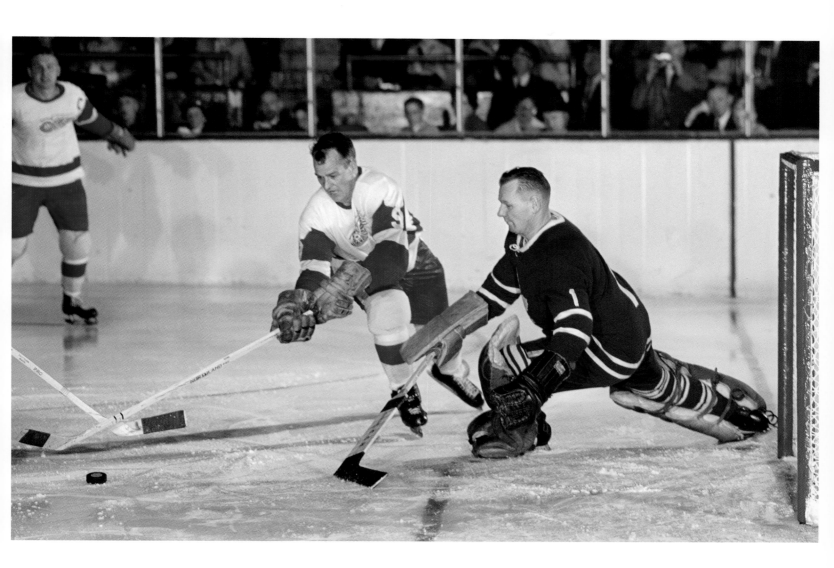

below: Norm Ullman (#7) played a 20-year Hall of Fame career with Detroit and Toronto. In 1965–66 Ullman led the NHL in goals scored with 42. He recorded 1,229 career points (including 490 goals) in 1,410 games played. Ullman scores here against Boston's Eddie Johnston while defenseman Bob McCord (#4) checks Floyd Smith of the Red Wings.

facing: Orland Kurtenbach (#7) was one of the league's toughest players during his NHL career (1960–74). Other players were wary of tangling with Kurtenbach for fear of getting destroyed by his fists. He was named first-ever captain of the Vancouver Canucks in 1970.

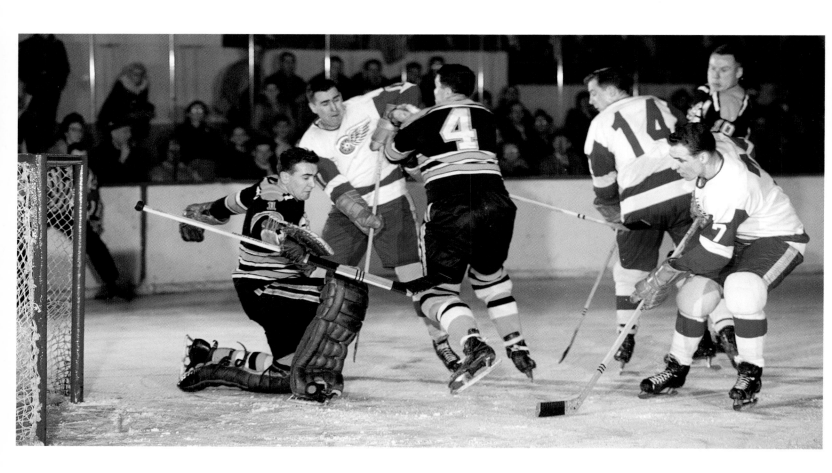

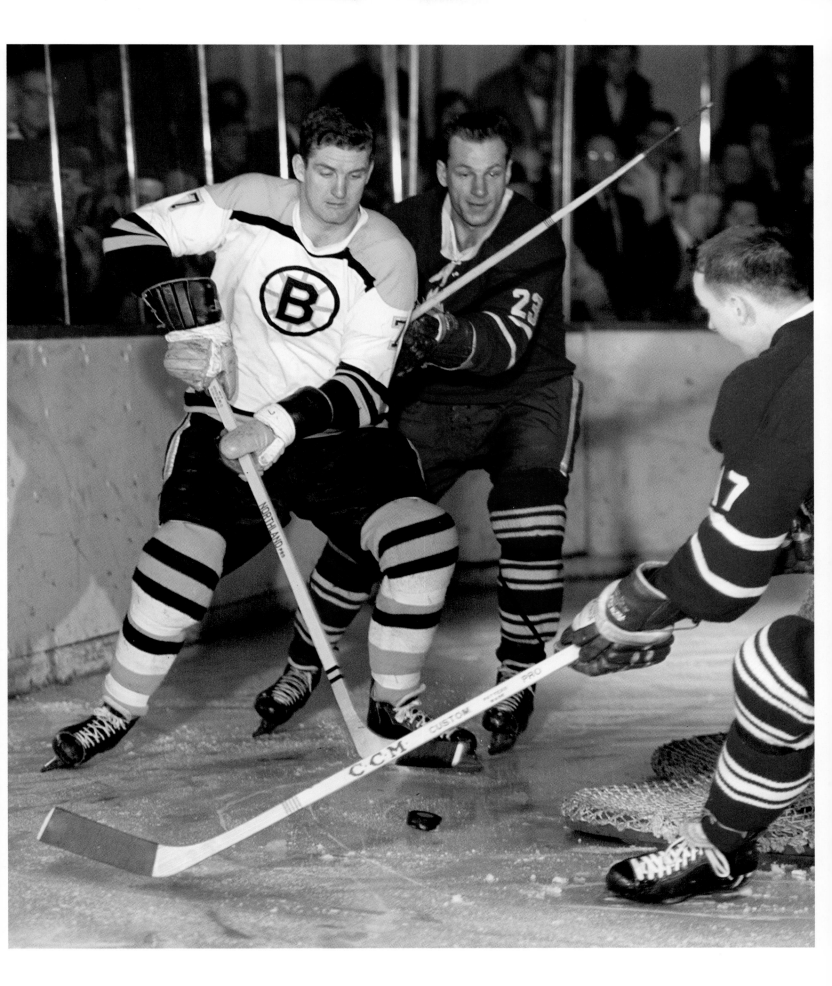

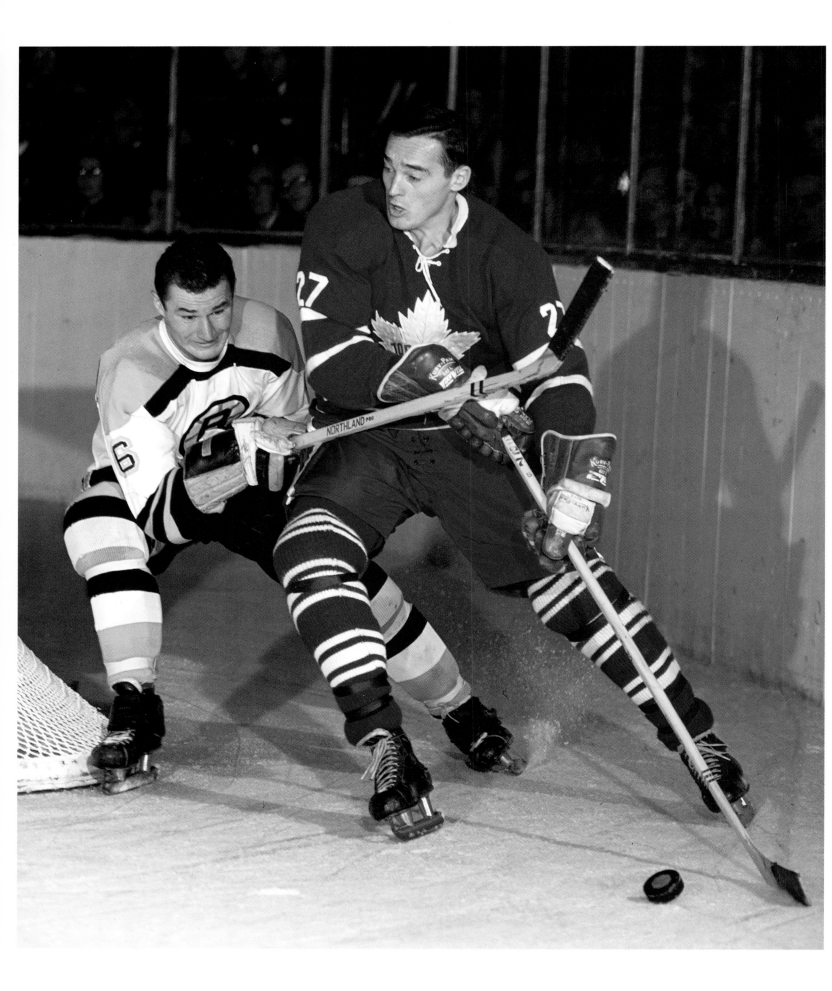

facing: Boston defenseman Ted Green has his hands full with Toronto winger Frank Mahovlich. Green was a tough player for the Bruins, racking up 1,029 penalty minutes in 620 games. Mahovlich led the Leafs in goals scored six straight seasons from 1960–61 to 1965–66.

below: Boston's Warren Godfrey was one the few players in the NHL to play with a helmet during the 1960s. He was a stay-at-home-type defenseman who never scored more than six goals in a single season over his 16-year career. Boston goalie Eddie Johnston (#1) guards the Bruins net.

overleaf: The 1963 All-Star Game was played at Maple Leaf Gardens in Toronto. The game ended in a 3–3 tie between the Maple Leafs and the NHL All-Stars. Here, Bobby Hull (#7) scores for the All-Stars with the help of Bernie Geoffrion (#5) against Johnny Bower of the Leafs.

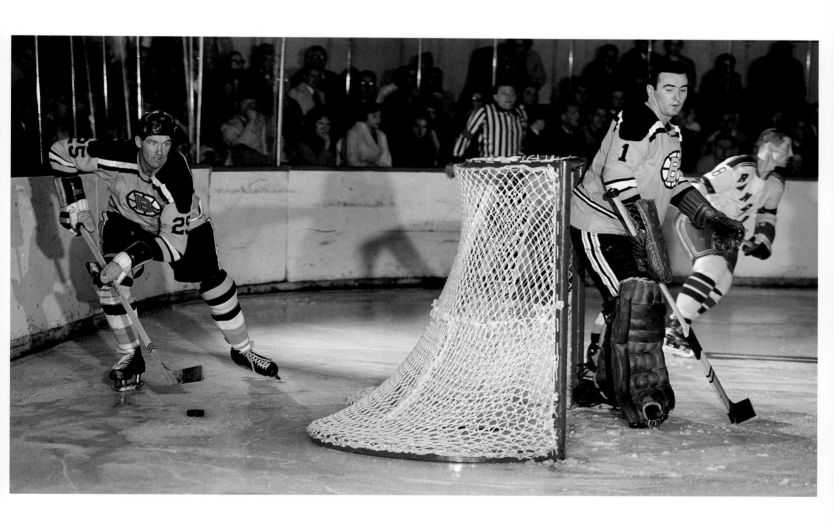

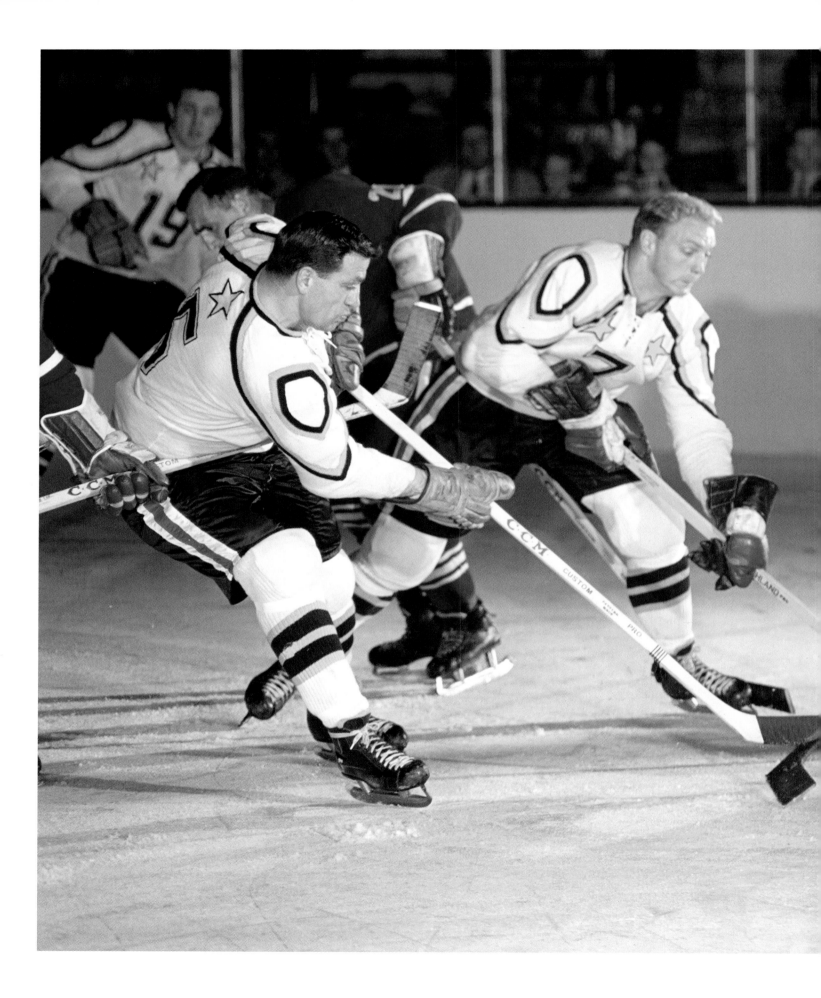

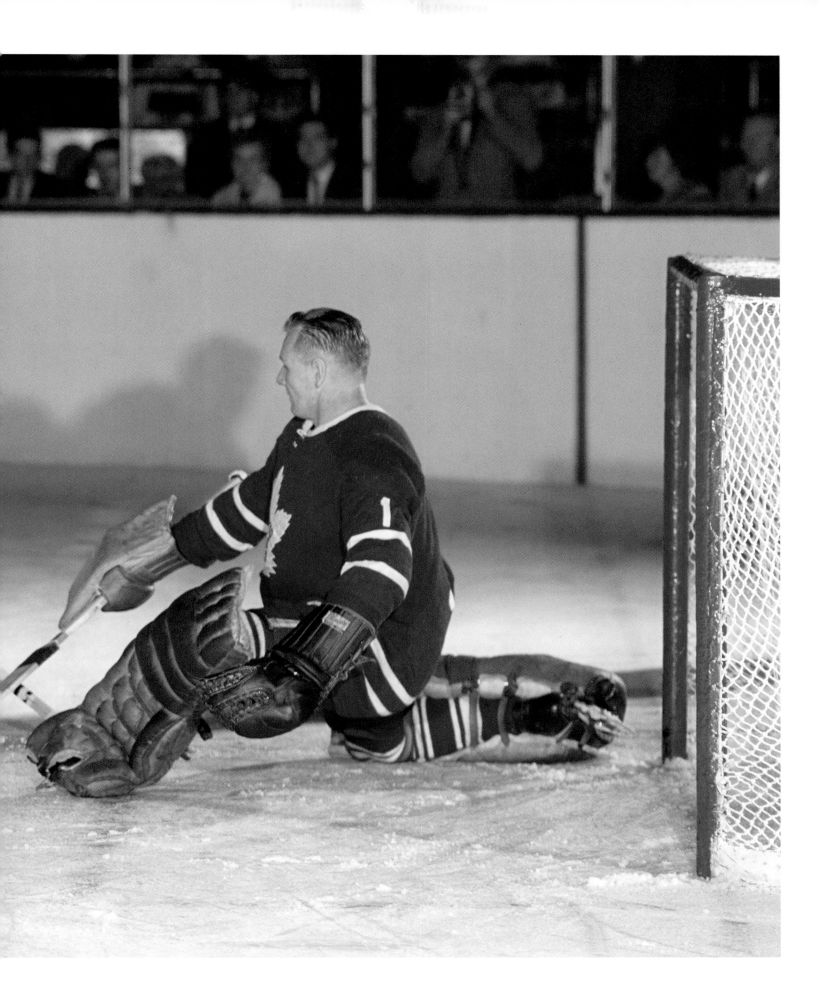

below: Boston defenders Ed Westfall (#18), Ted Green (on one knee), Tom Johnson (#10), and goalie Eddie Johnston (#1) combine with another Bruin to defend against the Maple Leafs. Johnston played in all 70 games for the Bruins in 1963–64. Billy Harris (#15) is the Leaf with the helmet.

facing: The Maple Leafs sent five players to Springfield of the American Hockey League to acquire defenseman Kent Douglas in 1962. The 27 year old was named the winner of the Calder Trophy as best rookie for the 1962–63 season. Here, Douglas has knocked down Bobby Hull of Chicago (#9).

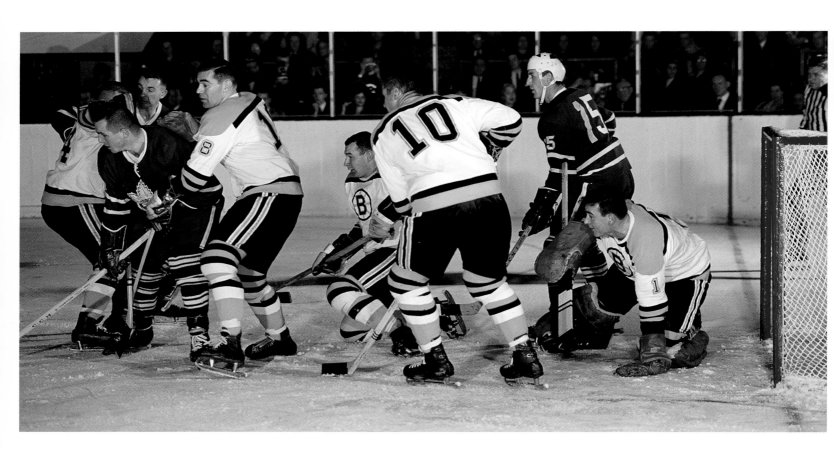

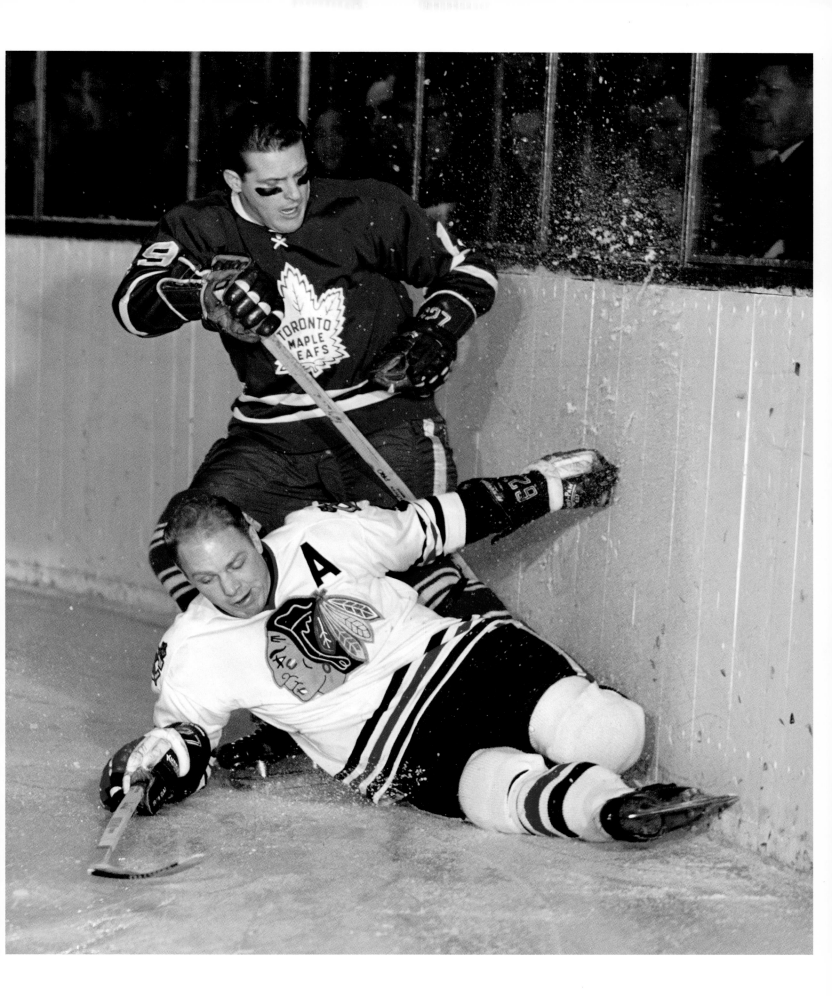

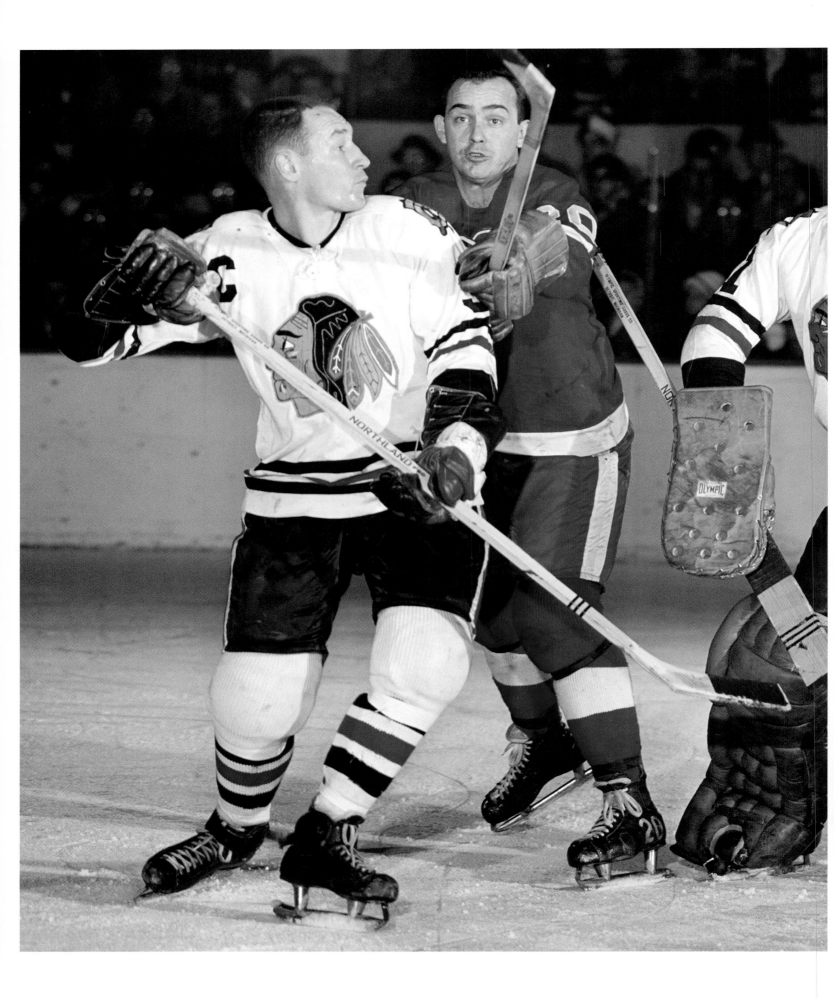

facing: Chicago blueliner Pierre Pilote was named the winner of the Norris Trophy as the NHL's best defenseman three straight years from 1963 to 1965. Pilote recorded 498 career points in 890 games. He also had 1,251 penalty minutes during his Hall of Fame career.

below: Rod Gilbert, seen here slipping one past Glenn Hall, played his entire career for the New York Rangers and scored 406 career goals with the Rangers. Gilbert had his most productive years during the 1970s. Hall recorded 84 career shutouts.

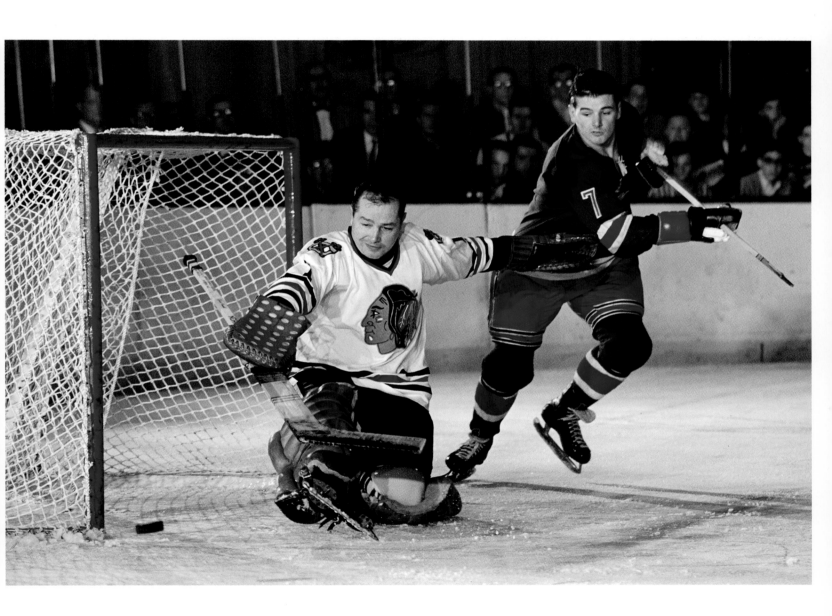

below: The Rangers plucked tough winger Vic Hadfield—seen here rushing Toronto's Johnny Bower—from the Black Hawks in 1961. Hadfield tallied over 100 minutes in penalties three times between 1961 and 1967.

facing: New York defenseman Jim Neilson watches Ken Wharram of Chicago very closely. Neilson played in 1,023 career games, recording 368 points and made the Second All-Star Team in 1968. Wharram was forced to retire in 1969 with heart problems, after scoring 30 goals in 1968–69.

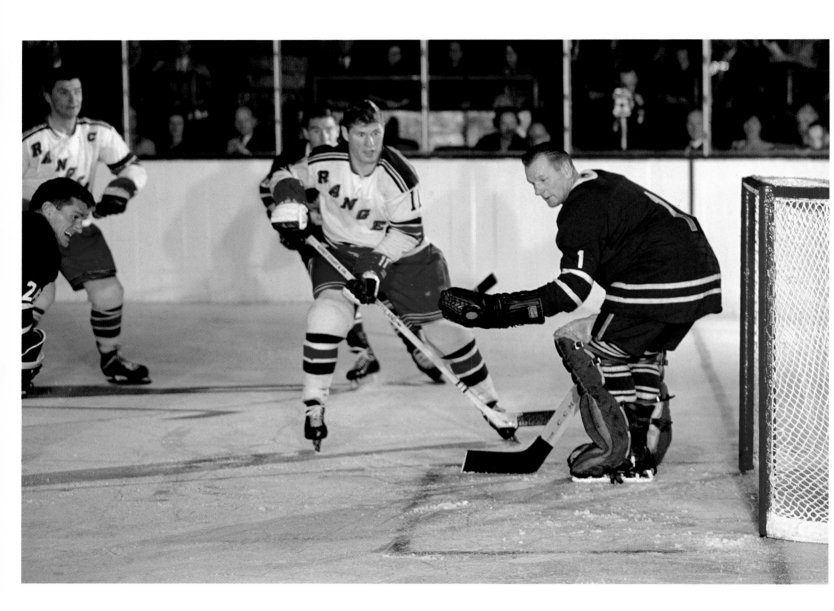

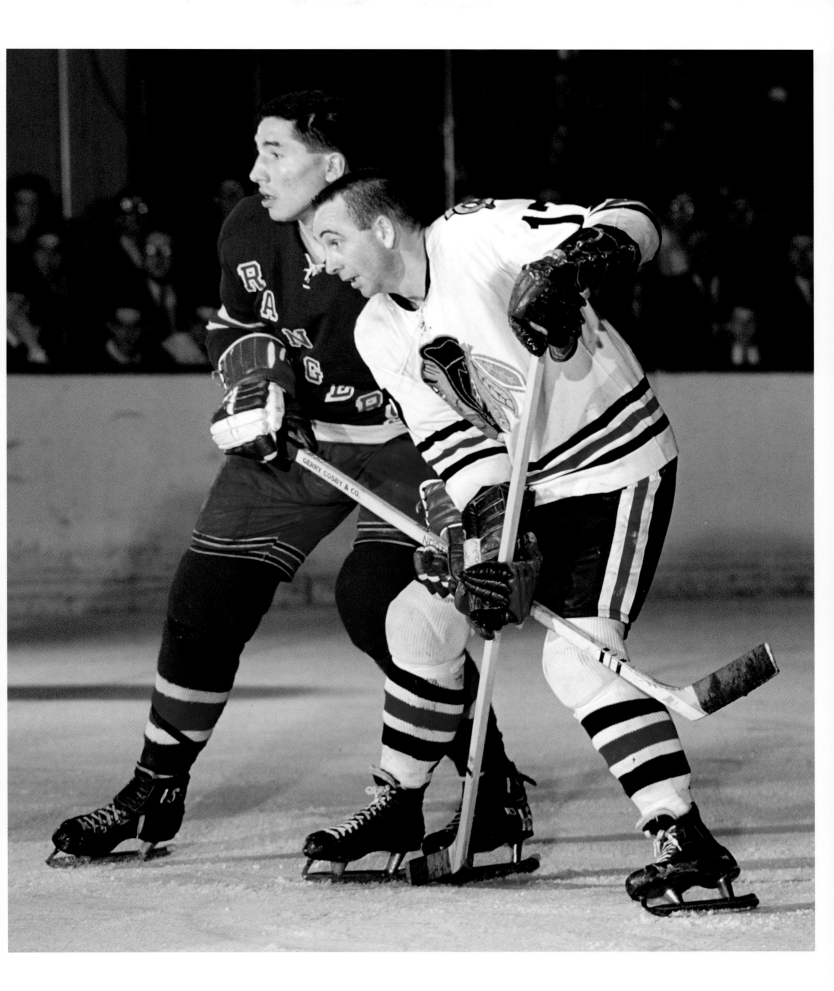

New York goalie Jacques Plante tries to find the puck with the help of teammates Don Johns (#6) and Jim Neilson, as Chicago's Bobby Hull enters the fray. Plante was traded to the Rangers in 1963 but his stay in New York was not a success, lasting only a season and a half.

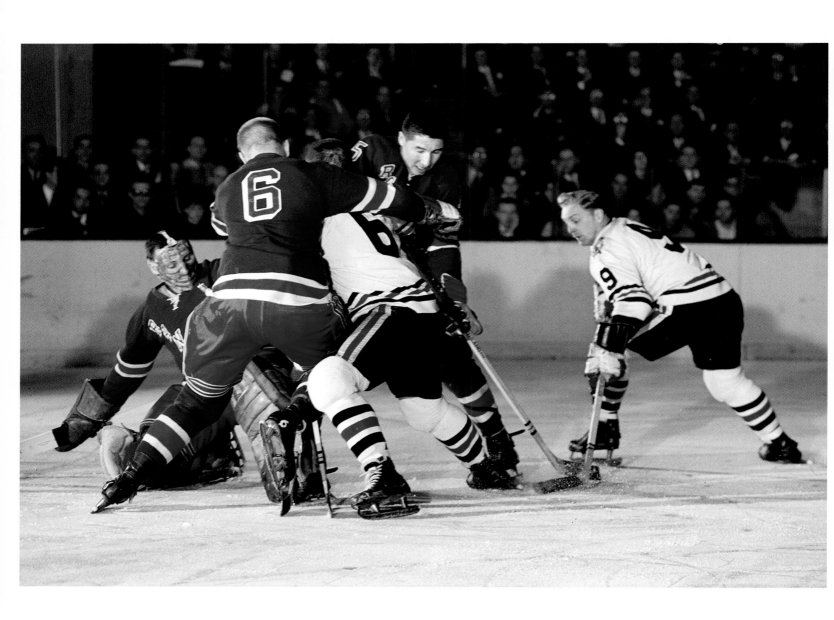

below: Chicago forward Johnny "Pie Face" McKenzie tries to score on Jacques Plante of New York. McKenzie scored a total of 17 goals for Chicago over two seasons before the Hawks dealt him to New York. He finished his NHL career playing for Boston.

overleaf: Detroit's Ted Lindsay (#21) and Gordie Howe (#9) crash the Chicago goal area occupied by Denis DeJordy. Lindsay was crushed when he was traded to the Black Hawks in 1957. He came out of retirement at 39 to join Detroit for the 1964–65 season and helped the team finish in first place.

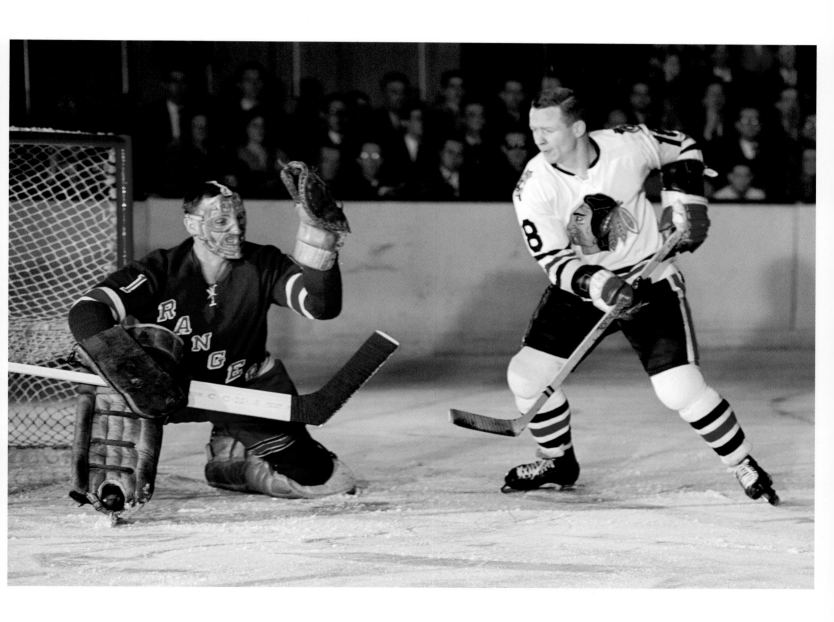

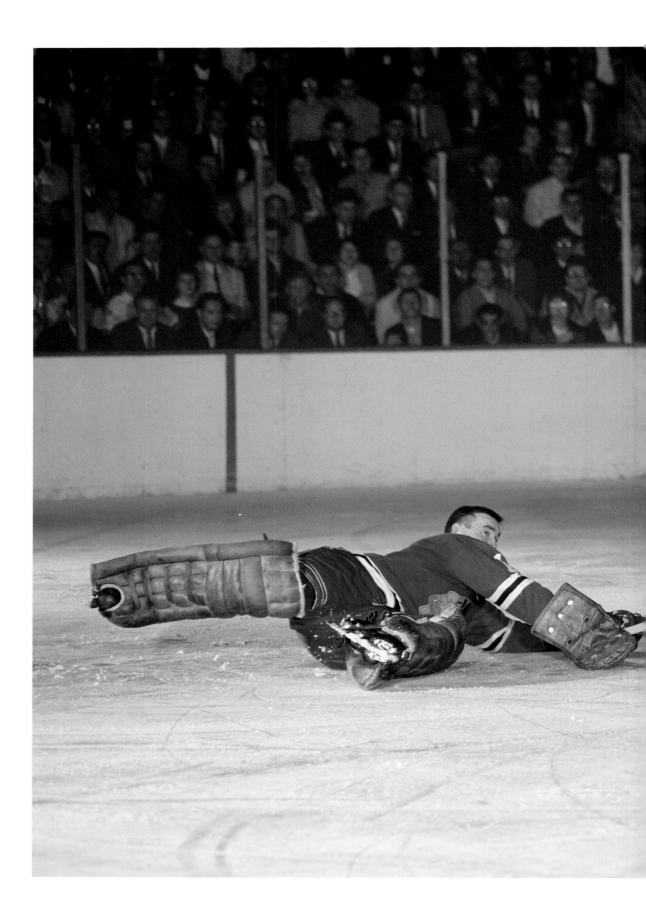

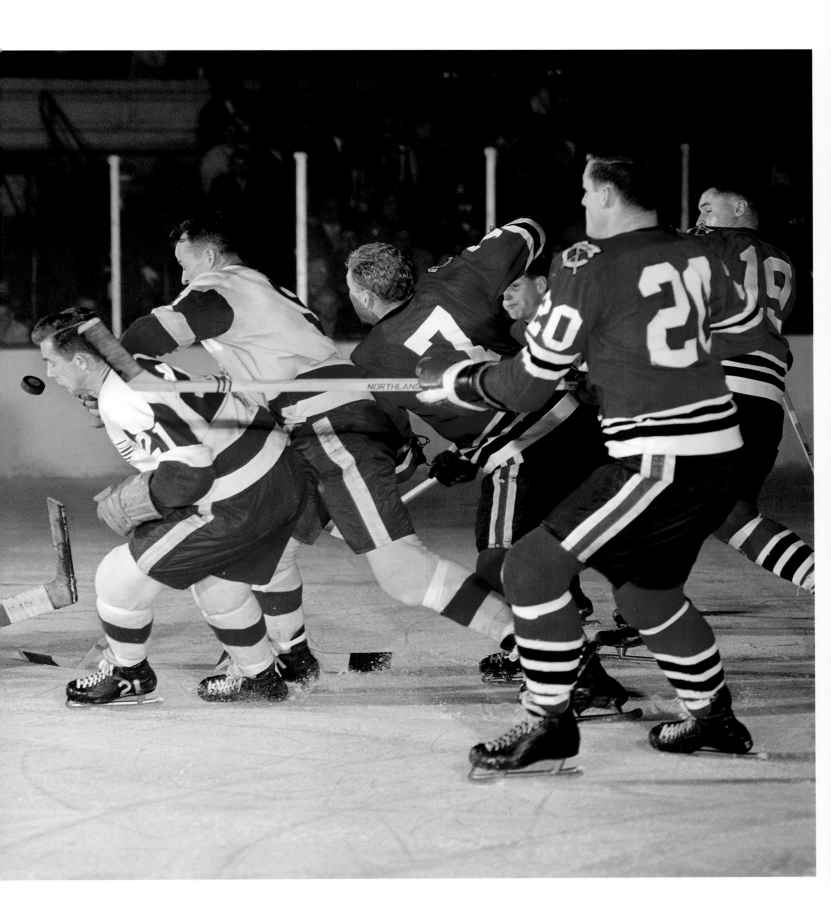

below: Detroit's left winger Ron Murphy (#12) scored 205 career goals in 889 games played. He scored 30 of his goals as a Red Wing and also played for New York, Chicago, and Boston.

facing: The Rangers gave up four players to acquire the rights to goalie Eddie Giacomin, shown here defending against Dave Keon of the Leafs. He would post a 288–209–96 career record and would be named to the Hall of Fame.

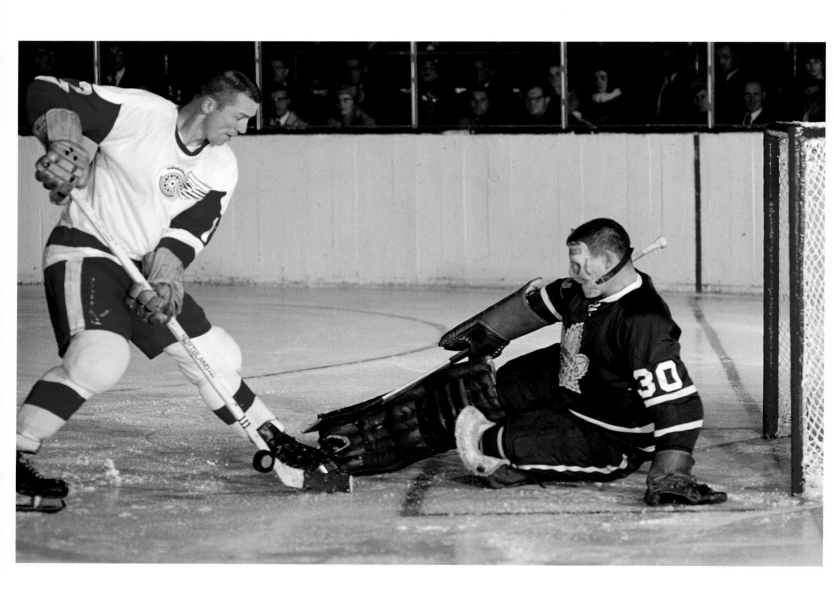

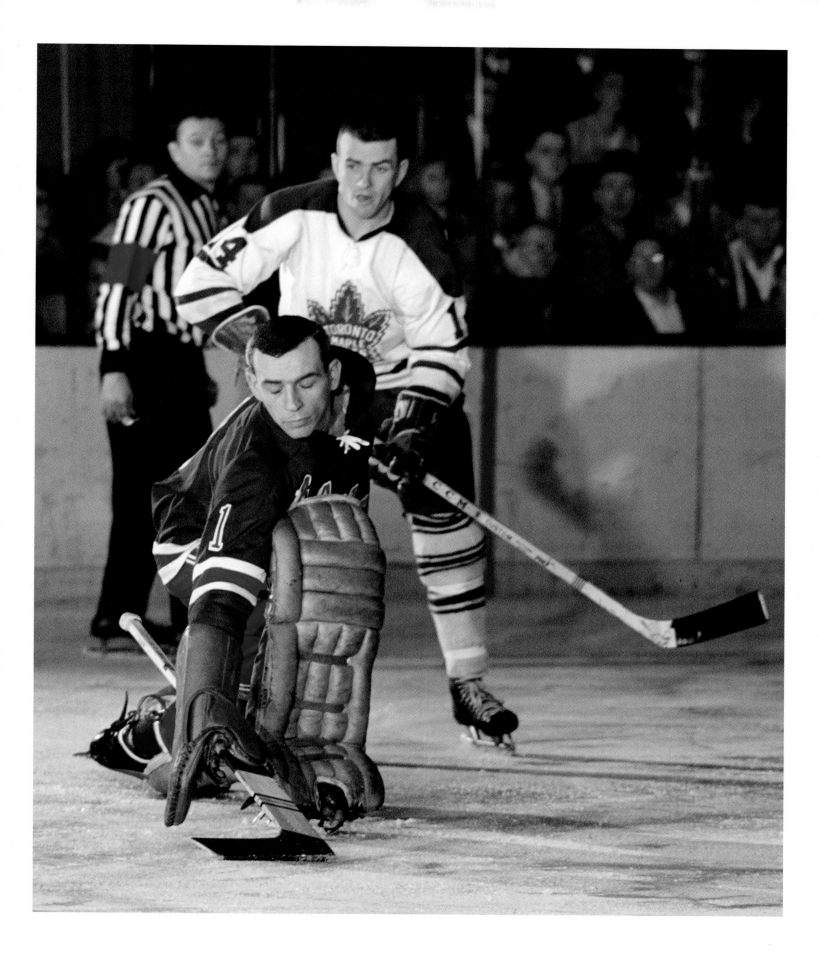

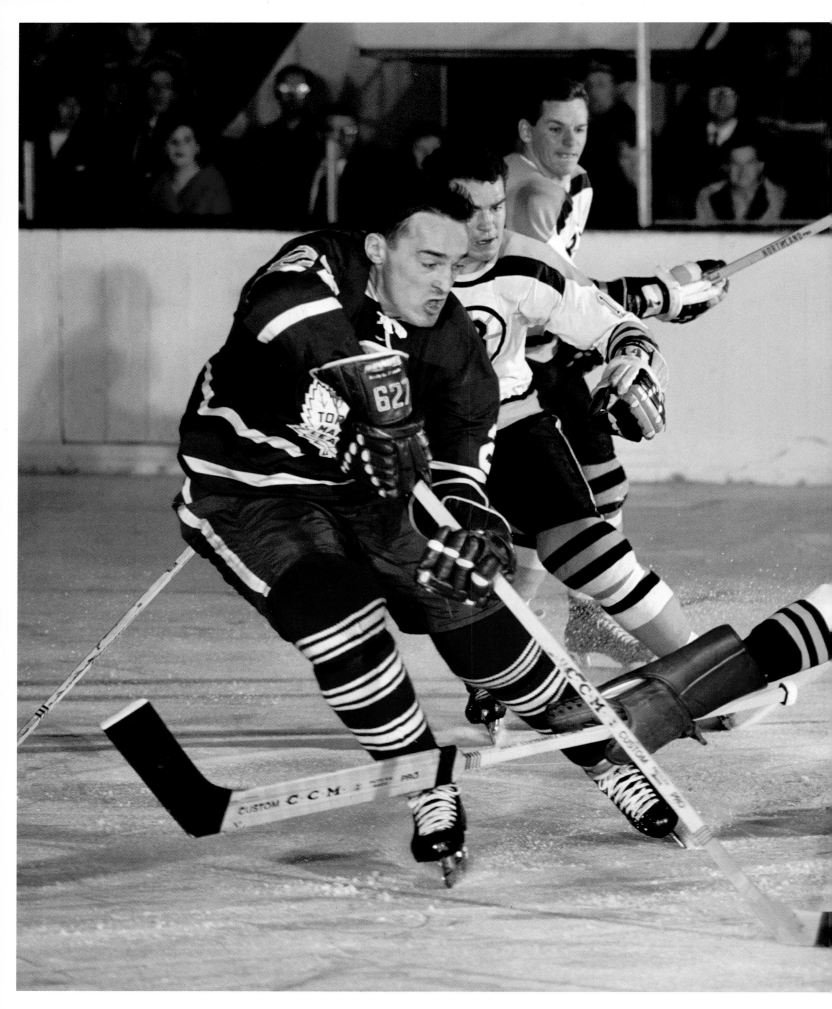

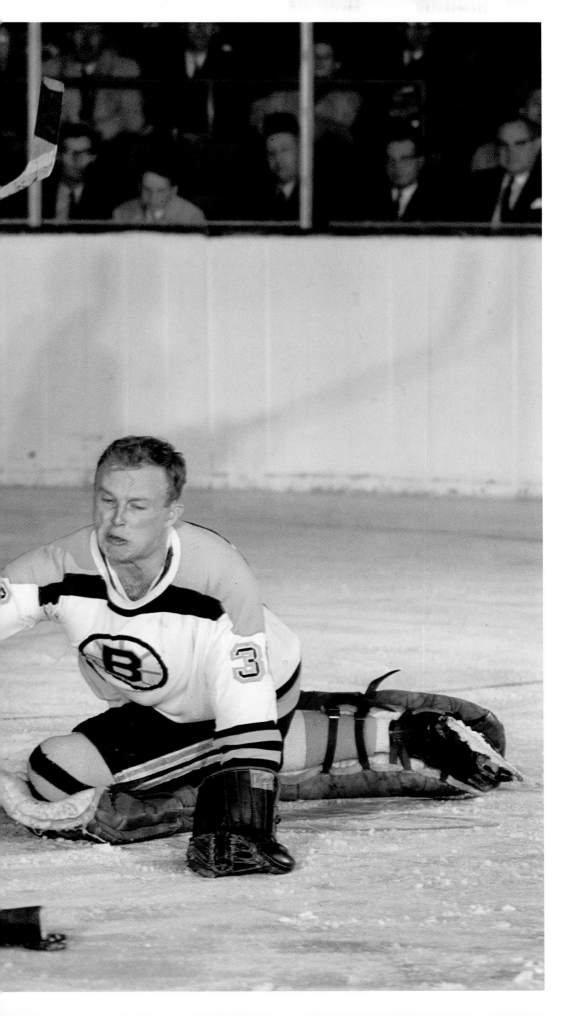

Frank Mahovlich had his last great season as a Maple Leaf in 1965–66, when he scored 32 times. Here, Mahovlich sweeps the puck past Gerry Cheevers (#30) in the Boston net for one of his classic goals.

below: After his record-breaking season in 1965–66, Bobby Hull scored 52 times in 1966–67, as his Black Hawks finished the regular season in first place. In this superb action photo, Hull is stopped by Toronto's Johnny Bower.

facing: Stan Mikita (#21) looks for a rebound against Toronto goalie Bruce Gamble (#30). Mikita won his third scoring title in 1966–67 when he recorded 97 points, including a league-high 62 assists.

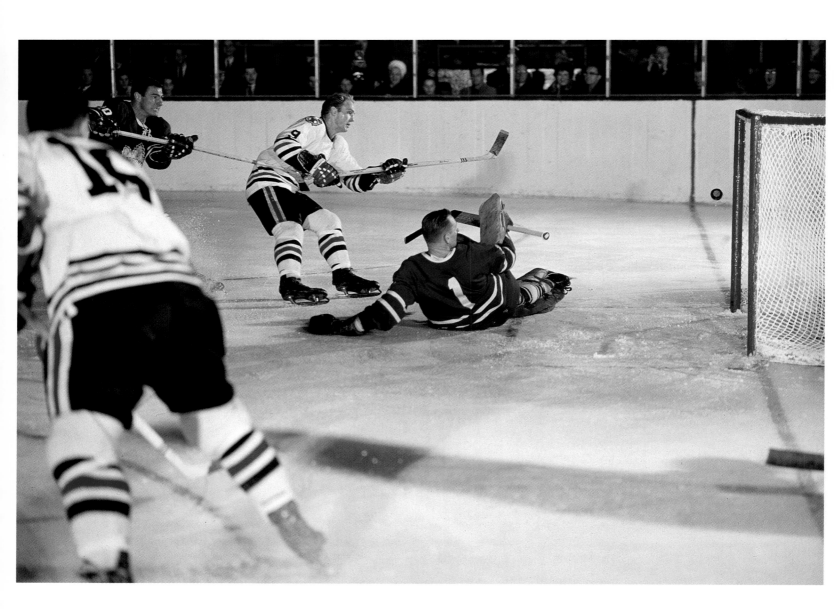

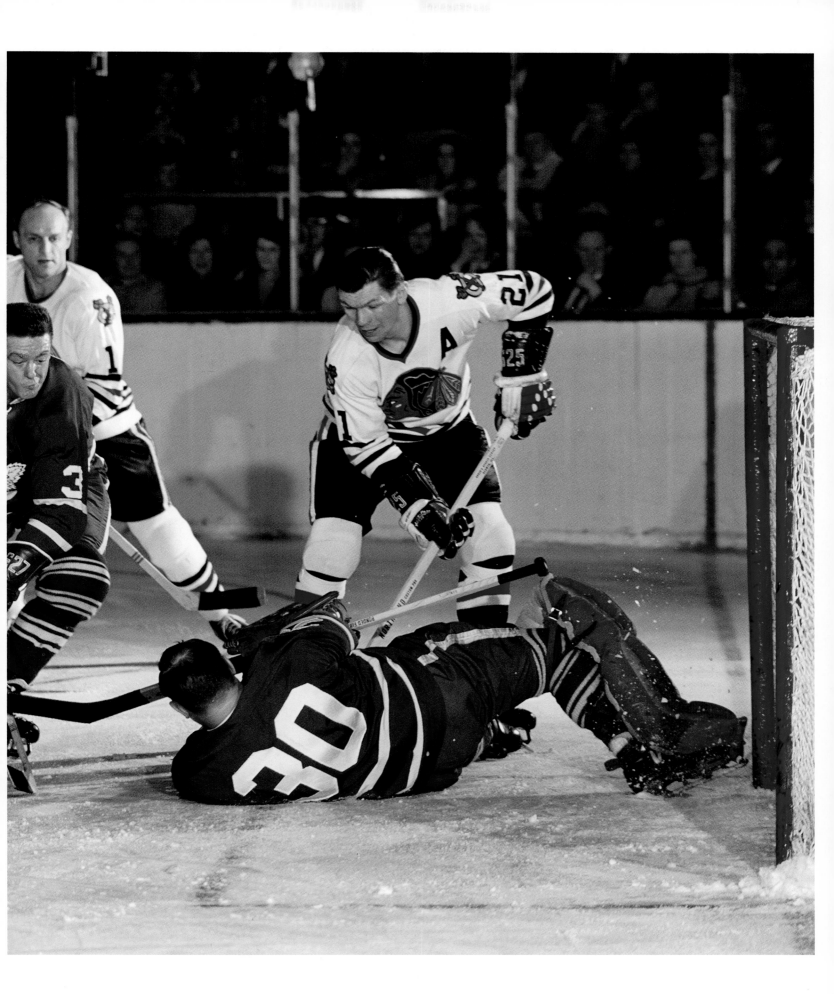

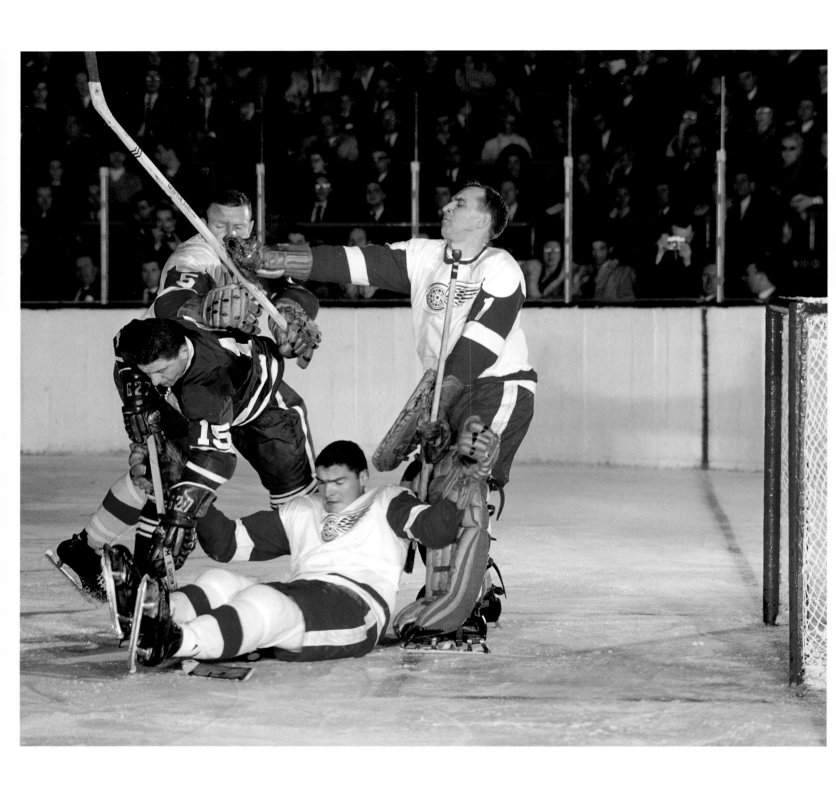

facing: Detroit goalie Roger Crozier (#1) sticks his catching glove in the face of defenseman Doug Barkley (#5) while battling Wally Boyer of the Maple Leafs. Barkley had a very good career cut short when he took a stick in the eye from Chicago's Doug Mohns in 1966.

below: Toronto's Terry Sawchuk sprawls to stop a shot by the Detroit Red Wings. In his first year with the Leafs in 1964–65, the veteran netminder played in 36 games, posting a 17–13–6 record while allowing only 92 goals.

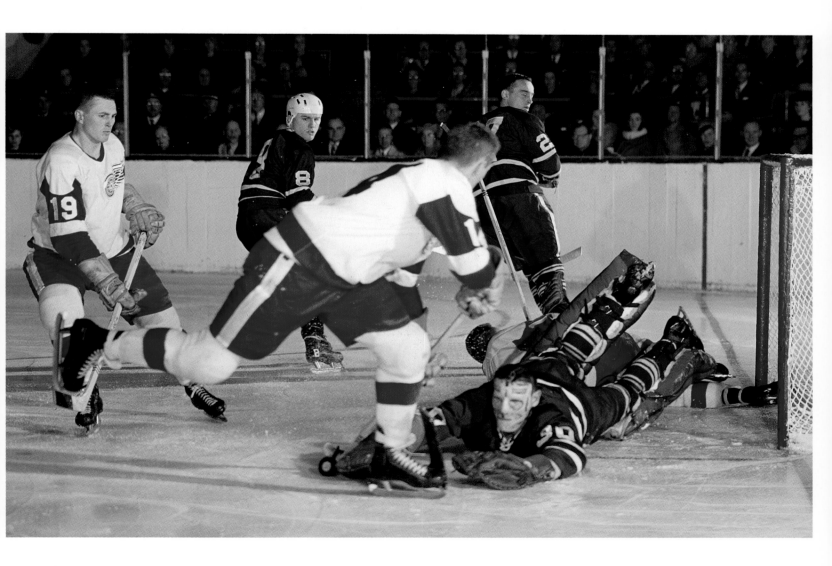

New York's Camille Henry (#21) gains position on Toronto defenseman Tim Horton while watching teammate Rod Gilbert (#7) go at the Leaf net occupied by Terry Sawchuk (#24). Henry also played for Chicago and St. Louis and finished with 279 goals and 528 points in 727 games played.

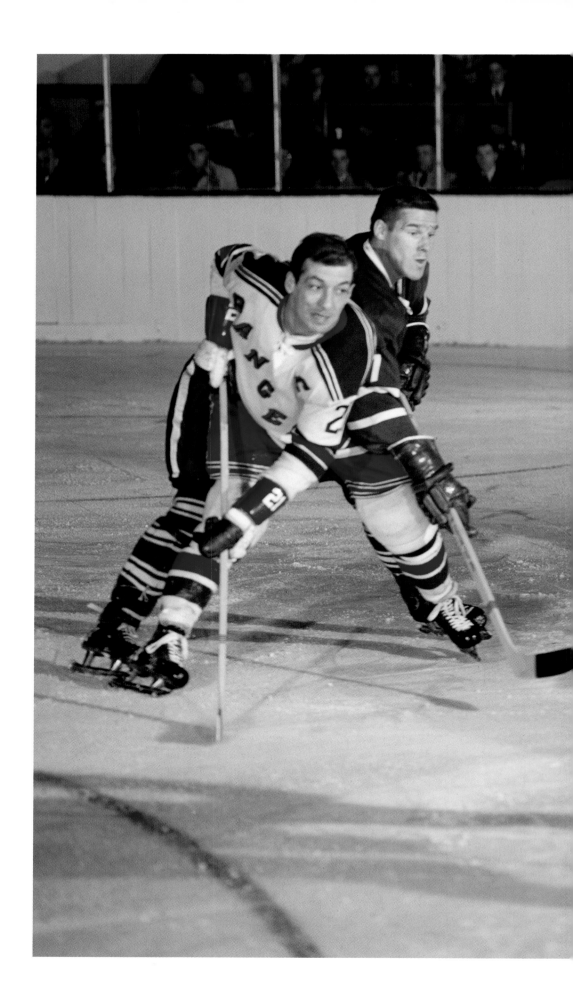

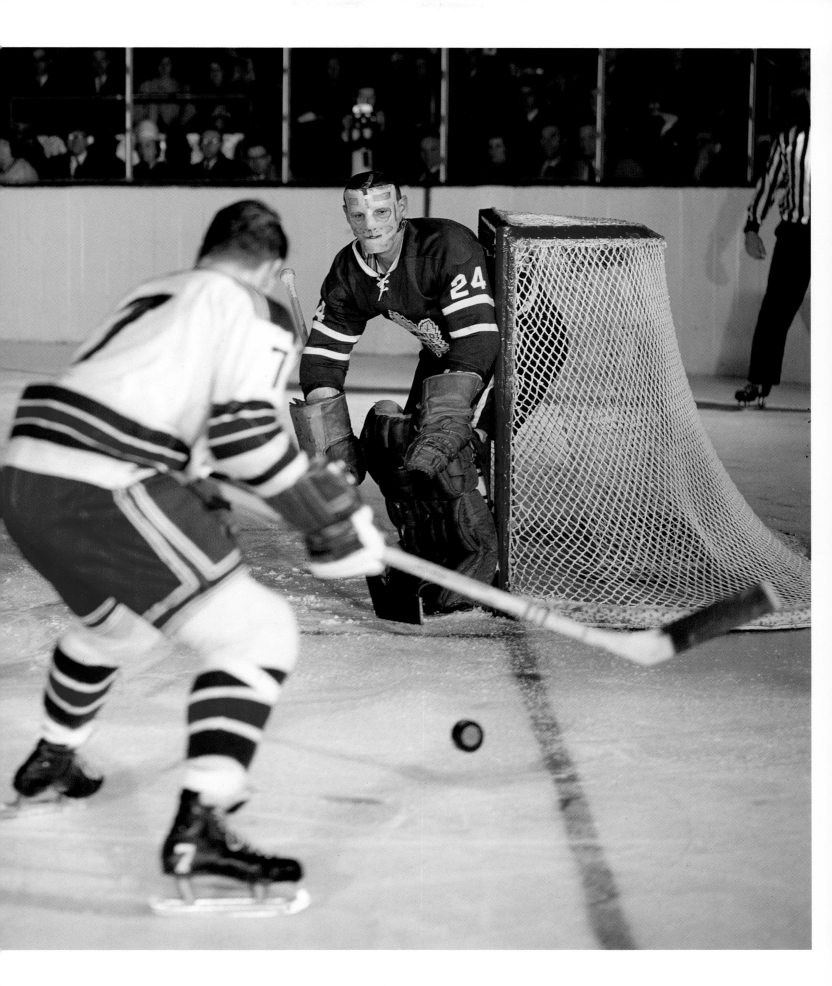

below: Detroit's Bruce MacGregor (#16) is shut down by the Toronto defense made up of Tim Horton (#7), goalie Johnny Bower, and Allan Stanley (#26). MacGregor entered the NHL in 1960–61 but had his best goal-scoring year in 1966–67 when he netted 28 for the Red Wings.

facing: Toronto's Eddie "The Entertainer" Shack is closely followed by Detroit's Howie Young. Shack could score goals and play a tough brand of hockey, recording 1,437 penalty minutes in 1,047 career games. Young was one the NHL's all-time bad boys and led the league with 273 penalty minutes in 1962–63.

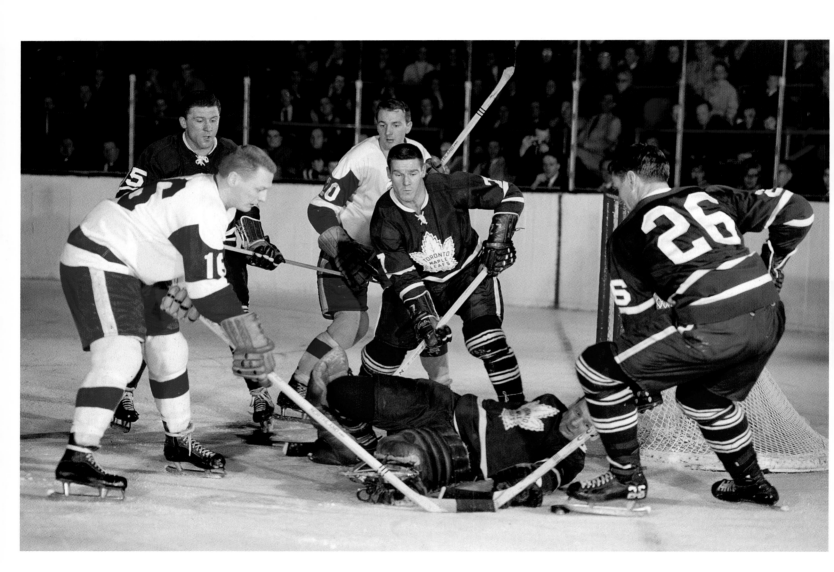

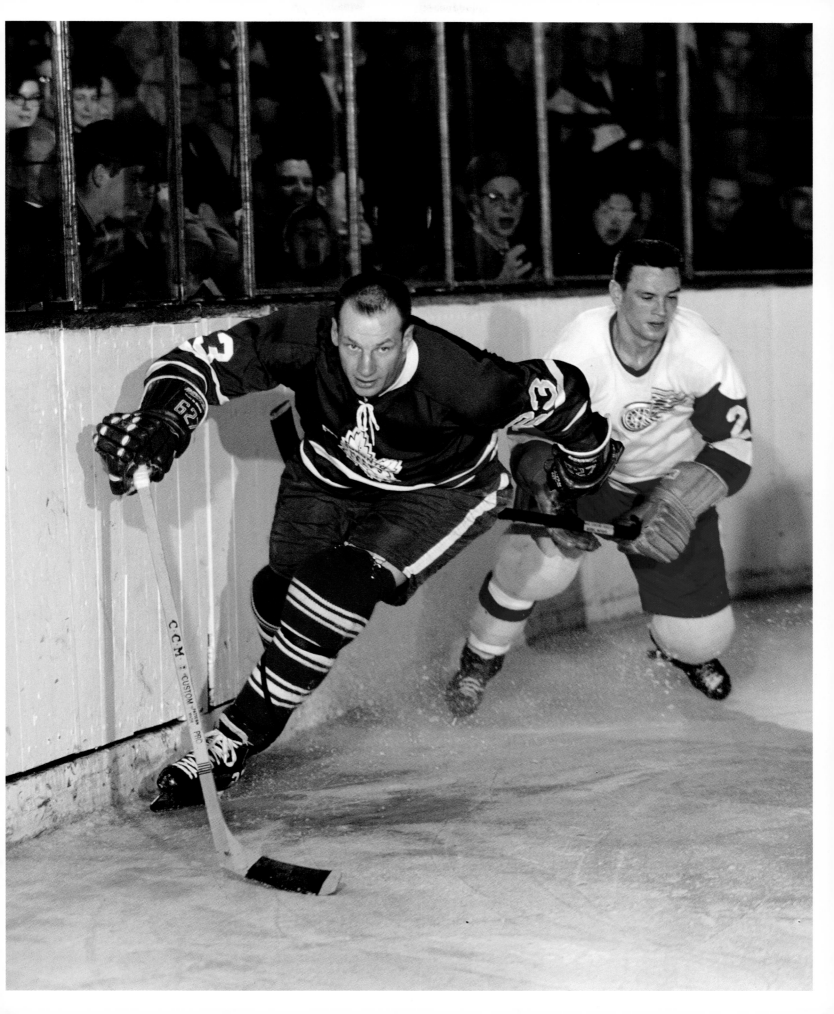

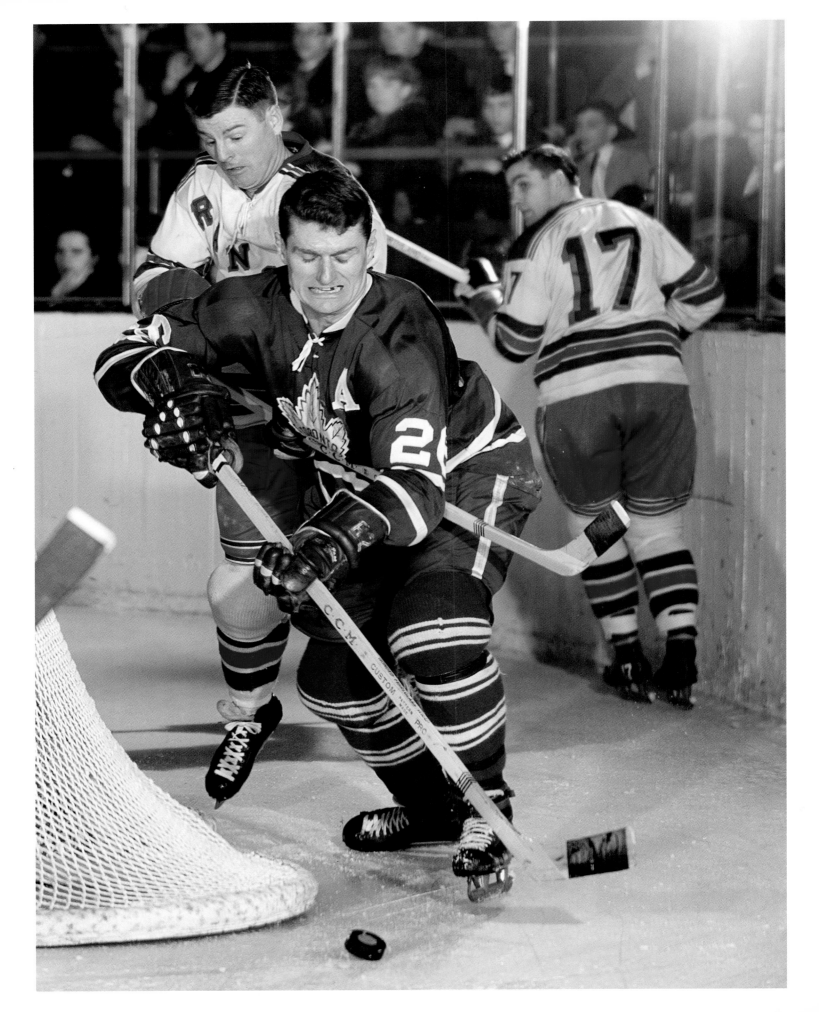

facing: Defenseman Allan Stanley (#26) was a prized prospect when he started his NHL career in 1948 for the New York Rangers. The Maple Leafs acquired him—after stints in Chicago and Boston—and he would help anchor the Toronto defense for the next ten seasons, which included four Stanley Cups.

below: Chicago players (from left) Glenn Hall, Pierre Pilote, and Dennis Hull defend against New York forward Rod Gilbert (#7). In 1966–67 the first-place Black Hawks scored a then-record 264 goals, allowed only 170, and won just about every individual award possible but could not take the Stanley Cup!

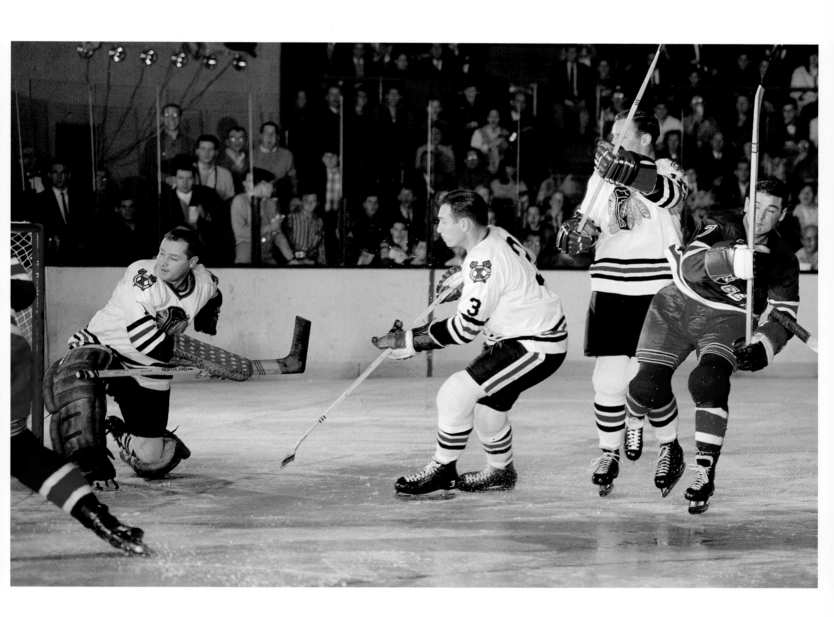

below: Doug Mohns (#2) leads a rush up the ice with Chicago teammate Pierre Pilote. Mohns was a long-time (11 seasons) member of the Boston Bruins before he was dealt to the Black Hawks in 1964.

facing: Toronto defenseman Tim Horton keeps the puck away from New York forward Jean Ratelle. In the 1962 Stanley Cup finals, Horton set a then-record for points by a defenseman in the playoffs with 16, as the Leafs reclaimed the championship for the first time since 1951.

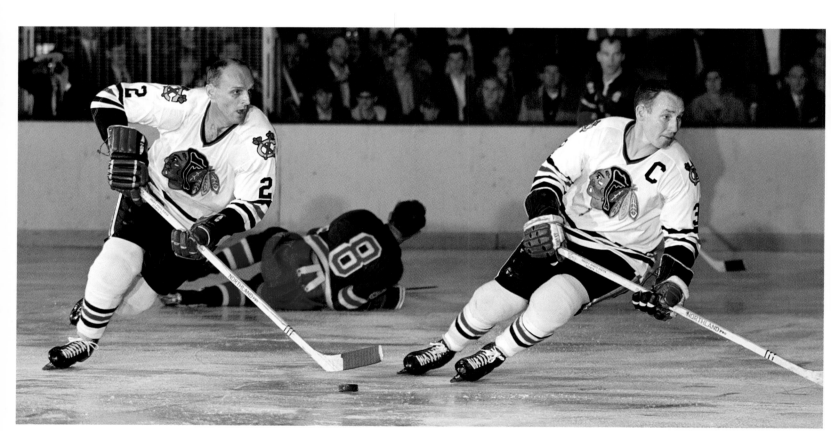

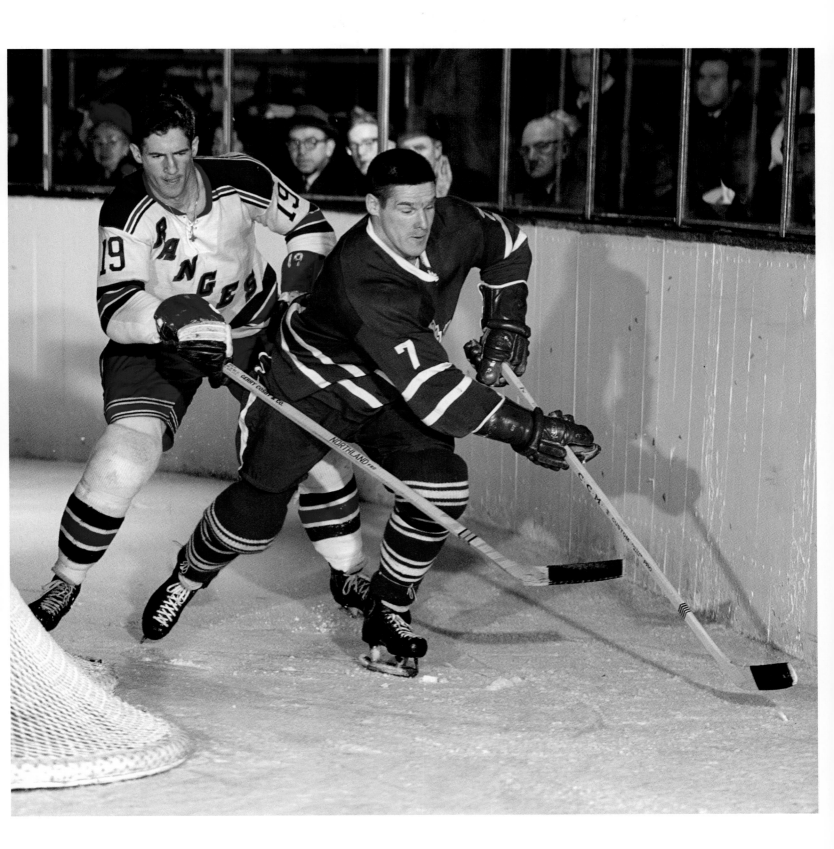

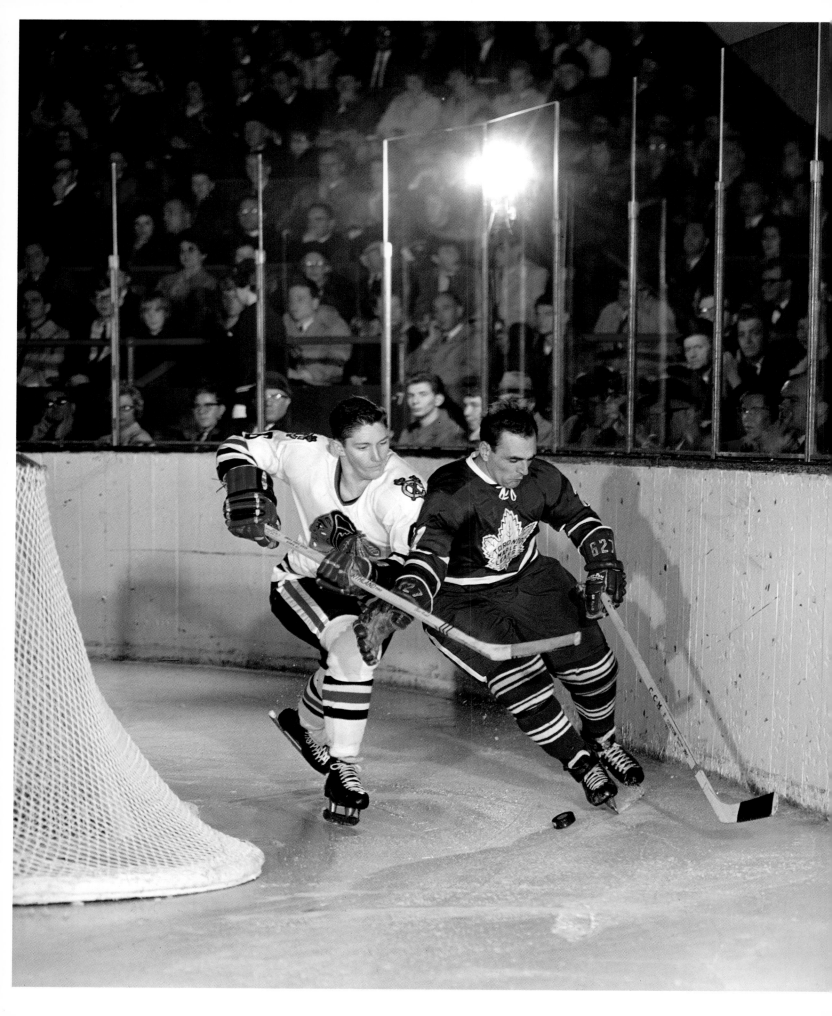

Chicago forward Fred Stanfield moves in on Maple Leafs defense-man Bobby Baun. None of Baun's three career playoff goals was bigger than the overtime marker he scored in the 1964 Stanley Cup playoffs, playing with a broken bone in his lower leg.

Detroit defenseman Bill Gadsby battles
Toronto right winger Ron Ellis. Gadsby played
in 20 NHL seasons but was never able to win
the Stanley Cup, despite three chances in the
finals with the Red Wings.

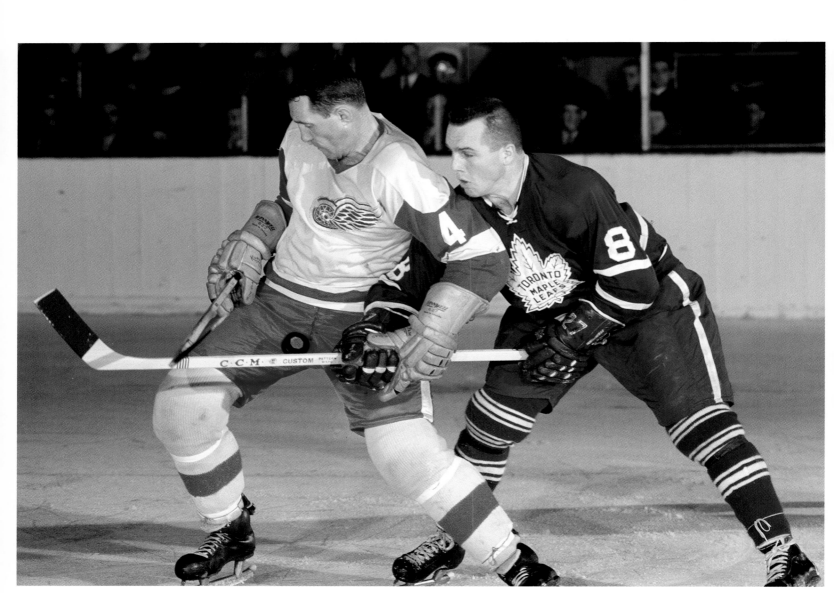

George Armstrong was the last Toronto captain appointed by Maple Leafs founder Conn Smythe. The Leafs right winger earned the last goal of the Original Six era when he scored an empty net goal versus Montreal on May 2, 1967.

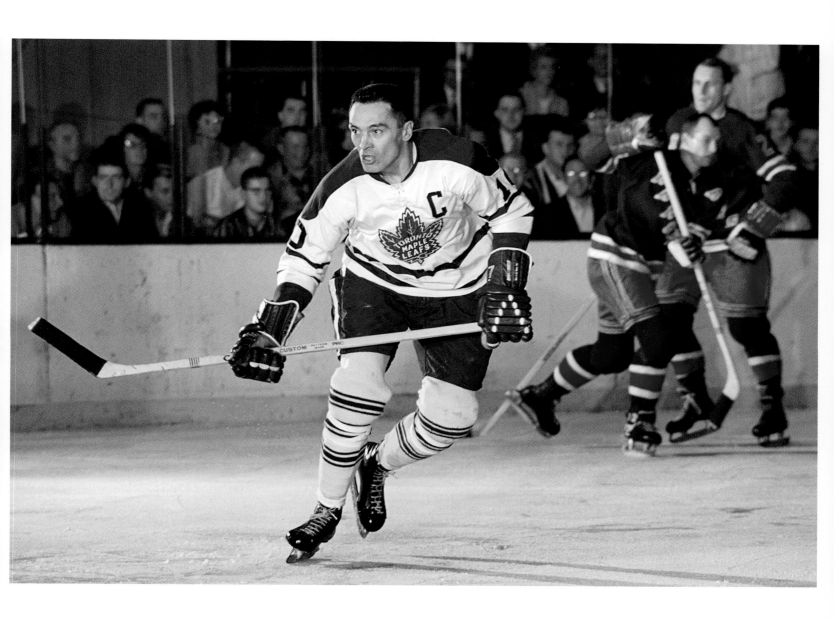

below: Considered one of the best junior prospects when he joined the Montreal Canadiens in 1963–64, Yvan Cournoyer was first used as a power-play specialist by Habs coach Toe Blake. Toronto defenseman Larry Hillman (#2) watches the Montreal forward known as "The Roadrunner."

facing: Montreal defenseman Terry Harper, seen here reaching up for a loose puck, was never a graceful skater but he knew exactly where to position himself defensively. His smarts kept him in the NHL for 19 seasons, and Harper was a part of five championship teams with the Canadiens.

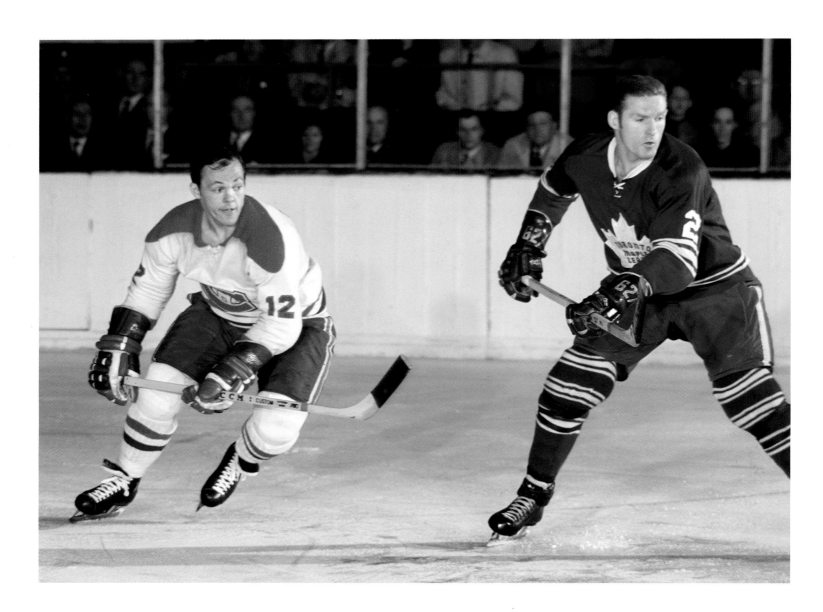

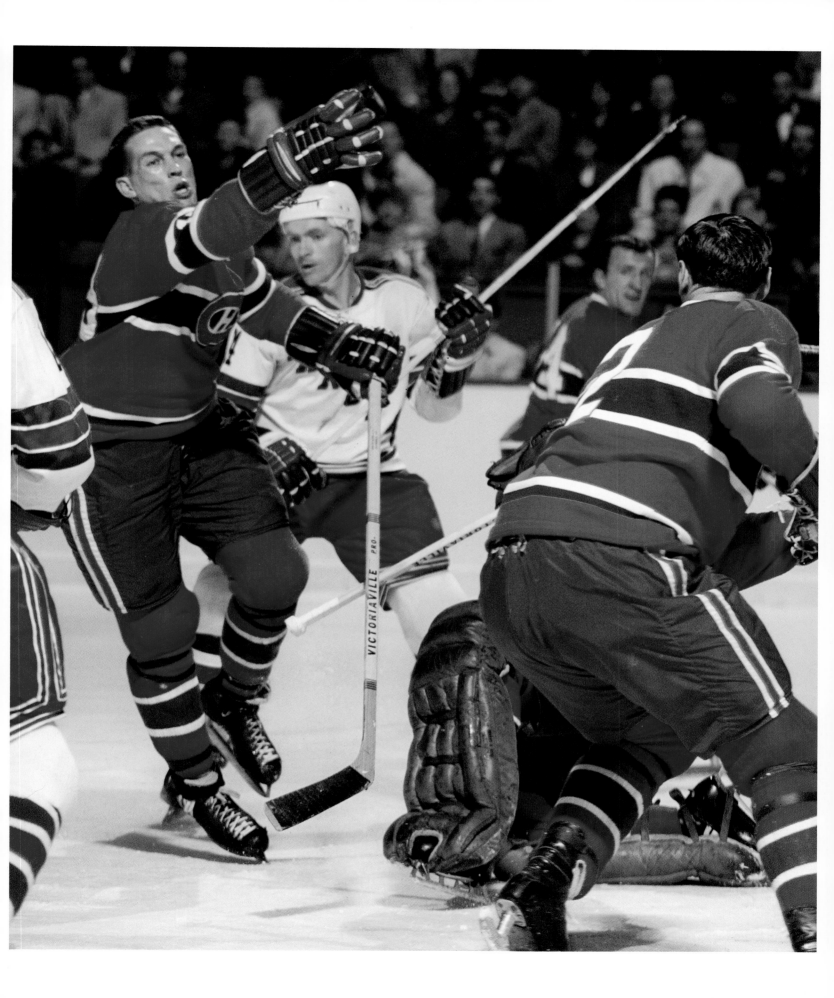

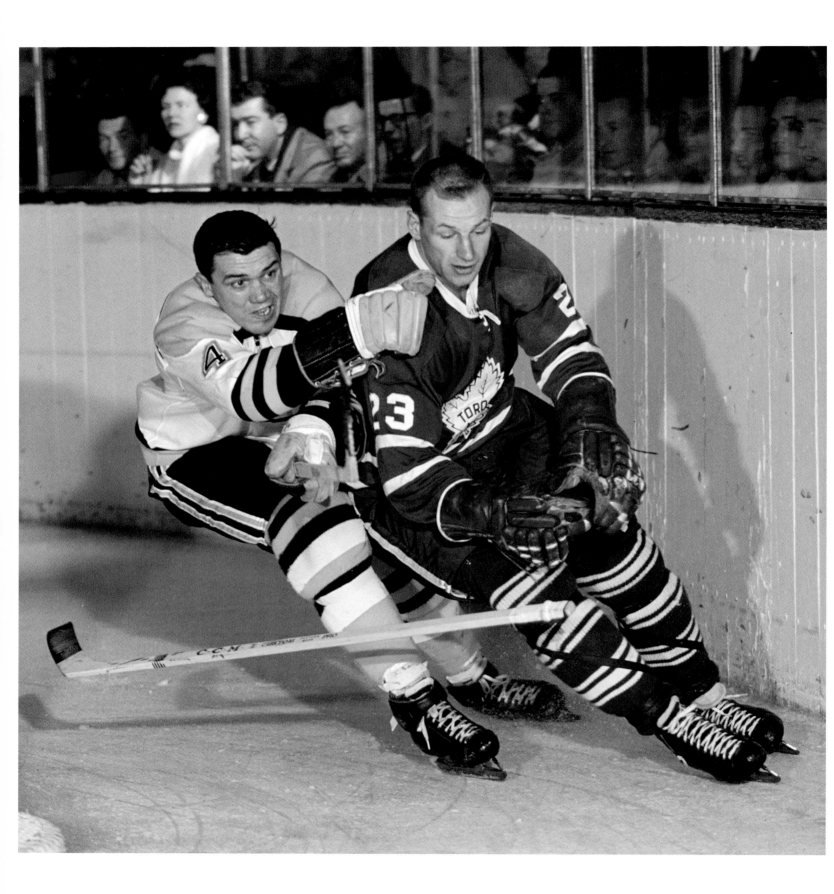

facing: Boston defender Bob McCord chases Toronto's Eddie Shack. The Leafs acquired the rambunctious winger from the New York Rangers in a 1960 trade and he stayed with them until the end of the 1966–67 season. McCord played for four different teams during his career.

below: Montreal defenseman J.C. Tremblay (#3) had a very good playoff in 1966 when the Canadiens won their second consecutive Stanley Cup. He had 11 points in ten playoff games, as Montreal knocked out Toronto and Detroit to capture the championship. All-Star forward Murray Oliver (#16) is in pursuit.

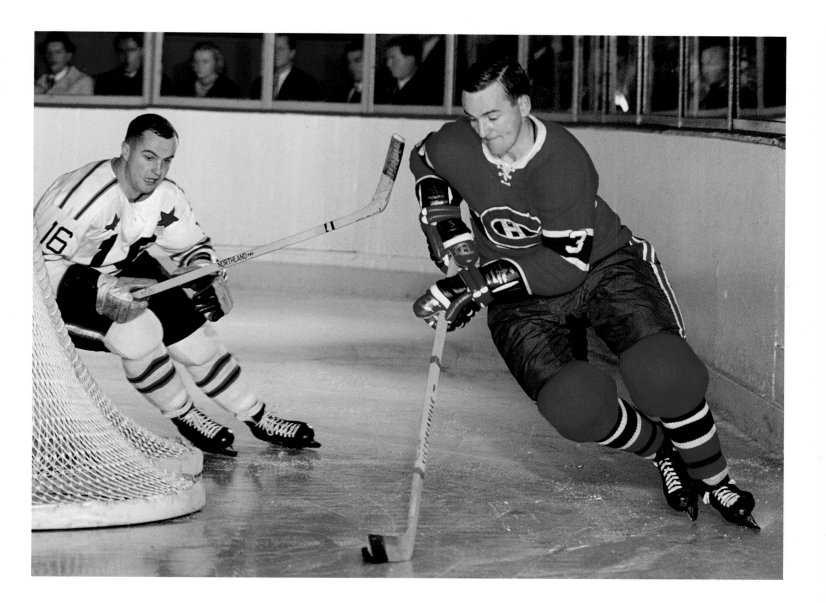

below: The 1965 NHL All-Star Game was played at the Montreal Forum. The NHL All-Stars defeated the Stanley Cup champions 5–2, with Norm Ullman (#8) scoring one goal (which came against "Gump" Worsley, #30 in photo).

facing: Toronto defenseman Marcel Pronovost tries to beat Norm Ullman of Detroit to the puck. Pronovost won four Stanley Cups with the Red Wings but a 1965 deal sent the veteran to Toronto, where he was an important player in the Maple Leafs surprising Cup win in 1967.

overleaf: New York's Phil Goyette contends with Boston defenseman Don Awrey and goalie Bernie Parent. Parent began his Hall of Fame career with Boston in 1965–66. Goyette played six seasons for the Rangers and had one of his best years with New York in 1966–67 when he tallied 61 points.

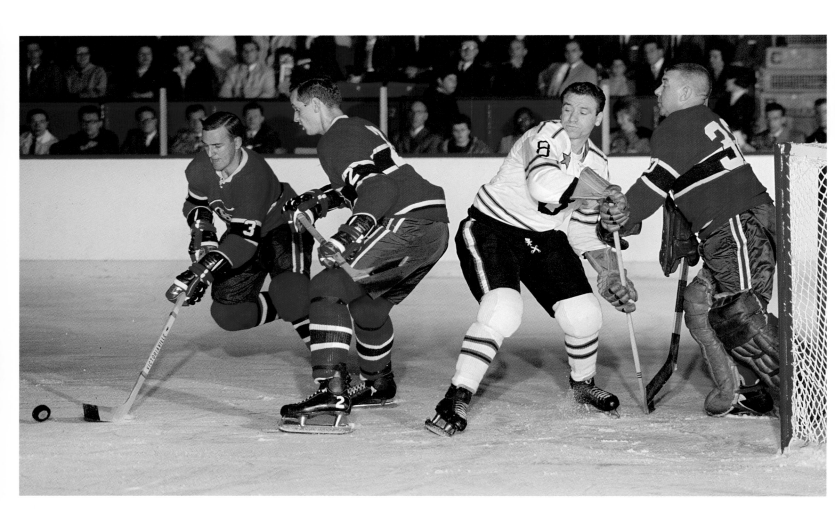

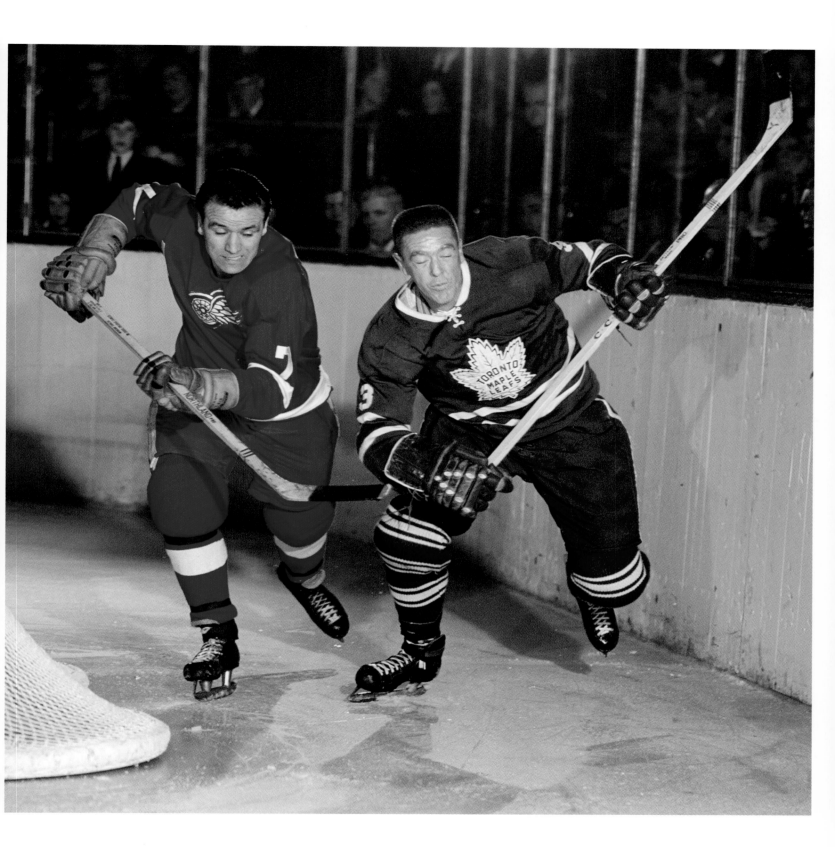

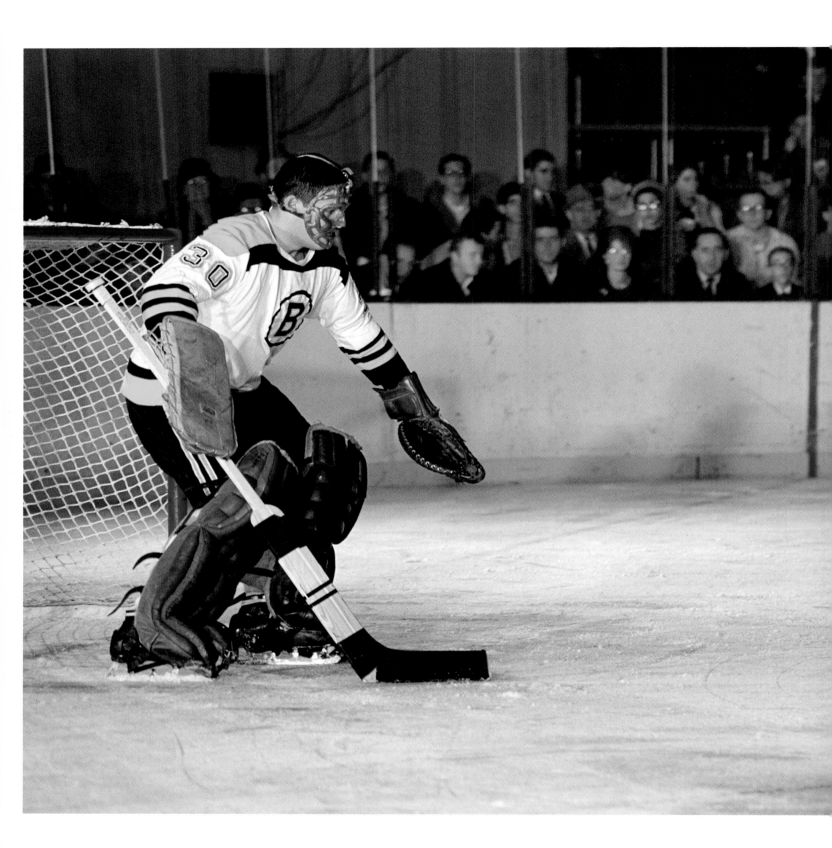

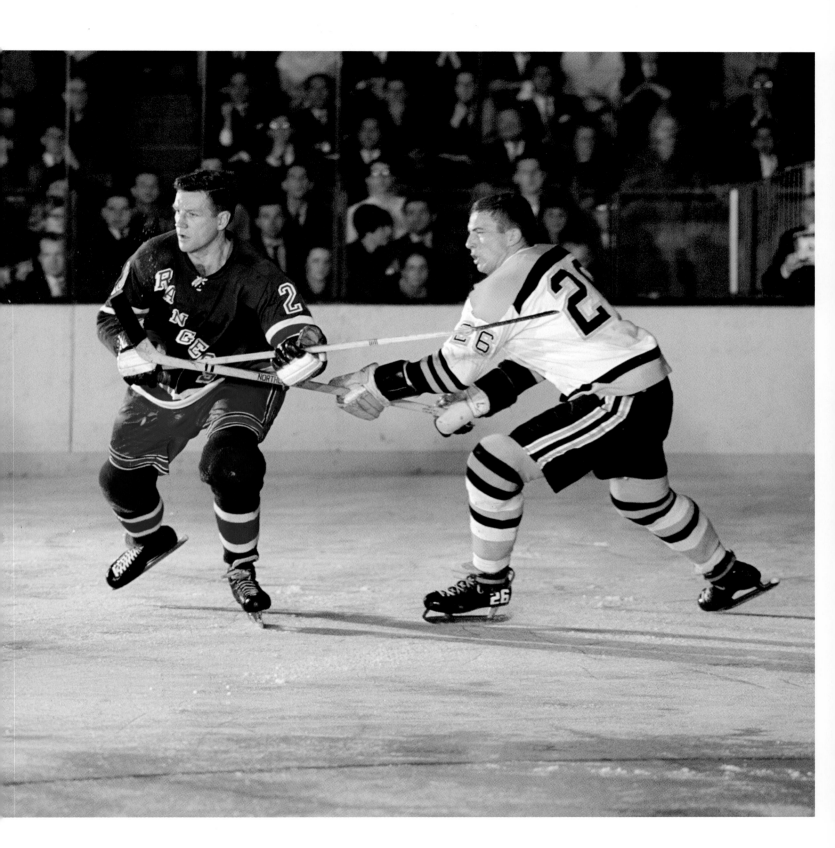

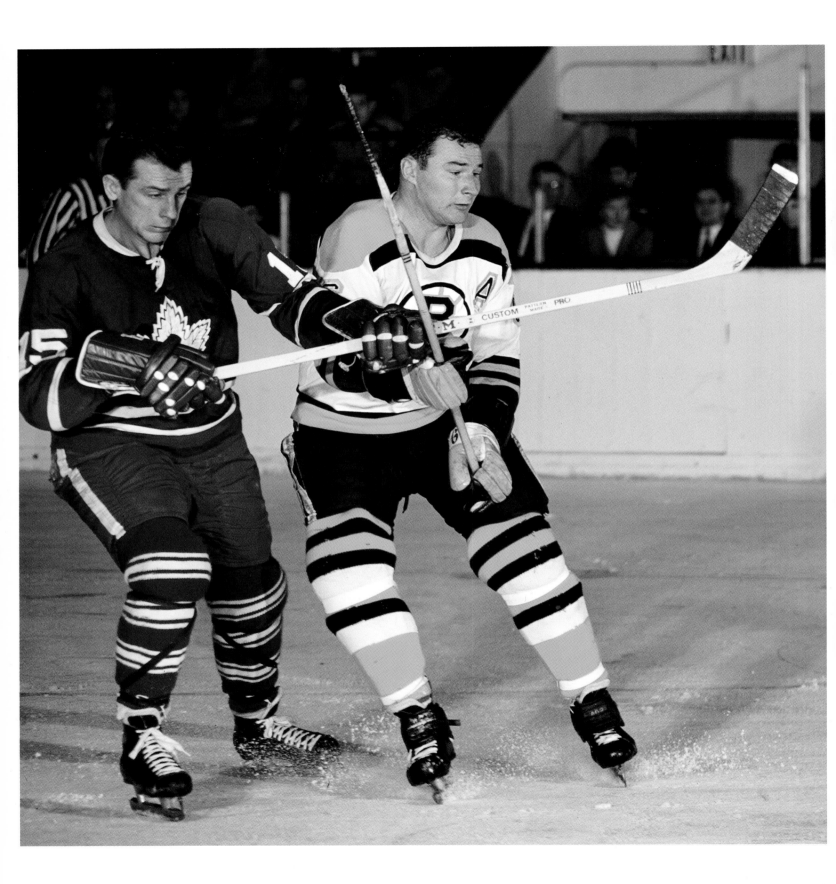

facing: Toronto forward Larry Jeffrey tangles with Boston rearguard Ted Green. Jeffrey, a very good junior prospect in the Detroit organization, came to the Leafs in a 1965 deal and was with Toronto when the team won the Stanley Cup in 1966–67.

below: The Hull brothers—from left, Bobby and Dennis—pose for a photo. Dennis was not nearly as famous as his older sibling but he was a very good NHL player who began his career in 1964–65 with the Black Hawks.

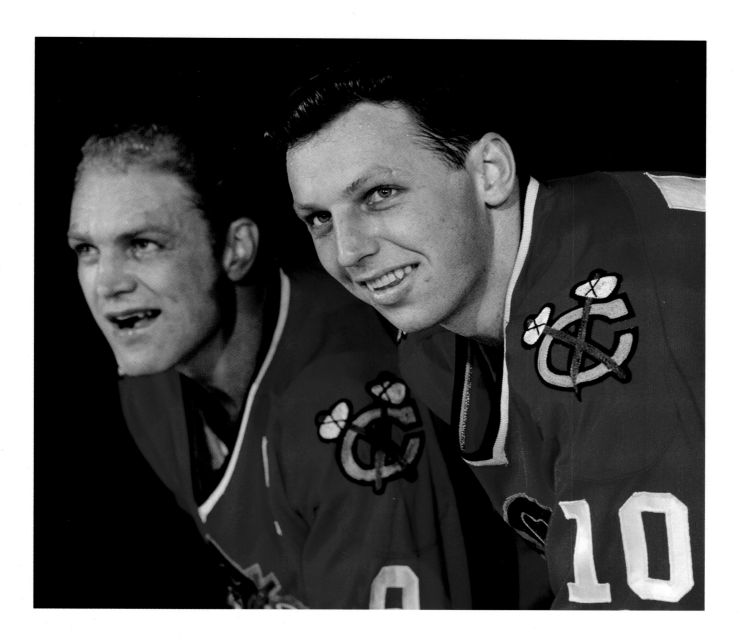

below: Toronto's mighty Tim Horton was runner-up for the Norris Trophy for best defenseman on two occasions, losing to Chicago's Pierre Pilote in 1964 and Boston's Bobby Orr in 1969. Murray Oliver (#16) was one of few bright lights on the Bruins in the 1960s—he had three-straight seasons of 20 or more goals.

facing: Montreal's Henri Richard won the Stanley Cup in each of his first five seasons in the NHL (1955 to 1960). The feisty and determined younger brother of Maurice "Rocket" Richard, Henri was known as the "Pocket Rocket." All-Star defenseman Bob Baun gives Richard a ride along the boards.

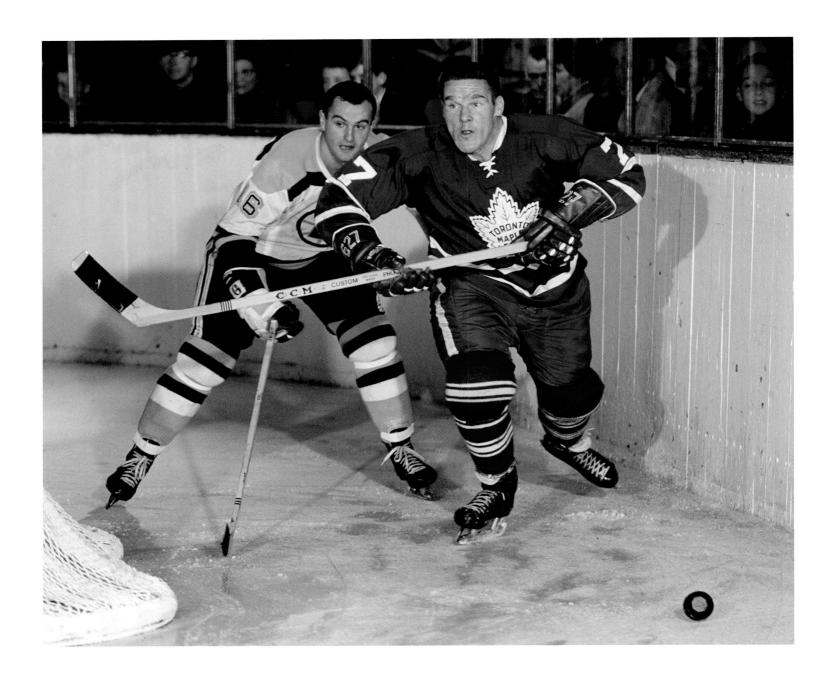

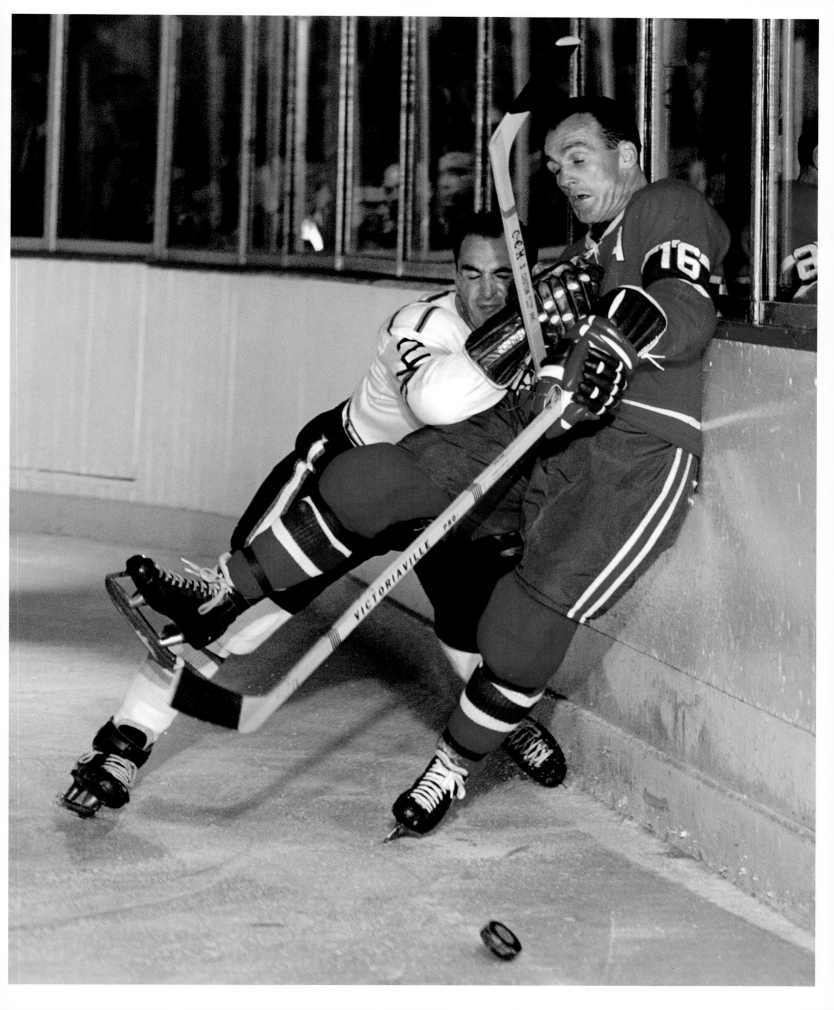

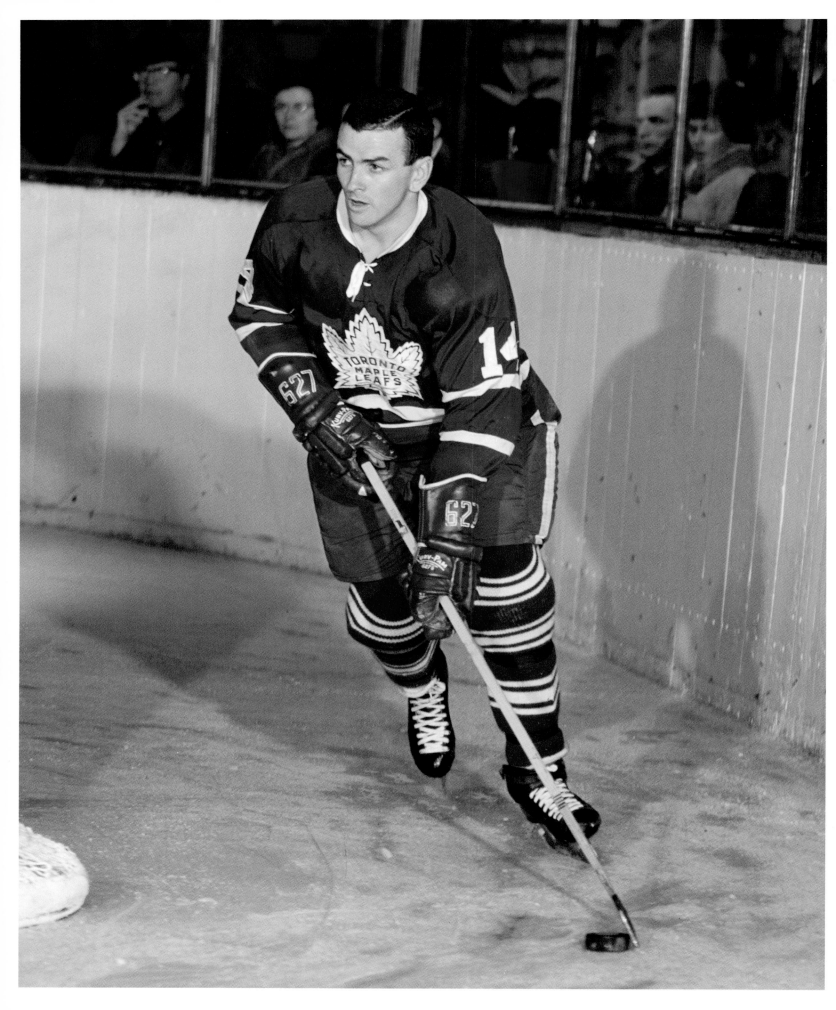

facing: Dave Keon remains the lone Toronto Maple Leaf to win the Conn Smythe Trophy as the best player in the playoffs. He was simply outstanding in the '67 post-season when he scored three goals and added five assists in 12 games played.

below: New York's Don Marshall (#22) is hoping for a pass to score on Bernie Parent of Boston. Marshall was traded from Montreal to the Rangers after winning five Stanley Cups with the Canadiens between 1956 and 1960.

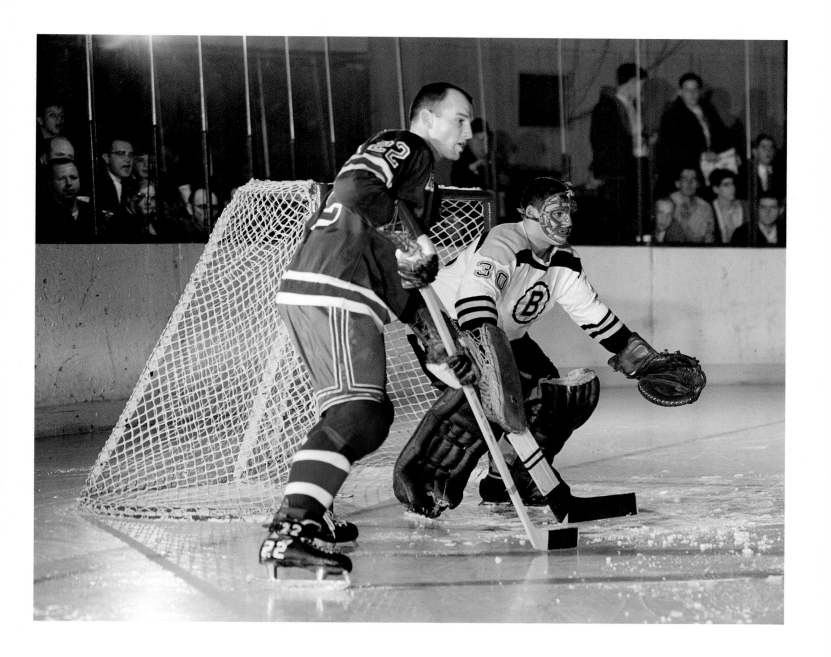

Detroit center Alex Delvecchio (#10) played his entire 1,549-game career with the Red Wings, scoring 456 goals and totaling 1,281 points. He was team captain from 1962 to 1973.

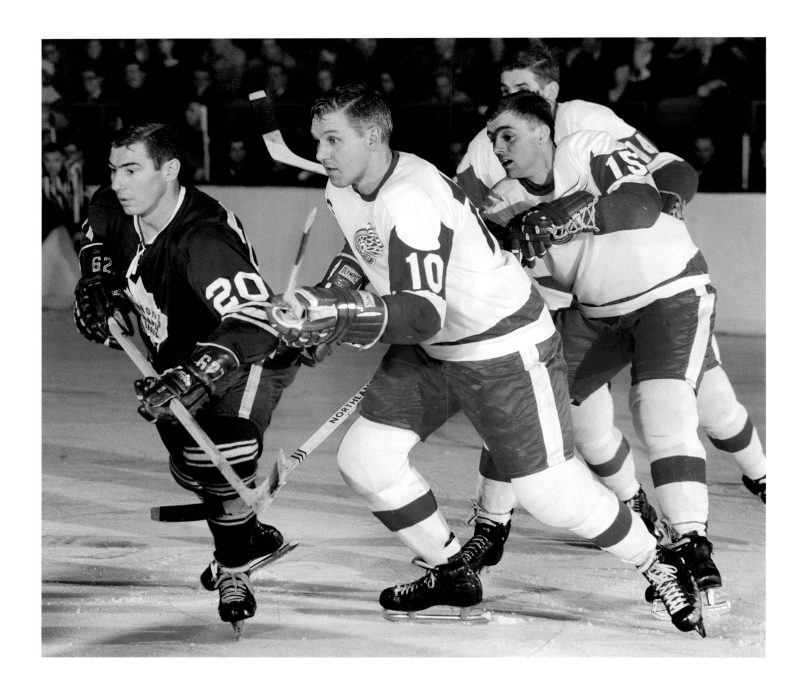

Goaltender Gerry Cheevers first belonged to
the Toronto Maple Leafs who did everything they
could to retain rights to him, including trying to list
him as a forward. The NHL would not allow the
Leafs to change his status as a goalie, and
the Bruins acquired him in 1965.

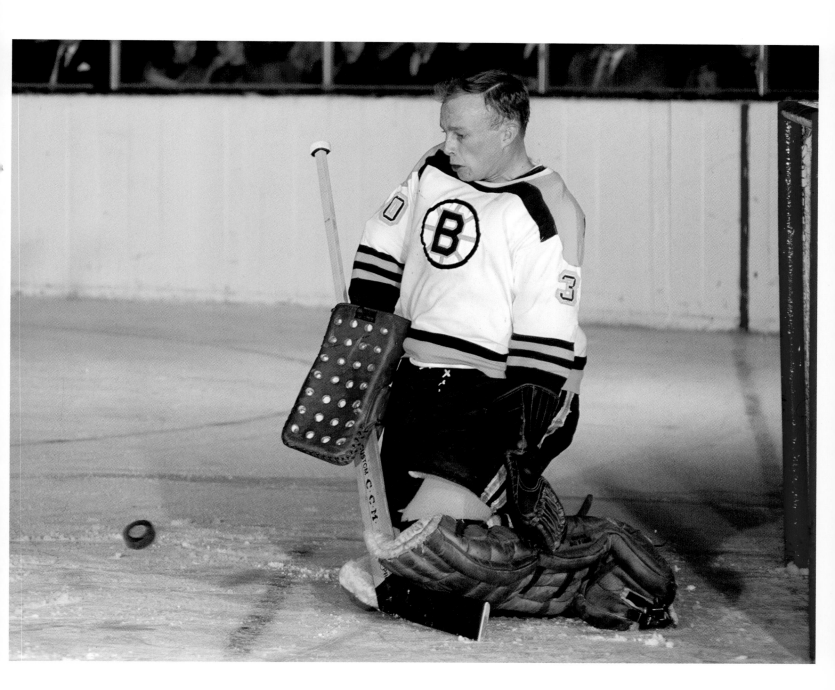

When the Toronto Maple Leafs won the Stanley Cup in 1967, they were led by veterans like George Armstrong (#10) and goalie Johnny Bower (#1). Nine players on the 1966–67 team were aged 30 or over, including 42-year-old Bower and 36-year-old Armstrong.

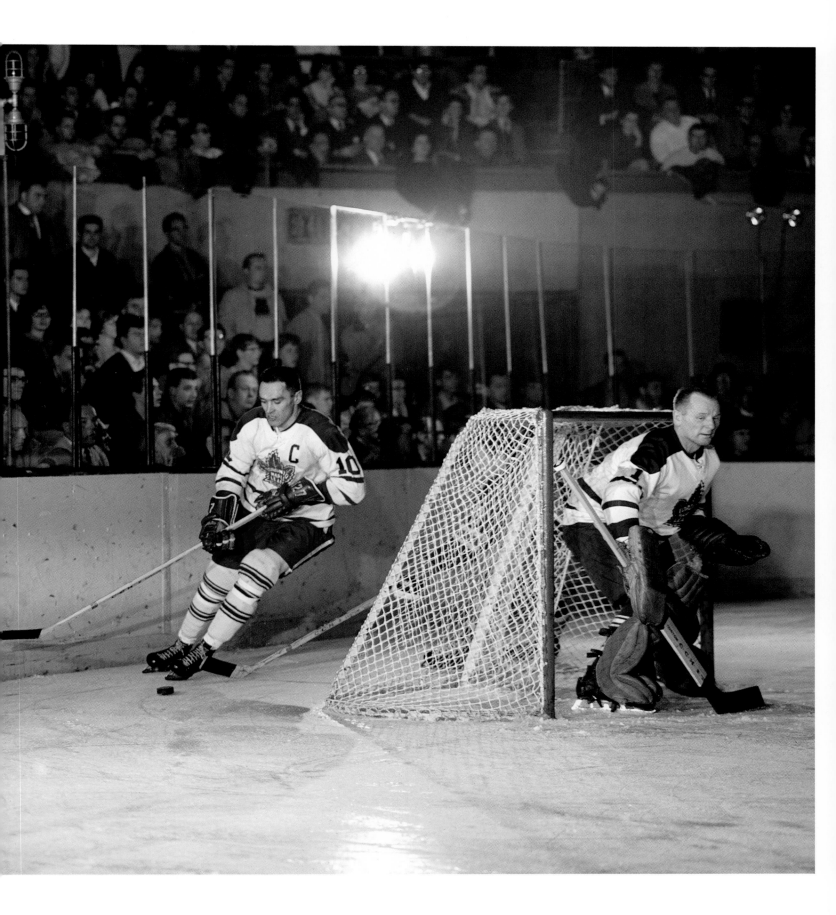

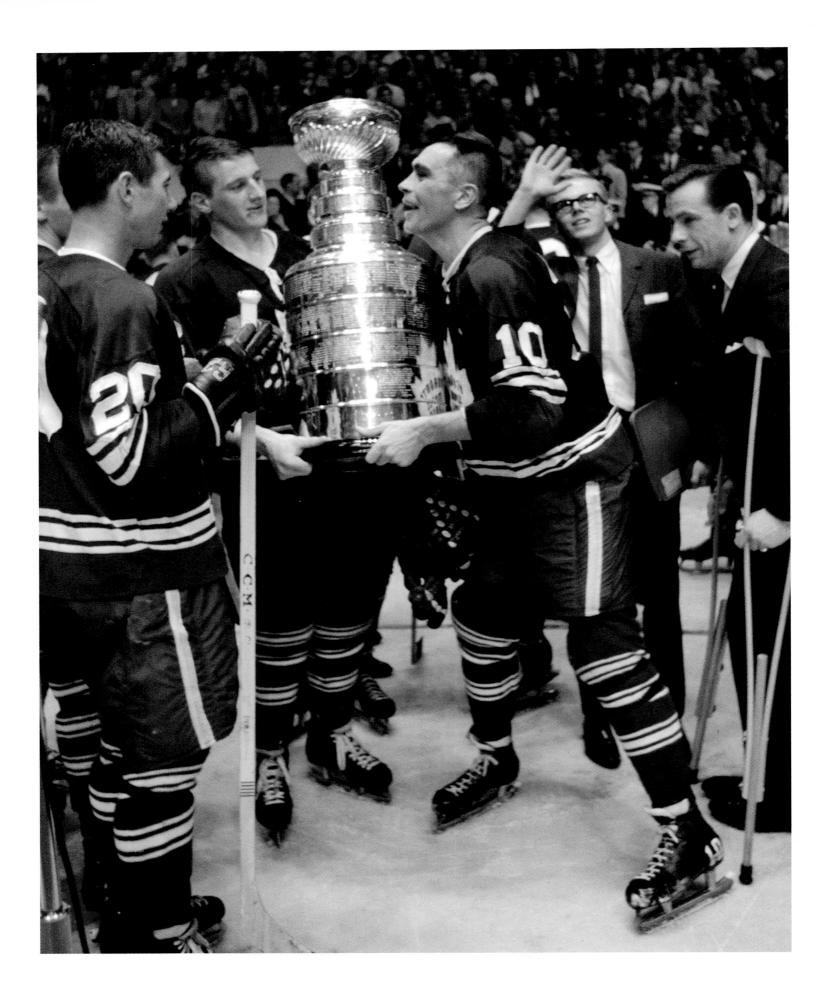

facing: Toronto captain George Armstrong holds the Stanley Cup with youngster Peter Stemkowski after the Leafs defeated Montreal in the 1967 Stanley Cup finals. Stemkowski teamed with Bob Pulford (#20) and Jim Pappin to form the Leafs best line throughout the 1967 post-season.

overleaf: Bobby Orr started his NHL career in 1966–67 as the much anticipated savior of the Boston Bruins. He won the Calder Trophy as top rookie, the first of many awards the superstar defenseman would win over the course of an illustrious, Hall of Fame career.

SOURCES

BOOKS

Diamond, Dan, and Eric Zweig. *Hockey's Glory Days: The 1950s and '60s.* Kansas City: Andrews McMeel Publishing Group, 2003.

Leonetti, Mike. *Hockey's Golden Era: Stars of the Original Six.* Toronto: Firefly Books, 1998.

———. *The Game We Knew: Hockey in the Sixties.* Vancouver: Raincoast Books, 1998.

———. *The Game We Knew: Hockey in the Fifties.* Vancouver: Raincoast Books, 1997.

Podnieks, Andrew. *NHL All-Star Game: 50 Years of the Great Tradition.* Toronto: HarperCollins Publishers Ltd., 2001.

GUIDES AND RECORD BOOKS

National Hockey League. *The National Hockey League Official Guide & Record Book 2010.* Chicago: Triumph Books, 2010.

National Hockey League. *Total Stanley Cup: 2007 NHL Playoff Media Guide.* Chicago: Triumph Books, 2007.

Toronto Maple Leafs Media Guide 2009–10. Toronto: Spalding Creative, 2010.

NEWSPAPER ARCHIVES

Globe and Mail. Available from Canada's Information Resource Centre, http://circ.greyhouse.ca/, see "Canada's Heritage from 1884."

Toronto Star. Available from Canada's Information Resource Centre, http://circ.greyhouse.ca/, see "Pages of the Past—The Archives of the Star since 1882." See also www.pagesofthepast.ca

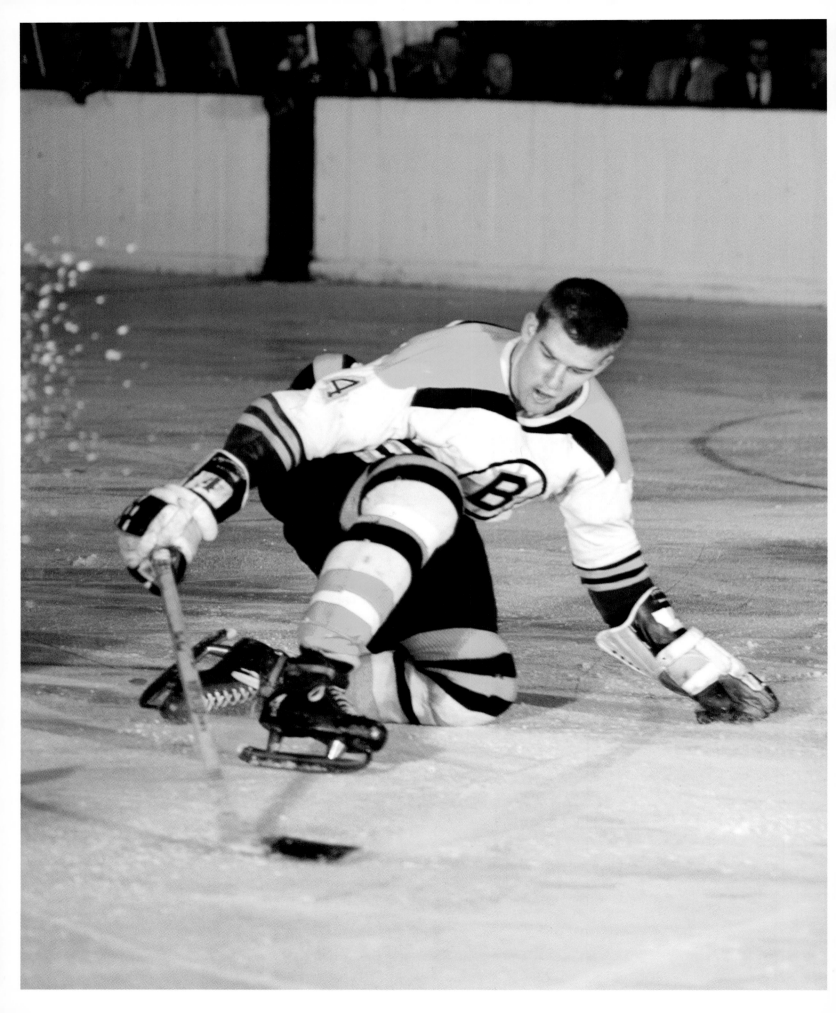